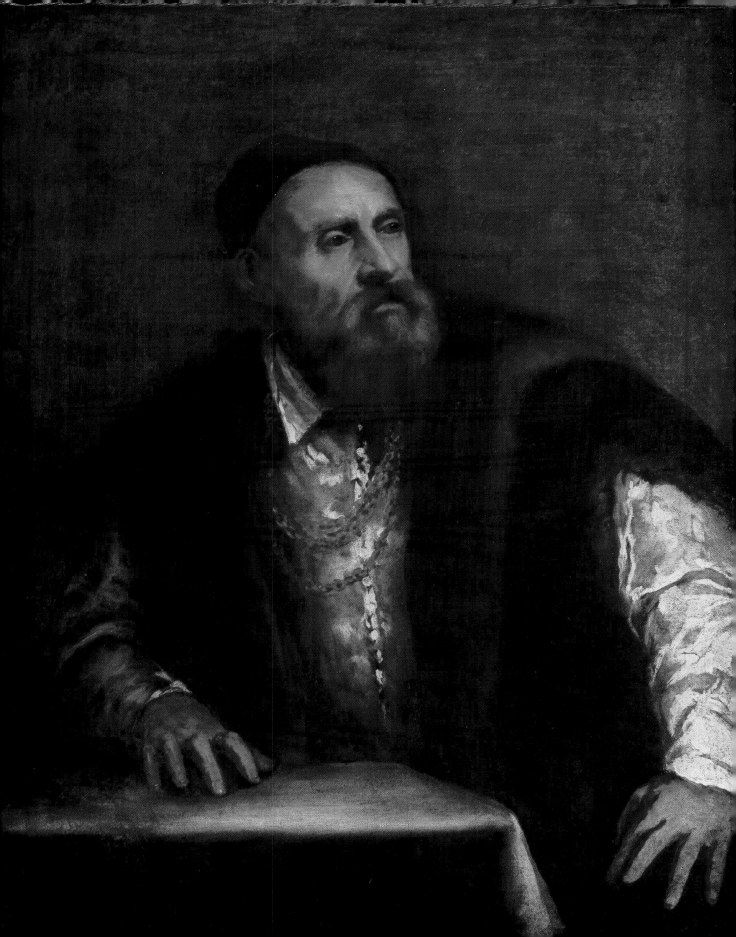

TITIAN

SELF–PORTRAIT

c. 1555

Oil on canvas, 37 3/4 × 29 1/2″

Staatliche Gemäldegalerie, Berlin-Dahlem

In this assertive image Titian, approaching seventy, presents himself as still vigorous, his rapacious hands still powerful. Whereas in other self-portraits he depicted himself holding the instruments of his art (figs. 60, 90), in the Berlin picture his own bulk and alertness convey the meaning; the golden chain, privileged insignia of the knighthood conferred by Charles V, serves as the single outward sign of status. The table before the sitter, modifying the parapet motifs of Titian's earlier portraits, functions as a stabilizing base for the heavy yet dynamic contrapposto of the figure. Within the massive silhouette, the eyes and hands bespeak a special vitality. The major source of the portrait's energy, however, is surely the product of those hands, the painting itself. The brushwork in the hands not only defines but is, in fact, identical with their very structure, while the brilliance of the shirt and chain animates the entire field.

The painting is usually considered incomplete, yet a remarkable degree of finish is achieved in the rendering of the artist's face and right hand, articulated to the fingernails. Over the bolus ground the paint is applied in varied consistency, from light scumble with a dry brush to thick impasto, and from this combination of hard-edged stroke and softer toning derives the sense of clearly defined substance and structure. While it is conceivable, even likely, that the canvas might have been awaiting further work, in its present state it offers full testimony to the master's technique and art of painting. Despite the absence of a paintbrush, this self-portrait is, as it must be, a tribute to that art.

LIFT COLORPLATE FOR TITLE AND COMMENTARY

TITIAN

TEXT BY

DAVID ROSAND

Professor of Art History, Columbia University

THE LIBRARY OF GREAT PAINTERS

HARRY N. ABRAMS, INC., *Publishers*, NEW YORK

To the memory of my brother

MICHAEL LEWIS ROSAND

Editor: Ellen Shultz
Designer: Deborah Jay

Library of Congress Cataloging in Publication Data

Rosand, David.
 Titian.

 (Library of great painters)
 Bibliography: p.
 Includes index.
 1. Tiziano Vecellio, 1488/90–1576.
ND623.T7R595 759.5 77–11042
ISBN 0–8109–1654–1

Library of Congress Catalogue Card Number: 77–11042
Published in 1978 by Harry N. Abrams, Incorporated, New York
Printed and bound in Japan

CONTENTS

———————

COLORPLATES

PREFACE

"Titian! Now there is a man who seems made to be enjoyed by those who are growing old."
So Eugène Delacroix confided to his Journal on October 4, 1854. "I confess that when I had a
great admiration for Michelangelo and Lord Byron I never appreciated Titian. It is not, I believe,
by the depth of his expression, nor by his great understanding of the subject that he moves one, but
by his simplicity and his total absence of affectation. In his art the painterly qualities are carried to
the highest possible degree. Whatever he does is done thoroughly and completely; when he paints
eyes, for instance, they see, they are quickened by the fire of life; life and logic abound in every part
of his work."

While we might take exception to certain details of the French Romantic's assessment of the
Venetian master, there is much truth in it. Titian is a demanding artist. His work, deceptive in its
simplicity, is rarely fully revealing on initial viewing but requires time; one does indeed feel one-
self maturing as one gets to know a painting by him.

In the following pages I have tried to present my sense of the master at this particular moment
in my relation to his art—having no doubt that in ten or twenty years that relationship will be
different. I have focused on Titian the painter and on the affective structures of his art, on its tech-
nique and mimetic power, on its poetry. Generally, biographical details have been introduced only
where they bear directly on the painting, for, unlike his great contemporary, Michelangelo, Titian
speaks to us exclusively through his pictorial art. He wrote no poetry and his letters are for the
most part quite mundane in their concerns. Nonetheless, an impressive culture informs all his work;
his profound sense of drama and sensitive response to poetry, his deep understanding of religious
experience, his human sympathy—all this resounds in the paintings themselves.

I trust that my presentation of the painter and his art, admittedly personal and necessarily
partial, is a balanced one; I have built my essay about those themes I felt were most significant and
illuminating. The sequence of colorplates is organized chronologically and intended to provide a
clear sense of the master's stylistic evolution. The majority of the attributions are not problematical,
and only in those few cases, mostly in the earliest work of the artist, where controversy still divides
specialists, have I felt obliged to defend my own position.

Many of the ideas and approaches contained in this study were conceived and first tried in the
lecture hall and seminar room, and I would like to express my gratitude to those students at Colum-
bia who created that healthy testing ground. To Michelangelo Muraro, friend and companion in
Venice, I owe a continuing debt, indistinguishably personal and professional. In writing the book,
in getting to know its subject, I have enjoyed the constant aid, encouragement, and guidance of my
wife Ellen; my gentlest and severest critic, she is in so many ways responsible for this volume.
And I can hardly express what I owe to our ever enthusiastic venezianisti *Jonathan and Eric, who*
once asked, "Do you believe in Titian?"

NEW YORK
MARCH, 1975

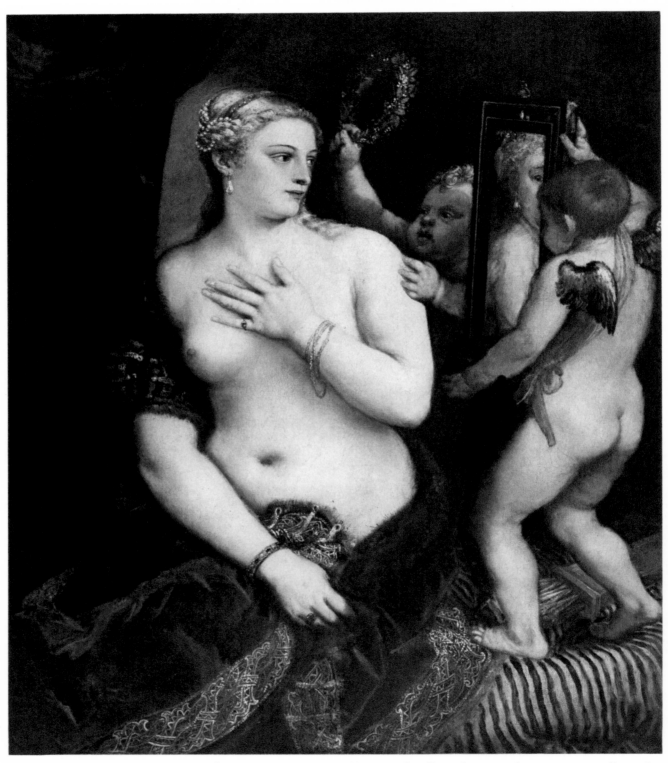

1. VENUS WITH A MIRROR. C. 1555. Oil on canvas, 49 × 41 1/2". *National Gallery of Art, Washington, D.C. Mellon Collection, 1937*

TITIANVS

Flesh was the reason why oil painting was invented.
—WILLEM DE KOONING

INTRODUCTION: THE VENETIAN BACKGROUND

Ever since the sixteenth century, the name of Titian has been synonymous with modern oil painting, the manner of painting that originated in Venice shortly after 1500. Rich in the variety of its textures and substances, this kind of painting offers in its thick impasto a visceral correlative to the stuff of nature and, in its freely applied brushstrokes, a record of the very process that brought the image into being. Forms tend to be open; depicted objects and containing space interpenetrate to weave a unified fabric, at once establishing the fiction of deep space, inviting the participation of the observer's imagination, and maintaining the structured integrity of the picture's surface, inviting the viewer's touch.

The Oil Medium

Although the use of oil in painting goes back to antiquity, its first consistent and focused development in pictorial representation dates from the early fifteenth century, when Flemish artists—above all, Jan van Eyck—exploited its particular qualities to produce images of a remarkably heightened reality. Oil, usually linseed, is naturally transparent and when used as a binding medium for pigments the resulting colors can be mixed to retain that luminosity, acquiring new intensity and profundity. Light both reflects off the polished surface and penetrates it, reflecting again off the underlying surfaces of paint or prepared ground. The application of such glazes, layers of oil with varying degrees of pigmentation, thus modifies the surface of a picture, complicating the reflective activity so that light seems actually to emanate from within the image itself.

The story of the introduction of the Flemish oil technique into Italy is rather difficult to unravel. Although Northern paintings were highly valued by Italian collectors throughout the fifteenth century, later writers, notably Giorgio Vasari, credited the introduction of the necessary studio knowledge to Antonello da Messina (d. 1479), who had direct contact with the Flemish tradition in Naples and who worked in Venice in 1475–76. In any event, by the end of the Quattrocento Venice had become the major center for the further development of the Eyckian heritage, especially in the art of its leading master, Giovanni Bellini (c. 1431/32–1516).

Whether or not he depended upon contact with

9

Antonello, a debatable issue, Bellini found in the oil medium a way of taking the traditional Venetian aesthetic commitment to light and coloristic effects —embodied throughout the Middle Ages in the mosaics of San Marco and in the gilded magnificence of elaborately carved altarpieces—onto a new level of pictorial sophistication. The medium allowed the re-creation in purely painterly technique of the glowing impact of actual gold: the sanctified aura of the mosaic chapel could be preserved on the glazed panel (fig. 2). Divine light, however, was not only embodied in the golden tesserae but was present as well in the light of nature—as painters of an earlier generation, in Italy and north of the Alps, had already demonstrated, elaborating certain theological tenets and metaphors. Bellini extended that vision in his own painting of landscape, suffused by a subtle and eloquently differentiated illumination through which the divinity manifested itself (fig. 3). With Giovanni Bellini, landscape emerged as a central concern of Venetian painting.

The transparency of the medium in this kind of painting, basically slow and precise in execution, depended for its full effect upon the hard white gesso surface of the prepared panel. The forms, large and small, from which this extraordinary light emanated were rendered with discrete contours; their closed integrity was a necessary component of their radiant significance. Like his Flemish predecessors, Bellini built up his painting from light to dark, working up a series of transparent tonalities; the light itself found its deepest reflecting surface at the level of the gesso ground, from which it returned through the modifying layers of glaze to create that depth of color and effect of inner illumination. "With these methods," in the words of Millard Meiss, "the diffusion of light could become a major pictorial theme."

Another factor essential to the later development of Venetian painting in the sixteenth century was the adoption of canvas as a ground. Like the use of oil it, too, had a long history; appreciated for its lightness, canvas was used mostly for portable images such as processional banners. In fifteenth-century Venice, however, it acquired a much more monumental and permanent status: as the great fresco cycles in the Palazzo Ducale, initiated in the fourteenth

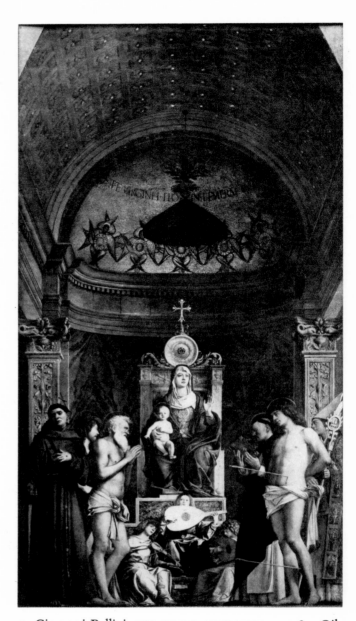

2. Giovanni Bellini. SAN GIOBBE ALTARPIECE. c. 1485. Oil on panel, 15′5 1/2″ × 8′5 1/2″. *Gallerie dell'Accademia, Venice*

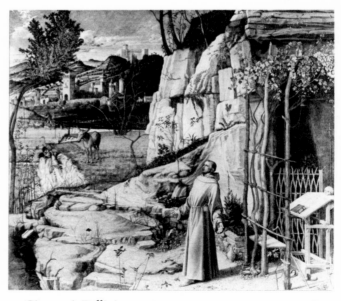

3. Giovanni Bellini. SAINT FRANCIS IN ECSTASY. c. 1480. Oil on panel, 48 3/4 × 54″. ©*The Frick Collection, New York*

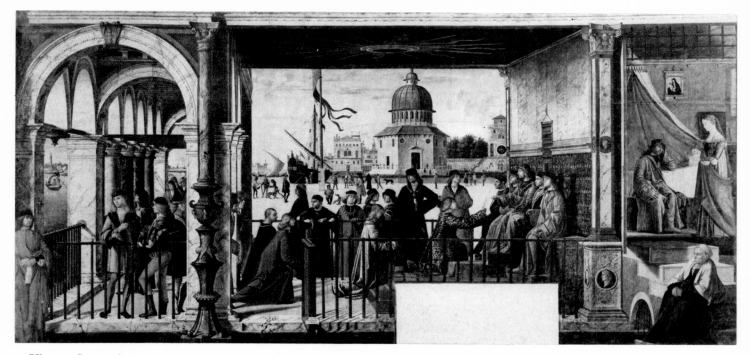

4. Vittore Carpaccio. THE RECEPTION OF THE ENGLISH AMBASSADORS AND SAINT URSULA TALKING WITH HER FATHER. From the Scuola di Sant'Orsola cycle. c. 1496–98. Oil on canvas, 9' 1/4" × 19' 3 7/8". *Gallerie dell'Accademia, Venice*

century, deteriorated in the constant humidity of the lagoon climate, the original compositions were eventually replaced by canvas murals. By the end of the Quattrocento, pictorial cycles decorating the Palazzo Ducale and the various *scuole* (confraternities) in Venice were painted or repainted on canvas, and this woven ground became the most frequent choice of Venetian painters and their patrons both for large-scale decorations and for the newer modes of smaller cabinet pictures that were coming into vogue.

The consequences of this choice were at least as far-reaching as the use of the oil medium itself. Unlike the smooth, hard surface of the gesso-prepared panel, canvas offered to the painter's brush a coarse-textured woven surface. While this roughness could be minimized by using a finer weave or, as was frequently the case in Florence, by application of a thin gesso ground, the Venetians accepted the rougher surface and exploited its expressive potential. Moving across such a ground—which militated against sharp, continuous contours—the brush left a broken trail of pigment, open and suggestive. This technique proved particularly effective in large-scale mural painting, and one finds it at work in the decorative *teleri* (canvases) of such artists as Carpaccio in the last decade of the fifteenth century (fig. 4).

Giorgione and the New Sensibility

Heir to both traditions, the oil medium and the canvas ground, Giorgione (c. 1477–1510), the leading master of a younger generation, created out of this double inheritance a new kind of painting, a new vision. According to Vasari's art-historical scheme, the enigmatic artist from Castelfranco ushered in the modern age in Venice—as Leonardo da Vinci had done, earlier, in Florence. Rejecting the labored techniques of the older generation, their dry, cramped manner of drawing, he began to give his works greater softness and relief, with a more gracious style (*bella maniera*); he would copy living things from nature, imitating them with colors alone, blocking them out directly in various tones without making preliminary drawings. Although, as we shall see, Vasari was rather critical of this abandonment of the guiding drawing, he fully appreciated the revolutionary aspect of Giorgione's technical innovations.

Fundamental to this procedure was a reversal of the traditional application of tonal structure in painting. Giorgione constructed his picture upon a toned ground, working up from dark to light. Thus, light did not emanate from the depths of the glazed strata but emerged rather from a basic underlying dark-

ness; no longer a function of the transparency of oil, it was applied as white pigment, thick and opaque. Glazing was reserved now for the final stages of execution, the final modifying layer of the painting.

In this new technique of oil painting the actual stroke of the brush naturally came to assume a more significant and signifying role, since the trail of paint it left behind determined the very character of the forms rendered. If a careful preliminary drawing ceased to be for Giorgione the basic first step in conceiving and preparing a picture, the process of drawing nonetheless gained a new kind of importance—by transfer, so to speak. The brush itself served as a drawing implement, recording the pressure and direction of the guiding hand; the surface of the painting became, in effect, a record of successive and accumulated touches. And, just as naturally, the change in the way forms were rendered entailed a serious modification of the very concept of form itself; blocked out in areas of tone and color, built up of individual strokes, depicted shapes no longer depended upon clarity of outline for their functional integrity. Indeed, submerging figures and objects in shadow, Giorgione—in a manner related to Leonardo's *sfumato*—sacrificed some of that discrete bounding to create a new kind of atmospheric unity in which solid and void, interpenetrating, shared a phenomenological continuum.

In these developments the canvas ground came to play a determining role. Its rough texture encouraged a broken touch; as the brush left its pigment essentially on the ridges of the woven surface—unless by determined application the artist forced the paint into the valleys of the weave—areas of color were naturally broken and varied.

Furthermore, the process itself was as open as its product. Since the painter relied less on the transparency of glaze, he could more readily overpaint with the opaque pigment. The process of painting became freer, more actively dialectical; entire compositions could be radically altered in the course of execution, and X-ray investigations have demonstrated the degree to which Giorgione—and Titian after him (figs. 56, 57)—capitalized on this freedom to change his mind. Why, indeed, fix a composition in a clear initial drawing when in the course of execution it was likely to undergo serious alteration?

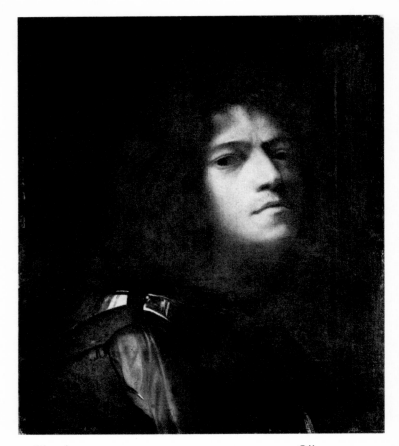

5. Giorgione. SELF-PORTRAIT AS DAVID. c. 1509–10. Oil on canvas, 20 1/2 × 17″. *Herzog Anton Ulrich-Museum, Braunschweig, Germany*

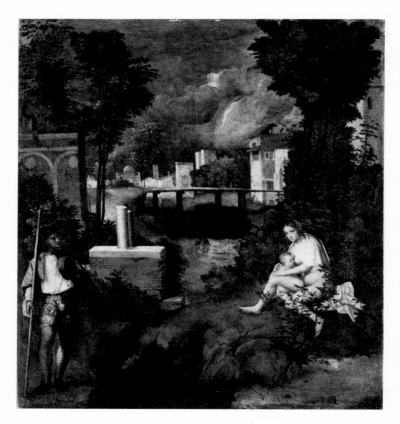

6. Giorgione. THE TEMPEST. c. 1506–8. Oil on canvas, 32 1/2 × 28 3/4″. *Gallerie dell'Accademia, Venice*

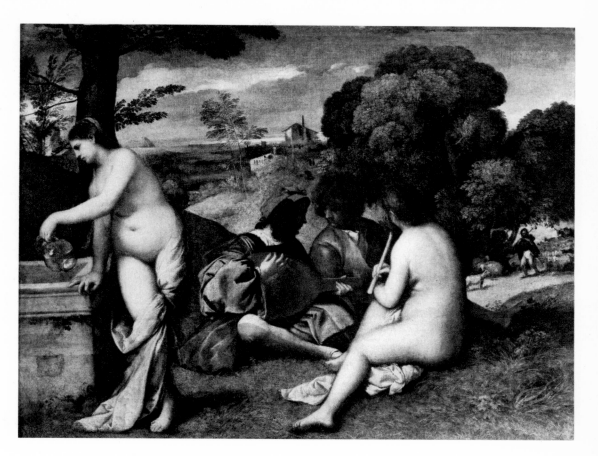

7. Giorgione. CONCERT CHAMPÊTRE.
c. 1509–10. Oil on canvas, 43 1/4
× 54 3/8″. Musée du Louvre, Paris

This new sense of form and of artistic process was not a uniquely Venetian phenomenon. Throughout Europe, about 1500, the older ideas of crafted finish were being challenged: Leonardo's conscious use of the sketch as an open exercise in pictorial exploration and creative indulgence of the imagination attests most articulately to the new attitude, and in the North Hieronymus Bosch was subjecting the Eyckian tradition of oil painting to a related transformation with a technique of broken touches and a resultant openness of style.

Reciprocally inspiring and inspired by a new sense of the affective function of the painted image, Giorgione's technical innovations evolved: the formal devices of losing a contour in shadow (fig. 5), implying rather than explicitly stating the fullness of a form, required the active participation of the beholder in completing the image. And this new subjectivity applied as well to the themes of painting, for the subjects of many of Giorgione's pictures, like the famous *Tempest* (fig. 6), appear to us deliberately vague, so that the observer is forced also on the interpretive level to extend himself. Such involvement seems a perfectly natural and appropriate experience in light of the formal invitation

of the composition. A new generation of patrons commissioned and sought a new kind of picture, small in scale and intended for intimate appreciation. Often sharing the themes and iconography of the revived literary traditions of the pastoral (fig. 7), these compositions extended and, as it were, secularized the landscape tradition defined by Giovanni Bellini (fig. 3). Such cabinet pictures created an aura of private, poetic reverie, and, as we continue to debate their precise meaning—or, indeed, whether or not they ever had a precise meaning—we continue to accept their invitation to involvement.

TITIAN'S EARLY CAREER

Like Giorgione, Titian was born on the mainland, but high in the Dolomites, in Pieve di Cadore, of an important local aristocratic family. The actual date of his birth is undocumented, and legend, inspired by the exaggerations of the aged master himself, eventually established that when he died in 1576 he had attained the age of ninety-nine. The truth, however, would reduce that impressive longevity by about a decade. Among our most reliable sources

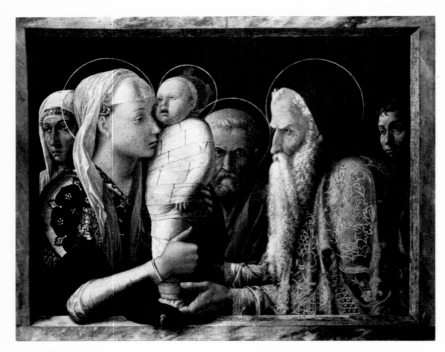

8. Andrea Mantegna. THE PRESENTATION OF CHRIST IN THE TEMPLE. C. 1455. Tempera on canvas, 26 3/4 × 33 7/8". *Staatliche Gemäldegalerie, Berlin-Dahlem*

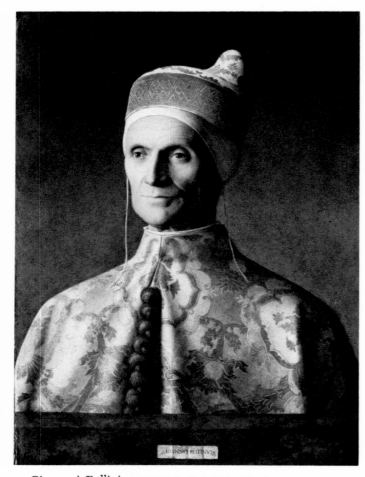

9. Giovanni Bellini. PORTRAIT OF DOGE LEONARDO LOREDAN. c. 1501. Oil on panel, 24 1/4 × 17 3/4". *National Gallery, London*

of information is Lodovico Dolce, whose biography of the artist was published during Titian's lifetime (1557) as a sort of official Venetian response to the neglect of the painter in the first edition of Vasari's *Lives* (1550). The fairly clear and convincing chronology that Dolce establishes for the young Titian allows us to place his birth about 1488—if, as Dolce writes, he was scarcely twenty when he worked with Giorgione at the Fondaco dei Tedeschi in 1508. At the age of nine the boy was sent to Venice and apprenticed to the mosaicist Sebastiano Zuccato, with whom he would have received his first training. Evidently recognizing the extraordinary talent that had been entrusted to him, Zuccato sent the young Titian on to the shop of Gentile Bellini (c. 1429/30–1507), the more conservative older brother of Giovanni. If, in art-historical retrospect, these first masters seem strange instructors for the future deity of painting, we must recall one important fact: Zuccato and Gentile Bellini enjoyed the highest official status open to painters in Venice; the former was head of the mosaic workshop of San Marco, the state church and central religious monument of the city, while the latter was the official painter of the state, in charge of the decorations in the Palazzo Ducale and portraitist of the doges. Both were directly responsible to the Venetian government. Politically, then, the youngster could not have been better placed; from the outset of his career he enjoyed a privileged position and quasi-official patronage.

Nonetheless, and still according to Dolce's account, the apprentice was impatient with Gentile's dry and archaic methods and, in fact, challenged the master with the boldness and speed of his own drawing. This confrontation between the generations led to Titian's departure from Gentile's shop to study, briefly, with his brother Giovanni; from there, Dolce continues, the young painter soon went to work with Giorgione. While this account of Titian's early training cannot be accepted as gospel—it neatly has the boy traversing the full art-historical arc from the most conservative to the most advanced masters then practicing in Venice—it almost certainly claims some grain of truth and historical plausibility. Titian would have served his required apprenticeship with Gentile Bellini and then, in some

capacity, worked as assistant to Giovanni. Dolce's information, after all, comes directly from Titian or those closest to him, and, even more significant, the early work itself affords further confirmation of this sequence of events.

Christ Carrying the Cross (colorplate 2) may well be Titian's earliest extant canvas and a document of the moment when he terminated his apprenticeship to Gentile Bellini, about 1505. Reflecting both the training in that shop and a knowledge of the art of Bellini's brother-in-law, Andrea Mantegna (c. 1431–1506) (fig. 8), the painting's dry style would soon be modified by a softening of form, apparent in the Berlin *Portrait of a Young Man* (colorplate 3), which suggests contact with Giovanni Bellini (fig. 9) and possibly even some experience of Giorgione's painting.

Titian and Giorgione

In 1505 fire destroyed the Fondaco dei Tedeschi at the Rialto, the great warehouse and commercial center of the German community in Venice, and the building was quickly rebuilt on an even greater scale by order of the Venetian government. The commission for the frescoes decorating the facade on the Grand Canal was awarded to Giorgione, and by the end of 1508 the work there was evidently completed and ready to be evaluated. Unfortunately only dim fragments of the original frescoes survive, and the decorations are known to us primarily through prints of the seventeenth and eighteenth centuries (figs. 10, 11). In the decoration of the side of the Fondaco overlooking the Merceria, the main commercial street of Venice linking the areas of San Marco and the Rialto, Giorgione took on as an assistant the young independent master Titian. Responsibility for design of the project was Giorgione's, but in executing the cartoons of the master Titian must have enjoyed a certain latitude and evidently—according to the anecdote reported by Dolce—imposed his own personality on the work. The composition representing *The Triumph of Justice* (fig. 11) is described by Dolce—who identifies it as a *Judith*—as "marvelous in both design and coloring, so that, since it was generally believed to be by

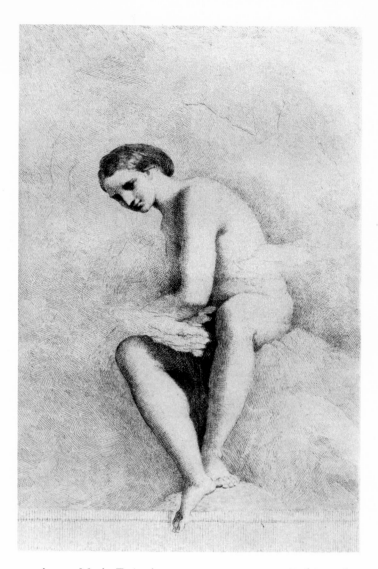

10. Anton Maria Zanetti. SEATED FEMALE FIGURE. Etching after the fresco by Giorgione on the Fondaco dei Tedeschi, Venice, from VARIE PITTURE A FRESCO DE' PRINCIPALI MAESTRI VENEZIANI (Venice, 1760). *British Museum, London*

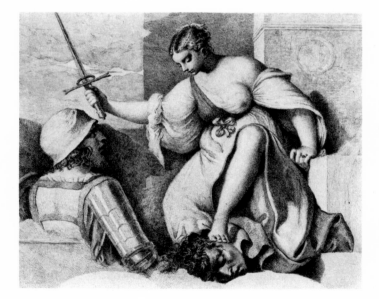

11. Anton Maria Zanetti. THE TRIUMPH OF JUSTICE. Etching after the fresco by Giorgione and Titian on the Fondaco dei Tedeschi, Venice, from VARIE PITTURE A FRESCO DE' PRINCIPALI MAESTRI VENEZIANI (Venice, 1760). *British Museum, London*

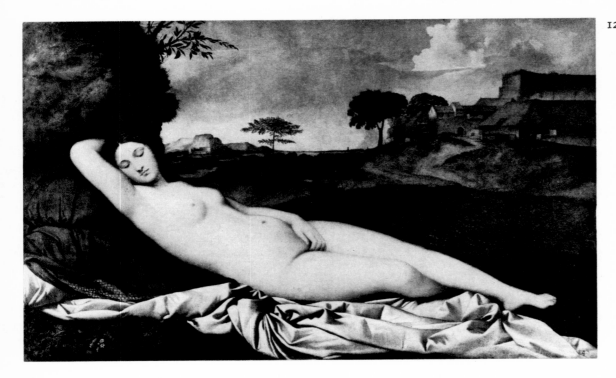

12. Giorgione (completed by Titian). SLEEPING VENUS. C. 1505–10. Oil on canvas, 42 1/2 × 68 7/8″. *Staatliche Gemäldegalerie, Dresden*

Giorgione, all his friends congratulated him, declaring it by far his best work. Whereupon Giorgione, with the deepest displeasure, responded that it was by the hand of a pupil, one who was already promising to surpass his master; moreover, he remained in seclusion for several days, as if in despair at having to admit that a youth was more capable than he." If the story seems a commonplace of such biographies, it nevertheless reflects a number of truths of the situation: it exemplifies the belief, according to the historical view of the sixteenth century, in the progress of art—most satisfyingly dramatized in the traditional theme of the outdistanced master—and in Titian's destined role in that progress, and it offers an example of the frequent confusion of the painting of Giorgione with that of the young Titian.

Any discussion of Titian's early work must in fact deal with the "Giorgione problem" and attempt to disentangle the two personalities. To critics from Vasari on, Giorgione's oeuvre has proved extremely vague and fluid, with only a very few generally accepted touchstones—such as the early Castelfranco altarpiece and *The Tempest* (fig. 6). As we have already seen, Giorgione's art, and especially the more mature work, is built upon an essentially tonal base; within its chiaroscuro atmosphere forms emerge, partially illuminated, and occupy space as much by implication as by actual displacement. A single comparison may serve to epitomize the distinction between the styles of the two artists, a comparison between the standing female nude in Giorgione's *Concert Champêtre* (fig. 7) and the corresponding figure in Titian's *Sacred and Profane Love* (colorplate 10). While both nudes seem to address the picture plane frontally, turning their heads to one side, Giorgione's involves a more complicated spatial organization, a greater variety of internal positions and movements; by that complexity the figure activates a spatial envelope about herself. Titian's figure, on the other hand, obeys a principle of frontality even more faithfully than the carved figures on the relief below; measured against the plane, the slightest nuances of change in her pose assume a heightened visual significance, as she addresses both the observer and her sumptuously attired companion. And that sophisticated nuancing in turn dictates and depends upon her rhythmically delineated contour, which maintains a sharpness of edge antithetical to the shadowed boundaries of Giorgione's painting. Presenting a certain sculptural quality, Titian's forms stand out clearly in a light created to describe the subtleties of their marmoreal surfaces. Giorgione's formal sense depends more on volume than mass, and the twilight illumination, merging object and surrounding atmosphere, further softens those forms. The same distinctions may be made with regard to the landscape structures, comparing Giorgione's taste for large billowing forms—clouds,

hills, trees—and the crisper articulation of Titian's more calculated constructions.

These distinctions naturally manifest themselves on the level of execution, in the application of paint and the handling of the brush. The looseness and openness of form characteristic of Giorgione's art, especially his later work, are the function of his new manner of painting, directly and freely; as he developed, his brushwork achieved an ever greater freedom—impelled perhaps by the experience of monumental fresco decoration at the Fondaco dei Tedeschi. Although Titian worked there with Giorgione and was called upon to complete canvases left unfinished at the time of the latter's premature death in 1510 (fig. 12), he did not immediately follow the example of Giorgione's sensitive brush handling. Rather, his own commitment to clearly delineated form seemed to require a tighter mode of execution; only in areas inviting deliberate pictorial display, as in the sarcophagus reliefs he invented, did the young Titian exhibit a corresponding freedom of brushwork (colorplates 8, 10).

Padua

It may have been the plague of 1510, which claimed the life of Giorgione, that led Titian to transfer to Padua, where during 1511 he painted three frescoes in the decorative cycle of the Scuola di Sant'Antonio (figs. 13, 14, and colorplates 6, 7). In the city of Saint Anthony he was competing with a venerable tradition of fresco painting—going back to Giotto's early-fourteenth-century cycle in the Arena Chapel and attaining a nearer peak in the young Mantegna's decoration of the Ovetari Chapel in the Church of the Eremitani. Moreover, this great pic-

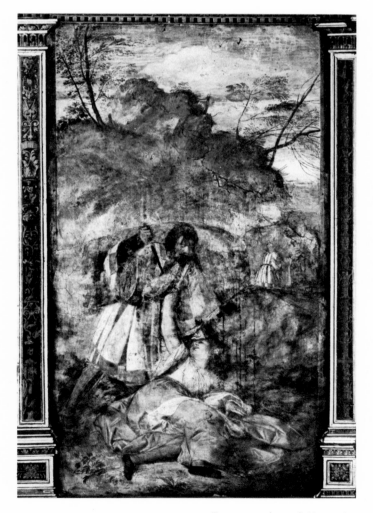

13. THE JEALOUS HUSBAND. 1511. Fresco, 10′ 8 3/4″ × 6′. *Scuola del Santo, Padua*

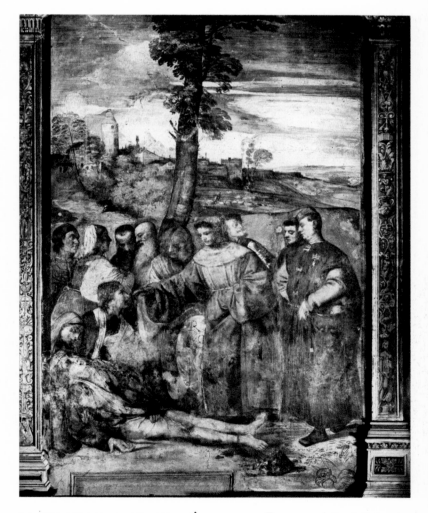

14. THE MIRACLE OF THE YOUTH'S LEG. 1511. Fresco, 10′ 8 3/4″ × 7′ 3 5/8″. *Scuola del Santo, Padua*

torial tradition was supported by a profound commitment to classical studies and archaeology in the university town. There Titian's innate classicism received confirmation and new impetus, and the progress of his work in the Scuola del Santo records his movement toward a heightened classical control.

The fresco of *The Jealous Husband* (fig. 13)—ambitious, even impetuous, in the dramatic dynamics of its spatial construction and, at the same time, curiously archaic in its narrative mode, depicting the violent event and its aftermath of penitence and forgiveness in a single field—would seem to document a young master's first essay in monumental narrative composition. *The Miracle of the Youth's Leg* (fig. 14), also a scene of penitence and healing after violence, displays a more controlled pictorial idiom; with Giotto's eloquent *Lamentation* as a model and challenge, Titian seeks a more harmonic narrative through the deliberate orchestration of gesture and glance. Finally, in *The Miracle of the Newborn Infant* (colorplates 6, 7), he achieves a full statement of his own kind of classicism, in which clear compositional structure and the precisely manipulated poses of the figures contribute equally to the monumental affect.

Conception and execution on this scale must have encouraged that boldness of drawing which supposedly upset the conservative Gentile Bellini, for in the course of his work in the Scuola del Santo Titian arrived at a new technical assurance and freedom.

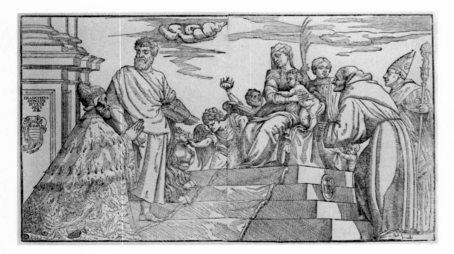

15. After Titian. MADONNA AND SAINTS WITH DOGE FRANCESCO DONÀ. Modified copy of the destroyed votive picture of Doge Andrea Gritti. Woodcut. *The Metropolitan Museum of Art, New York. Rogers Fund, 1922*

One other product of these early years further testifies to that confidence: the design for the monumental woodcut of *The Triumph of Faith* (fig. 80). Inspired by Mantegna's imperial triumphs and, even more significantly, by the pictorialism of Dürer's graphics, Titian managed to transform the traditional language of the woodcut, introducing the new breadth and power of his own draftsmanship.

TRIUMPH IN VENICE

The year in Padua proved a crucial experience in the development of the young painter; there he came to maturity. Returning to Venice, he quickly established himself as a major personality in the public arena, exhibiting a confidence, personal and professional, that was assertive to and beyond the limits of arrogance. An invitation to join the papal court, evidently arranged by Pietro Bembo, served to enhance his position at home; armed with this bid, he offered his services to the *Serenissima*. In a letter of May 13, 1513, he asked to be allowed to work on the mural decorations of the Sala del Maggior Consiglio in the Palazzo Ducale, volunteering to paint a battle scene to replace a decaying fresco of the fourteenth century—a task, he wrote, "so difficult that no one yet has dared to undertake it." Insisting, somewhat rhetorically, that his art was a means to honor rather than gain, he asked in return only payment for the colors and other necessary expenses and the promise of the next *senseria*, a lucrative broker's patent, to fall vacant at the Fondaco dei Tedeschi. This, however, was tantamount to requesting recognition as heir apparent to the official state painter, for the *senseria* and the privileges and exemptions that went with it were reserved for that appointment; the current holder was the aged Giovanni Bellini.

The acceptance of Titian's bold offer evidently aroused certain political opposition; the initial decision was soon revoked but then in turn reconfirmed. By the end of 1514 Titian had begun work on the battle piece; two years later, following the death of Bellini, he assumed the financially rewarding and prestigious position of painter to the state, charged with overseeing the decorations in the Pa-

lazzo Ducale and with painting the portraits and votive pictures of the doges (fig. 15).

The Battle Picture

With this, his first official commission in Venice, Titian established a pattern of procrastination that would characterize much of his career; not until 1538, and only after severe threats from the government, did he complete the canvas of *The Battle of Spoleto*—the twelfth-century subject of the early fresco that he was replacing, although Titian's painting would later come to be known as *The Battle of Cadore*, an event of 1508. Destroyed by fire in 1577, the composition is known to us through copies (fig. 16) and from several preparatory drawings (figs. 68, 69). Although he failed to execute the work immediately, Titian surely presented some sort of *modello* to his state patrons, a demonstration of his ability to make good his boast, before they awarded him the commission.

The compositional study in the Louvre (fig. 68) represents the earliest surviving record of Titian's ideas for this explosive picture—inspired by Central Italian battle designs, especially Leonardo's *Battle of Anghiari*—but his very first thoughts for the composition seem to have borne fruit in another image, his design for the monumental woodcut of *The Submersion of Pharaoh's Army in the Red Sea* (fig. 81), published about 1515. The great sweep of figures around a central void powerfully develops a compositional pattern suggested earlier in Venice by Giorgione (see fig. 6) as well as by the traditional Venetian interest in asymmetrical structures; such preferences acknowledge the very positive function of landscape and of atmospheric space in the dramatic expression of a painting.

The Altarpiece

The first great public work by Titian unveiled in Venice, in 1518, was on the high altar of Santa Maria Gloriosa dei Frari (colorplates 12, 13, fig. 17); with the monumental panel of the *"Assunta,"* much to the consternation of his Franciscan patrons, the painter transformed the genre of the altarpiece, infusing it with a new affective power. In the course of

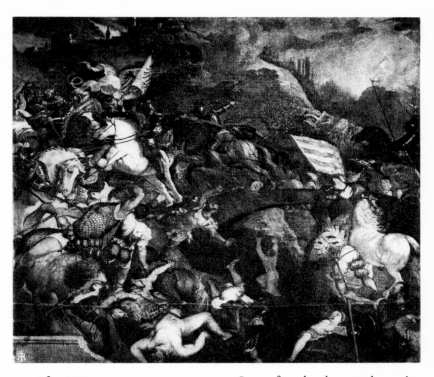

16. After Titian. THE BATTLE OF SPOLETO. Copy after the destroyed mural in the Sala del Maggior Consiglio, Palazzo Ducale, Venice. *Galleria degli Uffizi, Florence*

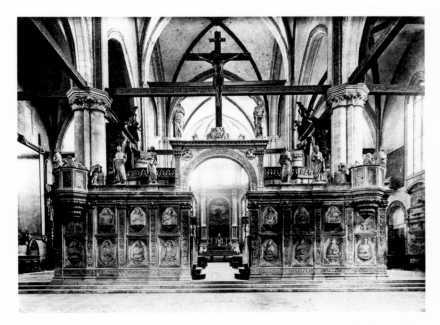

17. View through the choir screen to the apse, Santa Maria Gloriosa dei Frari, Venice

the following decade he proceeded to explore further the possibilities of that genre, expanding its expressive range and variety, and by that same process he articulated more clearly and precisely its function and the very meaning of the religious image. For it is important to recognize that Titian rarely indulged in merely aesthetic variation; his motivation was always based in a profound awareness of all the

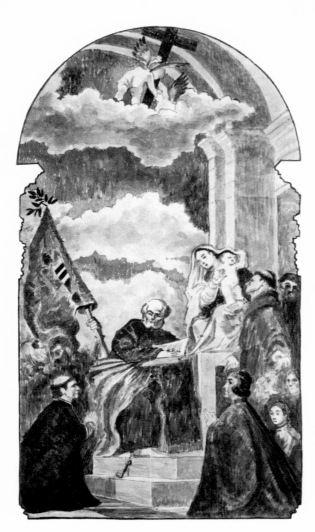

18. Reconstruction of the presumed early state of Titian's MADONNA DI CA' PESARO

dimensions implicit in the religious experience. The miracle of the Virgin's Assumption into heaven takes on an impressive palpability through the sheer magnitude of the pictorial conception as well as through the exact dramatic observation of its narrative.

In the altarpiece of the Pesaro family (colorplate 14), executed between 1519 and 1526, Titian's sophisticated handling of spatial structure, of the conventions of hierarchic presentation, and of portrait formulas creates out of two distinct pictorial traditions—altarpiece and votive picture—an image whose unity is all the richer for the variety contributed by its individual components.

The reality of individual experience, like that of individual objects and substances, becomes an increasingly critical constituent of Titian's art. Totally unified by the synthetic pictorial structure, comprising both the larger compositional design and the

more immediate level of actual execution—the touches of color and brushwork—these various degrees of experience combine in the resonance of an altarpiece such as that commissioned by Alvise Gozzi, and dated 1520 (fig. 19), for the church of San Francesco in Ancona. As in *The Madonna di Ca' Pesaro*, but rather more intimately, we are at once witnesses to a drama of private devotion and, through our own direct contact with the heavenly vision, participants in this prayer for salvation. The concreteness of the donor portrait supports the reality of the interceding saints and holy figures above, while the sea and skyscape on the horizon, with its recognizable view of Venice, confirms the reality of the cumulous heaven.

In his development of the altarpiece Titian was in a sense continuing to explore avenues opened by Raphael, with whose work he was certainly familiar —even without a trip to Rome—and whose *Madonna di Foligno* (Pinacoteca Vaticana, Rome) in particular may have played a role in the ideation of the Ancona altarpiece. Titian, however, was less committed to the structural closure and formality of Roman classicism; asymmetry, openness, and relative informality distinguish his conception of the altarpiece, in which landscape assumes an ever more significant function—becoming a major protagonist in the altarpiece of *The Martyrdom of Saint Peter Martyr* (fig. 20).

About 1526 Titian won the competition for this commission in the church of Santi Giovanni e Paolo, defeating Palma il Vecchio and Pordenone, and by 1530 he had completed the painting; until its destruction by fire in the nineteenth century it was among the most influential and frequently copied of Titian's creations. While the figures in this dramatic narrative assume a greater power and energy of pose, possibly reflecting Titian's continued study of Michelangelo, still more impressive is the degree to which the trees themselves participate fully in the heroic mode of the composition; indeed, they assume a position traditionally reserved for monumental architecture. The full import of the martyr's story, involving violence, fear, hope, and faith, depends upon the total contrapuntal organization of the composition, in which human action gains greater resonance through the arboreal forms; reflecting

19. MADONNA AND CHILD WITH SAINT FRAN-
CIS AND SAINT ALOYSIUS AND THE DONOR,
ALVISE GOZZI. 1520. Oil on panel, 10′6″ ×
6′ 9 1/8″. *Museo Nazionale delle Marche,
Ancona, Italy*

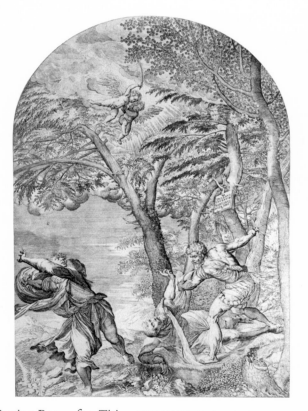

20. Martino Rota, after Titian. THE MARTYRDOM OF SAINT PETER
MARTYR. Engraving after the altarpiece completed in 1530
(destroyed in 1867) in Santi Giovanni e Paolo, Venice.
*The Metropolitan Museum of Art, New York. Gift of Geor-
giana W. Sargent, in memory of John Osborne Sargent, 1924*

and accentuating that action, these heroic trees rise
majestically, at once covering the earthly stage be-
low and yielding to the luminous intrusion of the
heavenly vision. With this painting Titian estab-
lished a new kind of narrative altarpiece and dis-
covered in landscape elements new possibilities of
monumental eloquence.

THE COURTS OF ITALY

Just as he was assuming his position as Giovanni
Bellini's official successor in Venice, Titian was es-
tablishing his fame at the most important centers of
court culture throughout Italy. In 1514 Bellini
completed and signed *The Feast of the Gods* (fig. 21),
painted for Duke Alfonso d'Este of Ferrara, and it
has been suggested that in this project, a commission
rather alien to his temperament, the aged master was
helped by the more secular brush of Titian—who
was later to revise the composition by repainting the
landscape. And Titian, who had declined the invita-
tion to Rome, continued to enjoy the courtly pa-
tronage of Alfonso; he visited Ferrara in 1516,
possibly delivering *The Tribute Money* (fig. 22) at
that time. In the course of the next two decades he
developed close ties with the Gonzaga court at
Mantua (fig. 23) and with the Della Rovere of Ur-

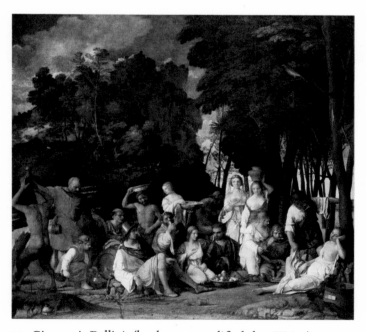

21. Giovanni Bellini (landscape modified by Titian). THE
FEAST OF THE GODS. 1514. Oil on canvas, 67 × 74″.
*National Gallery of Art, Washington, D.C. Widener Col-
lection, 1942*

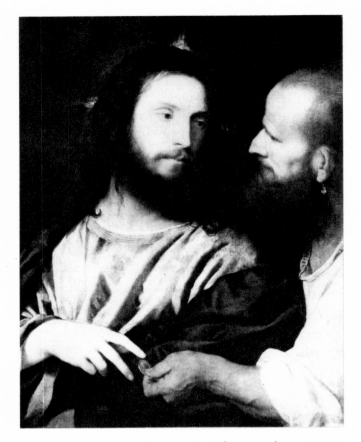

22. THE TRIBUTE MONEY. C. 1516. Oil on panel, 29 1/2 ×
22″. *Staatliche Gemäldegalerie, Dresden*

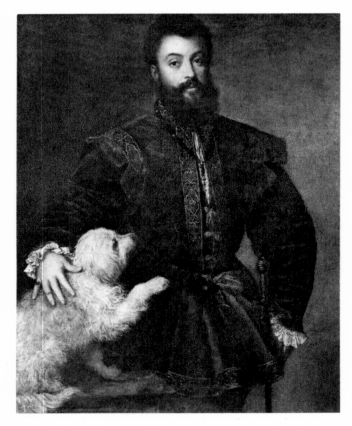

23. PORTRAIT OF FEDERICO II GONZAGA, DUKE OF MANTUA.
c. 1525. Oil on panel, 49 1/4 × 39″. *Museo del Prado,
Madrid*

bino (figs. 24, 25), and, still later, his relationship
with the Farnese (colorplate 27) would culminate
in his trip to Rome in 1545–46 and a telling series of
portraits of the old Pope Paul III (colorplate 32).
Titian's pre-eminent position as painter of princes
was fully and officially confirmed by 1533 with the
knighthood conferred upon him by the Holy
Roman Emperor Charles V.

Portraiture

Titian's earliest portraits (colorplates 3, 9) had been
based upon the traditions of portraiture as developed
by Giovanni Bellini and then by Giorgione (figs.
9, 5): a bust-length image seen behind the framing
barrier of a low parapet. Studying and refining the
aesthetic of those models, he endowed them with a
higher degree of classical composure, creating in
effect the Venetian equivalent of Raphael's High
Renaissance effigies. Without ever totally rejecting
it, he subdued Giorgione's romantic chiaroscuro,
subjecting it to a more precise control and seeking a
careful balance between tonal softening and the sub-
stantial reality of surfaces. The appeal of his images
is at once tactile and visual; we are invited to test
their objective reality as well as to project ourselves
into psychic realms at which they only hint (color-
plate 15).

It is just this naturalistic component that distin-
guishes Titian's court portraits from those of his con-
temporaries in Florence and Rome. In the half- or
three-quarter-length format of the genre, Titian's
sitters present themselves and the necessary defining
attributes of their rank and person with little of the
self-conscious elegance and artifice characteristic
of the Florentine court portrait. Accompanying
symbols and emblems, rather than proclaiming their
function with heraldic decorative clarity, are ab-
sorbed into a larger phenomenological context;
they become part of the world and presence of the
sitter—like the cannon symbolizing Alfonso d'Este's
fame as an artillery expert and his skill in statecraft
(in a painting known through a copy in The Metro-
politan Museum of Art, New York), or the faithful
dog in the portrait of Federico Gonzaga, Duke of
Mantua (fig. 23).

On the other hand, Titian could indeed create

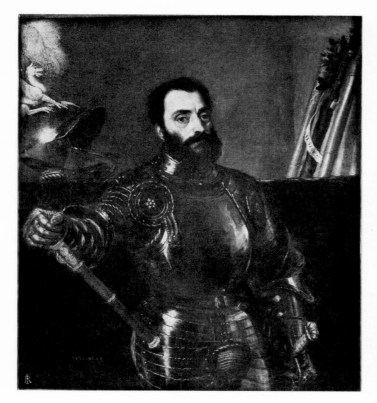

24. PORTRAIT OF FRANCESCO MARIA DELLA ROVERE, DUKE OF
URBINO. 1536–38. Oil on canvas, 45 × 39 3/8″. *Galleria
degli Uffizi, Florence*

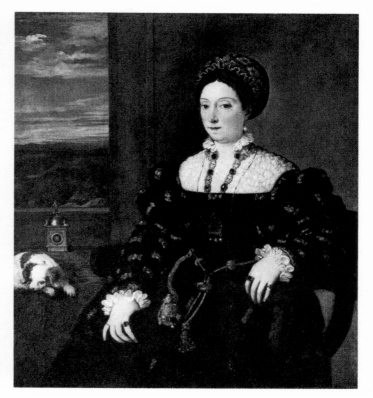

25. PORTRAIT OF ELEANORA GONZAGA DELLA ROVERE, DUCHESS
OF URBINO. 1536–38. Oil on canvas, 44 7/8 × 40 1/4″.
Galleria degli Uffizi, Florence

images of the most official bearing, summoning all
the associative power of specific iconographic tradi-
tions. His portrait of Francesco Maria della Rovere,
Duke of Urbino (fig. 24), was originally conceived
as a full-length composition, as we know from a
preparatory drawing (fig. 71). The duke was to have
been standing in a niche, in armor and with the baton
of leadership—a formula that would have endowed
the image with the impressive nobility of monu-
mental statuary. But that conception was altered to
a three-quarter-length view, possibly in order to
create a pendant relationship with the portrait of
the duchess (fig. 25). However, in these same years,
the later 1530s, Titian was also designing a series
of twelve images of Roman emperors for the Man-
tuan court (fig. 26). Based on the models of antique
portrait busts and medals, these images—preserved
only in copies—develop an imperial iconography
of the three-quarter-length figure with baton. And
it is this specific context that allows us a further un-
derstanding of Titian's intentions in the portrait of
the duke of Urbino, which thereby assumes a fuller
meaning as a ruler image.

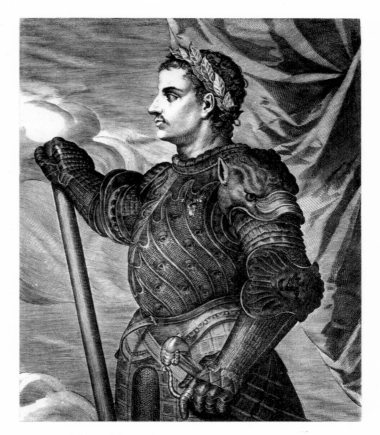

26. Aegidius Sadeler, after Titian. THE EMPEROR CLAUDIUS.
Engraving, based on Titian's cycle of Caesar portraits,
13 3/4 × 9 1/2″. *Staatliche Graphische Sammlung, Munich*

Beyond his role as portraitist Titian also gave the fullest pictorial realization to the poetic world sustained by court culture, with its evocations of classical antiquity and the pastoral tradition, its sensuality and allegorical elaboration. Dominating this culture and serving in a general way as its spokesman in the early Cinquecento was the figure of Pietro Bembo, who had been a luminary of the brilliant court of Caterina Cornaro at Asolo and who was responsible for carrying Titian's fame to Rome. For Bembo's friend, the Venetian official Nicolò Aurelio, Titian painted the *Sacred and Profane Love* (colorplate 10).

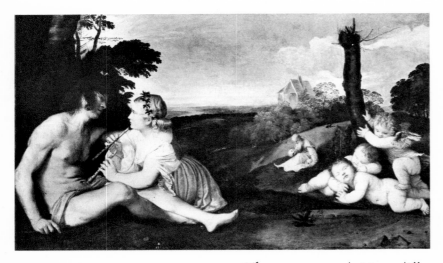

27. THE THREE AGES OF MAN. C. 1512–13. Oil on canvas, 41 3/4 × 71 5/8″. *National Gallery of Scotland, Edinburgh (on loan from the Duke of Sutherland Collection)*

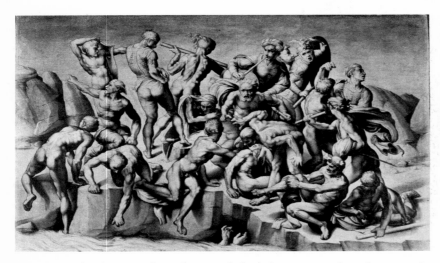

28. Aristotile da Sangallo, after Michelangelo. Copy after the central section of the cartoon for THE BATTLE OF CASCINA. Early sixteenth century. Grisaille on paper, 30 × 52″. *Collection Lord Leicester, Holkham Hall, Norfolk, England*

Related to that work in the clear articulation of its pictorial structure and its allegorical meaning is *The Three Ages of Man* (fig. 27). Here, too, Titian endowed a moralizing theme with dramatic vitality, not merely symbolizing the ages of man but tracing through a sequence of types and episodes the path of human life. Again, love serves as the basic unifier of existence, and Titian reserves a special emphasis for the amorous encounter of the nude shepherd—a figure reminiscent of Giorgione's in its pathos but conceived rather according to a more classical physical ideal, inspired by a figure in Michelangelo's *Battle of Cascina* (fig. 28)—and his lovely companion. Music, which will become perhaps even more central to Titian's art than it was to Giorgione's, functions as a metaphor—real, however, in its measurement of time and in its sensuous presence—for human experience. Perhaps no other painter so carefully and subtly controlled the nuances of erotic expression as Titian, for whom Neoplatonism's abstract hierarchies of experience assumed palpable life.

Precisely this capacity to recognize and realize the dramatic potential or core of traditional subjects enabled Titian to endow the classical myths with affective vitality. His first essays in this genre, for the court of Ferrara (colorplates 17–20), reveal that ability to project fully into a thematic situation, to define relationships, direct impulses, pace rhythms, and coordinate these patterns into a unified, harmonic vision. Titian, like Raphael, proves himself a consummate choreographer, and yet beyond the telling movement of the figures there are elements expanding the total dimensions of the experience; color and light, above all, establish moods and tones as expressively supple as the figures themselves: all nature participates in and defines the drama of Titian's paintings.

In a more focused way, this is especially true of the motif that, perhaps only after the portrait, would become most closely associated with Titian: the female nude, Venus herself, whose iconography Titian not only represented—as, for example, her birth from the sea (fig. 29)—but enlarged upon. Following the lead of his Renaissance predecessors and particularly that of Giorgione's *Sleeping Venus* (fig. 12)—which he himself had completed—

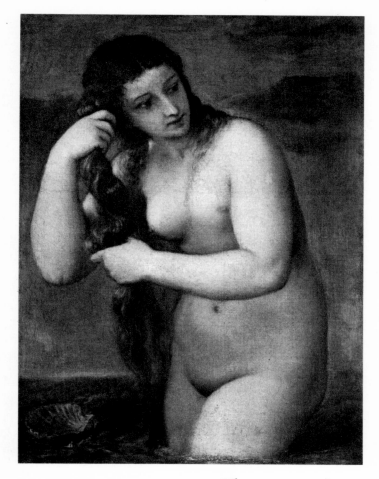

29. VENUS ANADYOMENE. C. 1520–25. Oil on canvas, 29 7/8 ×
22 1/2''. *National Gallery of Scotland, Edinburgh (on loan
from the Duke of Sutherland Collection)*

Titian created, as we shall see, new situations to
accommodate the goddess.

THE NEW APELLES

In reconstructing antique pictorial compositions
known only through literary sources, Titian was
participating in an activity central to the *rinascita
dell'antichità*. Moreover, in attempting to re-create
the lost pictorial culture of classical antiquity, the
Renaissance artist was accepting a double challenge:
to surpass the art of the past and, in so doing, to
demonstrate his own powers further by matching
the evocative model of his literary sources. Although
the paintings of the ancients were no longer extant
and could be known only through verbal descrip-
tions, writers such as Pliny the Elder had left a good
deal of tantalizing information concerning the fame
of those lost works and of their makers, and especial-

ly of the fourth-century B.C. painter Apelles.
Already in the Quattrocento, in fact, great painters
were accorded the title of "the New Apelles"; nor
was the rhetoric of such an honor entirely empty,
for the Renaissance painters themselves invited the
comparative equation by the very act of re-creating
the paintings of the ancient Greek master.

And no artist was more seriously compared with
Apelles than Titian himself. The list of subjects and
themes he treated reads at times like a program of
archaeological reconstruction. In addition to his
realization of the images described by Philostratus
the Elder, Catullus, and Ovid (colorplates 17–20,
31, 36, 42, 46), he gave form to the famous *Venus
Anadyomene* of Apelles, of which Pliny wrote:
"When the lower portion was damaged, no one
could be found to restore it, and thus the injury
redounded to the glory of the artist" (*Natural
History*, XXXV. 91). Titian's intention may have
been to render that very composition of Venus
emerging from the sea almost in its damaged state
(fig. 29). And his invention of the equestrian portrait
of Charles V (colorplate 33) may very well recall
Apelles' portrait of Antigonos. Furthermore, Apelles
was particularly celebrated for his depictions of
Venus and for the incredible truthfulness of his
portraits; the parallel with Titian's talents could not
have escaped the latter's contemporaries.

Imperial Painter

One fact in the biography of Apelles proved es-
pecially relevant to Renaissance theorists, concerned
with demonstrating the nobility of the art of paint-
ing, and to the painters themselves, anxious to im-
prove the social status of their art: Apelles had been
both court painter to and a close friend of Alexander
the Great. The courtly patrons of the New Apelleses
therefore naturally invited comparison with the
Hellenistic ruler—and none more deservingly than
the new Holy Roman Emperor. The coronation of
Charles V occurred in 1530 in Bologna, where
Titian first made his acquaintance; they met again
in the same city some three years later. During
these encounters Titian painted the portrait of the
emperor (figs. 30, 88), for which he was soon
rewarded in the most extravagant way: on May 10,

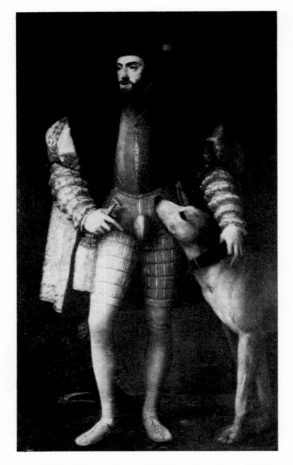

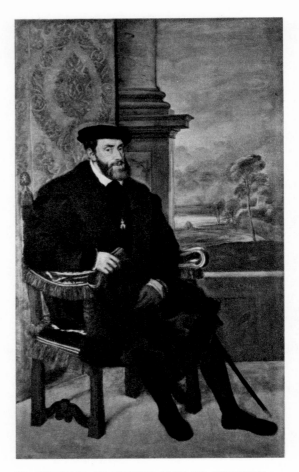

30. PORTRAIT OF THE EMPEROR CHARLES V WITH
A HOUND. 1533. Oil on canvas, 75 1/2 × 43
3/4''. *Museo del Prado, Madrid*

31. PORTRAIT OF CHARLES V IN AN ARMCHAIR.
1548. Oil on canvas, 80 3/4 × 47 5/8''.
Alte Pinakothek, Munich

1533, Charles conferred upon the painter the title of
"Knight of the Golden Spur, Count of the Lateran
Palace and of the Imperial Consistory." The patent
of nobility, moreover, explicitly recognized both
the cause of this extraordinary action and its cultural
context: "Your gifts as an artist and your genius for
painting persons from life appear to us so great that
you deserve to be called the Apelles of this age. Fol-
lowing the example of our forerunners, Alexander
the Great and Octavius Augustus, of whom one
would only be painted by Apelles, the other only by
the most excellent masters, we have had ourselves
painted by you, and have so well proved your skill
and success that it seemed good to us to distinguish
you with imperial honors as a mark of our opinion
of you, and as a record of the same for posterity."

Titian came to enjoy a relationship with Charles
that did indeed seem comparable to the intimacy
between Apelles and Alexander the Great. Called
to the imperial court at Augsburg in 1548 and again

in 1550, he painted the image of the emperor in his
moment of greatest public triumph (colorplate 33)
as well as in a more reflective and private mood (fig.
31), comprehending the human dimensions of the
ruler, the doubts and fatigue that would eventually
lead to Charles's abdication in 1556. And when he
retired to the monastery at Yuste, Charles prayed
for salvation before a heavenly vision that had been
prepared for him by Titian (colorplate 38).

The earliest of Titian's portraits of Charles V still
extant is a full-length image of the emperor accom-
panied by a large hound (fig. 30). Typically reserved
for the most official subjects, the full-length portrait
form was essentially a Northern motif, and, indeed,
Titian's painting copies a model dated 1532 by the
Austrian court painter Jakob Seisenegger. The com-
petition implicit in this situation suggests that Ti-
tian's portrait was in fact a highly self-conscious
demonstration piece, a proof of his skill—in this
case, the naturalism of his own art turning art back

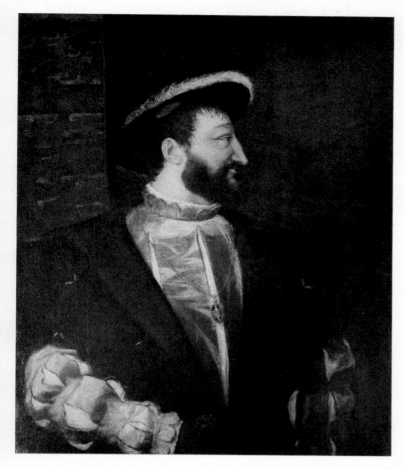

32. PORTRAIT OF FRANCIS I, KING OF FRANCE. C. 1538–39. Oil
on canvas, 43 × 35″. *Musée du Louvre, Paris*

With his accumulated titles and privileges, which
guaranteed him a rather handsome annual income
despite the difficulties of collecting his various pen-
sions, Titian enjoyed a status well beyond that of
other Renaissance painters—with the single excep-
tion of Michelangelo. And, like most men of aristo-
cratic culture, he assumed for himself an *impresa*,
a device carrying the motto NATURA POTENTIOR ARS
("Art more powerful than nature") and illustrated
by the image of a she-bear licking its cub into shape.
Ancient legend recounted that the bear's offspring
were born without form and were shaped in this
fashion by the mother herself, who, like the artist,
improved upon nature by giving form to its raw
material. Such a legend had a particular appeal for
a culture proud of its artists' powers, and surely no
painter could more legitimately claim to challenge
nature in this way than Titian.

Landscape

Titian's control over nature—perhaps most cele-
brated in his portraits, which amazed and frustrated
his more rhetorical contemporaries by their refusal
to speak—extended to all aspects of its realm and
especially to landscape. We have already noted, with
regard to the Peter Martyr altarpiece (fig. 20), how
Titian endowed the landscape with a monumental
affect. Still earlier, however, following the lead of
Giovanni Bellini and Giorgione, he had begun his
explorations of the theme, finding in it traditional
structures of moral alternatives (colorplate 10) or
temporal sequences (fig. 13). His capacity to discover
meaning in landscape and to engage it fully in the
dramatic functioning of his compositions depended
of course on a profound examination and under-
standing of its individual elements. Among his
drawings are those in which the forms of trees, for
example, assume an organic power of remarkable
expressiveness. This is apparent in the early study of
a grove of trees (fig. 61)—a motif that he would in-
corporate in the woodcut of *The Sacrifice of Abra-
ham* (fig. 82)—a drawing that is a prelude to the

into nature. Shortly thereafter, copying an earlier
portrait of Isabella d'Este by another master, he
gave youth back to the aging Marchioness of Man-
tua (Kunsthistorisches Museum, Vienna). And, in
1539, he similarly used a medal by Benvenuto Cel-
lini as the model for a portrait of Francis I (fig. 32),
commissioned by Pietro Aretino as a gift to the
French monarch.

More than just assertions of the superiority of Ti-
tian's brush, of his power to infuse life into art, these
activities also reveal something of the nearly totemic
function of portraiture. For Charles V, in 1545 and
again in 1548, Titian recorded the image of his de-
ceased empress, Isabella of Portugal (Museo del
Prado, Madrid); once more following a given model
by another artist (described by Aretino as the work
of a "trivial brush"), Titian brought that earlier
effigy and the memory of Isabella to life—as, in the
"*Gloria*" (colorplate 38), he would join the imperial
couple eternally in paradise.

dramatic eloquence of the Peter Martyr altarpiece. Such a drawing exhibits both an appreciation of the individuality of separate elements and the unifying vision of a complete composition. Other early drawings similarly record the atmospheric component of that vision (fig. 62)—a vision that Titian would realize with special clarity in his designs for woodcuts (figs. 85–87).

Never mere backdrops, Titian's landscapes are worlds inhabited, and they participate fully in the life of the picture: echoing and articulating the rhythms of that life (colorplate 20, fig. 20), establishing the appropriate mood (fig. 33), or signifying the divine presence on earth (colorplate 22). This variety of functions reflects Titian's sensitivity to distinguishing nuances within landscape itself, to its different expressive modes: idyllic (fig. 27), heroic (fig. 20), turbulent (fig. 87), satyric (fig. 74), tragic (colorplate 46). The categories are hardly absolute, and their recognition generally requires the confirmation of the figurative element. But the poetic imagination of the Renaissance was attuned to such distinctions, and the example of Titian's art, in turn, sharpened that awareness.

Pietro Aretino's famous letter of 1544 to the painter indicates to what degree Titian's art conditioned the vision of his contemporaries. Describing a view from his window on the Grand Canal, the writer uses the metaphor of painting—specifically, of Titian's painting:

Imagine the wonder I felt at the sight of those great clouds, partly in the foreground, low and upon the roofs of the houses, and partly in the middle distance, on the right, where they were a mixture of grays and black. I was astonished at such variety: those closest were ablaze with the fire of the sun, while those farther off glowed with a more subdued red-lead. Oh with what beautiful strokes of nature's brush was the atmosphere pushed back, clearing it away from the palaces, just as Titian does in painting landscapes! In certain parts it was colored with a bluish-green, and in others with a greenish-blue, colors truly mixed by the fantasy of nature, that mistress of masters. With lights and darks she created the effects of distance and modelling, so that I, who know that your brush is filled with the very spirit of nature, cried out three or four times: "Oh, Titian, why are you not here?" For, on my honor, if you had painted what I have described to you, you would certainly have awakened in men the same amazement that I felt when I beheld that scene; and, lasting longer, the marvel of such a painting would continue to nourish the soul.

Formally, Titian's landscapes extended the older Venetian traditions of Giovanni Bellini's sacred settings and Giorgione's pastorals into new dimensions of heroic monumentality and expressive nuance. His vision of nature, like theirs, was intimately related to his manner of painting, and those two factors, vision and style, mutually dependent, developed together. Titian's sense of form—his feeling for the integrity of objects and for the varied specificity of surfaces—and his rendering of form—the structuring function of his brushwork—comprise a unified process of vision and realization; seeing and making are one. Each stroke of the pen or brush affirms as it re-creates the reality of natural forms. That correlation between oil paint and natural substance, first appreciated and exploited by Giorgione, assumed increasing importance for Titian, particularly in the 1530s, when he devoted

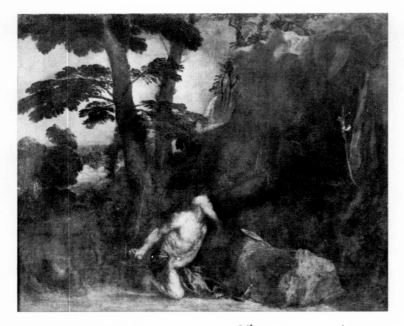

33. SAINT JEROME IN PENITENCE. c. 1530. Oil on canvas, 31 1/2 × 40 1/8″. *Musée du Louvre, Paris*

28

special attention to landscape. As the patterns of his brushwork opened up, individual touches and strokes acquiring at once greater independence and responsibility, formal as well as mimetic, the very surfaces of his paintings imitated nature with a new boldness. The magic involvement that had been the special attraction of deep tonality and chiaroscuro became as well a function of the open network of brushstrokes. Impressed by the organic vitality of painterly structures and entering into the dialectic tension between the rendering and the rendered, the woven crust of paint surface and the natural subject, the beholder engages in an active process of reconstitution. The organic structure of the painting effectively substitutes for that of nature: the world of painting becomes a real world. Aretino's feverish description, reversing the sequence, fully confirms the impact of Titian's vision of landscape.

THE ROMAN CHALLENGE

At the beginning of his biography of Titian, in the second edition of the *Lives* (1568), Vasari describes the innovations introduced by Giorgione; although appreciative of the novelty and effectiveness of this new mode of painting, the Tuscan biographer continues with a critical diatribe against Giorgione and Venetian painters in general. Vasari accuses Giorgione of abandoning the procedures of preparatory drawing—an allegation neither fair nor fully accurate—and thus of forsaking the true path. Drawing, Vasari argues, not only allows the painter to test his compositional ideas, to engage in a dialectical process of elaborating those ideas and hence also of filling the mind with new inventions, it further permits the artist, through constant practice, to achieve enough facility so that he need no longer depend upon having the model ever present before him; since he is thus able to render the variety of natural forms without having to consult nature itself, he gains a new freedom of invention. Unfortunately, Vasari laments, the Venetian painters—never having studied the marvels of Rome, the perfection of Roman art both ancient and modern—are forced to hide their inability to draw beneath the superficial beauty of their coloring. The two basic issues in-

volved in Vasari's critique, drawing and the study of classical art, were crucial to his own Central Italian aesthetic, and his criticism of the Venetians thus clearly defines the lines separating the two main camps of Italian art in the Cinquecento.

Painting vs. Sculpture

Like all polemical criticism, however, Vasari's somewhat distorts the situation to enhance the thrust of his argument. He himself knew perfectly well that Titian was a learned student of antiquity. From early in his career, this Venetian master displayed a profound knowledge not only of the forms of ancient art but, more significantly, of their meanings as well—adapting symbols of pagan imperial justice or archaeological fragments to new Christian contexts (colorplates 6, 7, 24), reconstructing lost paintings of antiquity (colorplates 17, 20, and fig. 29), and utilizing ancient sarcophagi as compositional models (colorplate 21). Well before his trip to Rome, Titian had the chance to study through copies the celebrated group of *Laocoön and His Sons* (fig. 34) and to introduce its forms into his own work, transforming the writhing figure of the Trojan priest into the res-

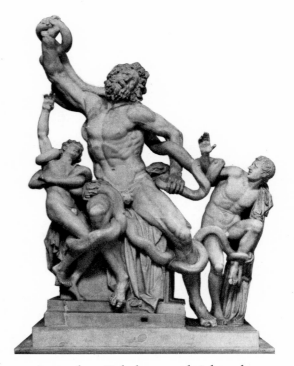

34. Agesandros, Polydoros, and Athenodoros of Rhodes. LAOCOÖN AND HIS SONS (before recent restoration). Hellenistic-Roman. Marble, height 7'. *Musei Vaticani, Rome*

35. ALTARPIECE OF THE RESURRECTION. 1520–22. Oil on panel, height 9′1 1/2″. *Santi Nazaro e Celso, Brescia, Italy*

36. PORTRAIT OF CLARISSA STROZZI. 1542. Oil on canvas, 45 1/4 × 38 1/2″. *Staatliche Gemäldegalerie, Berlin-Dahlem*

urrected Christ (fig. 35) or, viewed from a different angle, into a serpent-girt bacchant (colorplates 18, 19).

Titian's brush effected a metamorphosis of the marmoreal antique model into living substance, paint/flesh. On still another level, however, he played with the sculptural medium itself; his paintings display a gallery of carved reliefs, his own inventions conceived *all'antica*—portrait busts (colorplate 8), sarcophagi (colorplate 10), and fragments with dancing putti (fig. 36). Each of these invented motifs plays a profound role within the signifying structure of the painting, but they comprise as well, individually and collectively, an assertion of Titian's art, the art of painting. And this assertion culminates a long tradition of such demonstration on the part of painters—from Giotto through Jan van Eyck to Leonardo and Giorgione—of the inclusive superiority of their art: painting imitates and hence comprehends within its own realm the other visual arts. By the sixteenth century the *paragone*, the comparison of the arts of painting and sculpture, had indeed become a commonplace in criticism and aesthetic debate, and in the course of the century the terms of that comparison came to be personified by Titian and Michelangelo.

The Florentine's sculpture—for which the Renaissance congratulated itself in having surpassed the achievements of antiquity—was also known to Titian through copies, before his Central Italian sojourn, and its impact may be seen in at least two of Titian's paintings (colorplates 16, 20). A fragment of Michelangelo's cartoon for *The Battle of Cascina* (fig. 28) was preserved in Mantua and was evidently available to Titian, but even before his first documented trip to that northern Italian court Titian seems to have used figural motifs from the Florentine design—in *The Three Ages of Man* and in the woodcut *The Submersion of Pharaoh's Army in the Red Sea* (figs. 27, 81).

As he emerged as the archetypal painter, and as the public and rhetorical celebration of artistic giants grew, Titian increasingly had to accept the comparison with Michelangelo: Michelangelo alone came to represent the Roman challenge.

Titian's trip to Rome in 1545–46 was prepared for during the immediately preceding years, as his

figural style was developing toward a more conscious dynamism and monumentality—partly inspired, to be sure, by the example of Michelangelo's art. For a brief period in 1541–42 Vasari was in Venice, at the invitation of his compatriot Pietro Aretino, carrying with him drawn copies of Michelangelo's most recent work and spreading his own aesthetic gospel. Although cordially received by Titian, the visitor evidently met with a certain amount of hostility from the Venetian community of painters, and when he quit the lagoon he left behind an unfinished commission: decoration of the ceiling of the church of Santo Spirito in Isola. Vasari had gained that commission through Jacopo Sansovino, the transplanted Florentine architect and sculptor and close friend of Titian and Aretino; when Vasari departed, the project passed to Titian.

By the end of 1544 Titian completed the three canvases representing *Cain Slaying Abel*, *The Sacrifice of Abraham*, and *David and Goliath* (figs. 38, 39, 40). The nature of the commission suggested the *di sotto in sù* (seen from below) perspective with its

38. CAIN SLAYING ABEL. 1543–44. Oil on canvas, 9′ 7″ × 9′ 2 1/4″. *Santa Maria della Salute, Venice*

37. Michelangelo. BOUND SLAVE. 1513–16. Marble. *Musée du Louvre, Paris*

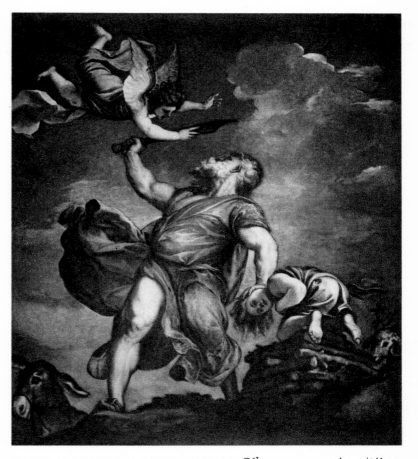

39. THE SACRIFICE OF ABRAHAM. 1543–44. Oil on canvas, 10′ 9 1/8″ × 9′3″. *Santa Maria della Salute, Venice*

31

daring foreshortening, while the violence of the themes themselves positively demanded such dynamic solutions. The emphasis on heroic rhetoric and gestures of conflict, generally characteristic of his style in the 1540s, is matched here by a muting of Titian's palette: within a somber tonal context cool chromatic areas—pale greens and yellows, grayish-blues and mauves—serve primarily to add further definition to the powerful forms. The ceiling paintings of Santo Spirito (which were transferred to the sacristy of Santa Maria della Salute in the seventeenth century) presented Titian with a new set of problems, and it is very likely that in solving them he turned to the more plastic art of the ceiling and vault decorations of painters such as Giulio Romano, Correggio, and Pordenone; it is also possible that he may have drawn upon designs left behind by Vasari, but of these we have no certain record. Despite the speed with which he executed the three large canvases and the surrounding *tondi*—and we must remember that he was aided by a large workshop— Titian undoubtedly studied the problems with unusual thoroughness; unfortunately, only a single preparatory drawing has been preserved to docu-

ment that process, a rather finished study for *The Sacrifice of Abraham* (fig. 76), squared for enlargement or transfer. The conception of the patriarch, assertive and forced, reminds us of the continuing function of the *Laocoön* as an aid and guide in the creation of moments of powerful affect.

Disegno vs. Colorito

When he finally traveled to Rome in 1545 Titian was already deeply involved with monumental figurative art in both the ancient and modern classical traditions. He went as the most famous painter of the age, and his meeting with Michelangelo must have been an event eagerly anticipated by many— but especially by Vasari, who served as his guide to the marvels of the Eternal City. One day Vasari and Michelangelo visited Titian in his Vatican studio in the Belvedere where they admired the *Danaë* (colorplate 31). Upon leaving, the two continued to discuss the picture and the merits of the painter. Michelangelo, Vasari narrates,

> praised Titian, saying that he liked his coloring (*colorito*) and style (*maniera*), but that it was a pity that in Venice one was not taught from the beginning to draw well and that painters there did not have a better method of study. For, he said, if this man were aided by art (*arte*) and drawing (*disegno*) as he is by nature, and particularly in copying from life, he would be without peer, since he has great spirit and a pleasing and lively style. And this is indeed the case [Vasari himself continues], for whoever has not drawn enough and studied selected ancient and modern works cannot hope to work with real flair (*fare bene di pratica*) by depending only on his natural talent, nor can mere imitation from life yield that grace and perfection that raises art above the order of nature since such imitation usually includes even the parts that lack beauty.

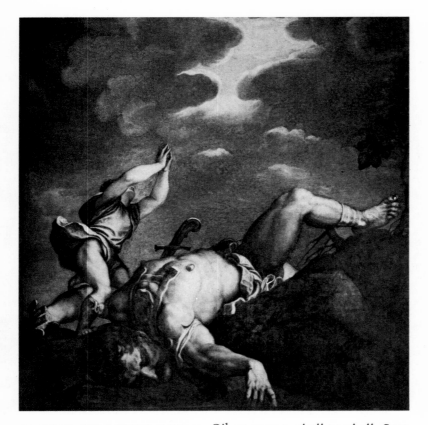

40. DAVID AND GOLIATH. 1543–44. Oil on canvas, 9′ 7″ × 9′ 3″. *Santa Maria della Salute, Venice*

Whatever the truth of this anecdote, it certainly illustrates the fundamental differences in taste separating Venetian painting from that of Central Italy. For all his greatness, in Vasari's view, Titian

suffered from the cultural deprivation of his Venetian background and training. We may appreciate that point of view by comparing Titian's *Danaë* with the contemporary work of a Florentine painter, Bronzino's *Allegory with Venus and Cupid* (fig. 41), which displays in its precision of contour, elegantly elongated proportions, and studied artifice of pose those qualities of *disegno, maniera,* and *arte* that were found lacking in Titian's painting, with its greater truth to nature. Inconceivable, on the other hand, in the courtly refinement of Bronzino's art is that dramatic involvement and mimetic power of Titian's naturalism, of his *colorito.* Rounding the sharp edges of contour, fusing them with the ambient shadow, softening surfaces and breaking the absolute tyranny of the picture plane, Titian's mode of painting creates a pictorial correlative that parallels rather than diverges from nature.

Within the standard Renaissance definition of painting as comprising thematic idea (*invenzione*), design or drawing (*disegno*), and coloring (*colorito*), Vasari, speaking for a Central Italian aesthetic, singled out *disegno* as the fundamental principle

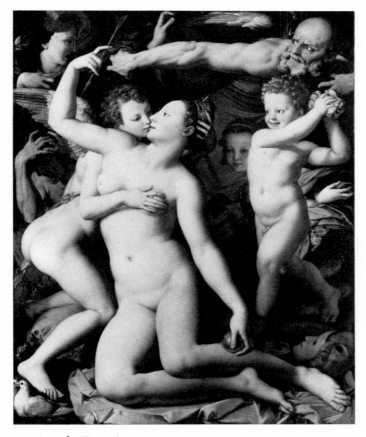

41. Agnolo Bronzino. ALLEGORY WITH VENUS AND CUPID. C. 1545. Oil(?) on panel, 57 1/2 × 45 3/4″. *National Gallery, London*

unifying the fine arts; it is, he declares, "father of our three arts of architecture, sculpture, and painting." The Venetian side of the debate, however, acclaimed *colorito* as the element of painting that most closely approached nature and, therefore, as the most important. More than merely referring to colors—which, as Dolce and Leonardo before him argued, are beautiful even as pure pigments in their boxes—the concept of *colorito* intended the art of their application, the brushwork itself, the very act of painting. And in this Titian was without rival. Titian alone, Dolce wrote in response to Vasari, "walks as the equal of nature, so that each of his figures is alive, moves, its flesh quivering. He has displayed in his works no empty grace, but colors appropriate to their task; no affected ornamentation, but a masterly firmness; no crudity, but the mellowness and softness of nature."

THE PAINTER OF VENUS

In *disegno* Michelangelo was admittedly the unchallenged master, and in the expressive anatomy of the male figure was to be seen the demonstration of his mastery. Titian's *colorito*, on the other hand, operated in a feminine mode and found its natural domain in the softer forms and substance of the female figure.

No other painter of the Renaissance so thoroughly explored the expressive possibilities of carnal sensation or discovered in the sensuality of flesh such thematic variation. Titian heightened the basic experience of the tactile appeal of flesh by setting it off against other kinds of texture: verdant landscape (fig. 43), luxuriant hair (colorplate 23), or, in one of his most precisely calculated inventions, soft fur (fig. 42). Formally, he spun his variations upon the classical figural type of the *Venus pudica* (modest Venus), whose hands, seeking to cover breasts and genitals, lead the arms in nearly caressing movement about the body. Venus, of course, offered the proper iconographic context for this celebration of female sensuousness, and, adorning her with jewels as well as silk-lined fur and adding a reflecting mirror, Titian created an image of beauty's own adoration that combined the cultural sanction of its icono-

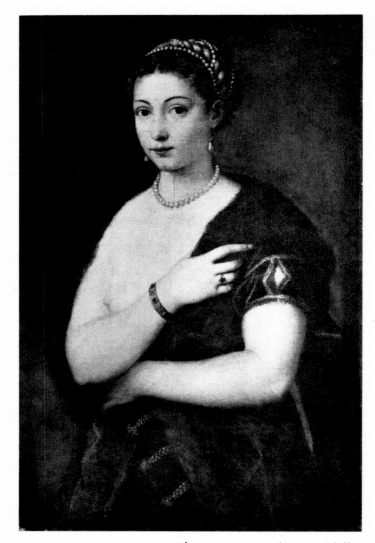

graphic attributes, especially the attendant cupids, and the intimacy of a genre scene (fig. 1).

It is just this capacity to move with ease along the hierarchies of values and references that allowed Titian to investigate the imagery of Venus with such thoroughness, to enable her nudity to represent with equal conviction the highest virtue of divine love (colorplate 10), marital love (colorplate 26), or, in a more narrative situation, to inspire satyric lust (fig. 43). Giorgione's invention of a reclining nude asleep in a landscape (fig. 12) became the point of departure for Titian's long development of the theme. The sylvan Venus continued at first to function in a landscape setting (fig. 43) in a complex canvas evidently initiated early in Titian's career, resumed about 1540, and sent to Philip II only in 1567; in the composition for Urbino (colorplate 26) Titian brought her indoors, assigning to her a specific social significance.

The horizontal format that accommodated—and was dictated by—the motif of the reclining figure set up a basic lateral movement in these compositions, and Titian's next step was to recognize the narrative implications of that movement. In the design of *Venus and Cupid* (fig. 44) he reversed the figure. Thus, given the inclination (in Western cul-

42. GIRL IN A FUR. C. 1535. Oil on canvas, 37 1/2 × 24 7/8″. *Kunsthistorisches Museum, Vienna*

43. THE PARDO VENUS. C. 1535–40, possibly retouched c. 1560. Oil on canvas, 6′ 5 1/8″ × 12′ 7 1/2″. *Musée du Louvre, Paris*

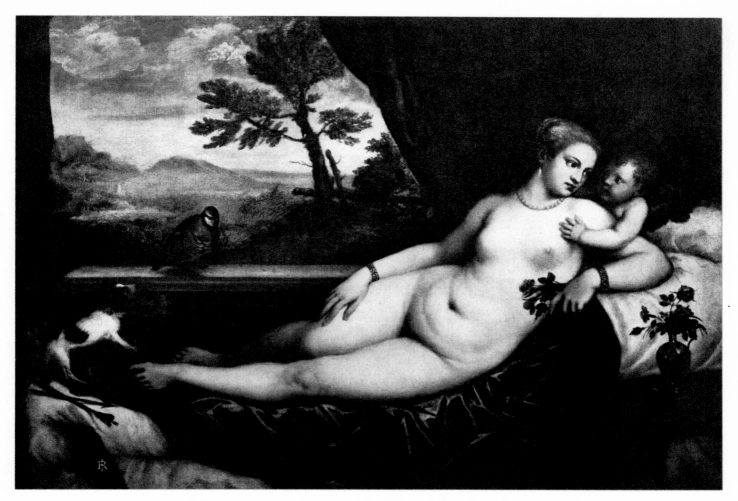

44. VENUS AND CUPID. C. 1545. Oil on canvas, 54 3/4 × 76 3/4″. *Galleria degli Uffizi, Florence*

45. VENUS AND THE ORGAN PLAYER. C. 1550. Oil on canvas, 3′9 1/4″ × 6′10 3/4″. *Staatliche Gemäldegalerie, Berlin-Dahlem*

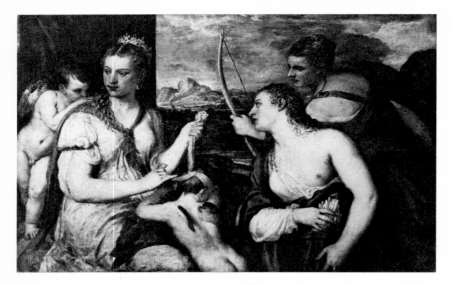

46. THE EDUCATION OF CUPID. C. 1565. Oil on canvas, 46 1/2 × 72 7/8''. *Galleria Borghese, Rome*

ture) to read from left to right, the image—which in Giorgione's *Venus* flowed from the sleeping head and its foreground support—now culminates at the right, where Venus exchanges tender glances with her son. The curtain forming the immediate backdrop to this encounter still recalls the traditional asymmetrical construction of Giorgione's composition, but its diagonal cut now reinforces the directional impulse.

Titian's next variation on the theme, more overtly realizing the narrative potential of the composition, represents a still more significant step: the introduction of a third figure, a musician at the feet of Venus. The occasion for this was a painting executed for Philip II (fig. 45). The narrative line here begins in the profile of the organ player, who bears a distinct physiognomic resemblance to the young prince himself; his adoring glance traverses the length of the canvas—initiated by the horizontal rhythm of the instrument's pipe openings, and continued in part by the inconspicuous motif of the horse-drawn carriage in the center of the landscape—and focuses on the amorous interchange at the right. Having established the type of Venus with an organist—which would be repeated in several studio versions—Titian later wrought one final variation on the theme, changing the musician to a lute player (colorplate 40). And with the introduction of that socially and physically more adaptable instrument he expanded the musical significance of the image, for

now Venus herself, with a recorder, participates in an ensemble; crowned the goddess of beauty, she is nonetheless accessible not only to the senses but through the social experience of music-making as well.

Elaborating upon Giorgione's original motif, then, Titian broadened its range of reference, and, as his brushwork loosened and his style conceived figures of ever greater sensuousness, the erotic appeal of the theme became that much more direct. But even at this late date in his career he could return to treat the goddess in her less ambivalently celestial role. In the so-called *Education of Cupid* (fig. 46), Venus, modestly clothed and crowned, blindfolds one cupid while another looks on. According to Erwin Panofsky's Neoplatonic interpretation, she now represents also "the Grace called 'Beauty'—waited upon by the Graces called 'Pleasure' and 'Chastity',", and the picture itself achieves "the ultimate resolution of the conflict between Eros and Anteros, i.e., 'terrestrial' and 'celestial' love." Like other similar images, *Sacred and Profane Love* and the *Venus of Urbino* (colorplates 10, 26), for example, *The Education of Cupid* may have been a marriage picture; its meaning, uniting love's several aspects, the virtue of chastity with the appeal of sensual beauty, acknowledges the social reality as well as the ideality of Venus.

THE PAINTER AS DRAMATIST

The affective power of Titian's painting derives in part from its naturalism, the mimetic conviction of painterly construction—but that conviction requires as well the shaping force of the imagination. More than impressive imitations of nature's forms—specifically, of the human body—Titian's figures, like his landscapes, also embody the animation of natural processes; the flesh itself may quiver with life, as Dolce observed, but beneath those surfaces one feels ultimately the soul or psyche of the fictive character. A commonplace of Renaissance artistic thought declared that the expressions of the face and the movements of the body were merely the outward signs of an inner life. Titian's tonalism accordingly must be read affectively as well as for-

mally; shadows not only draw us into the physical realms—imagined rather than fully perceived visually—but they also suggest dimensions of psychic experience that can only be comprehended intuitively.

When Titian's figures are brought together their individual presences interact in such a way that the image of their encounter is more than simply a sum of its psychological parts but functions on an entirely new level of complexity—a phenomenon subtly evident in group portraits like that of the Farnese (colorplate 32). Within the unifying atmosphere, glance and gesture, the essential means by which we reach out and establish contact with the world about us, weave an intricate network of interrelationships, drawing together the subjects and including also the observer himself.

Religious Narrative

By these same means Titian, from the beginning, defined dramatic situations with remarkable preci-sion and compelling affect. As he refined his control of these expressive mechanisms and as his style evolved, his figures assumed increased formal breadth and energy as well as *gravitas*, that measured element of profound seriousness linking High Renaissance art with that of classical antiquity; the drama he depicted acquired ever greater subtlety and impact. Within the range of narrative themes Titian distinguished a number of modes, each appropriate to its subject: for example, the heroic turbulence of the Peter Martyr altarpiece (fig. 20), the tragic pathos of *The Entombment* (colorplate 21), and the quiet dramatic awareness of the pilgrims of *The Supper at Emmaus* (fig. 47), in which the lessons of Leonardo's *Last Supper* are applied with acute understanding.

The major tragic theme of Christian art, the Passion of Jesus, offered Renaissance painters especially rich and moving possibilities for dramatic expression, and Titian explored them with deep sympathy, but also with the controlling consciousness of a

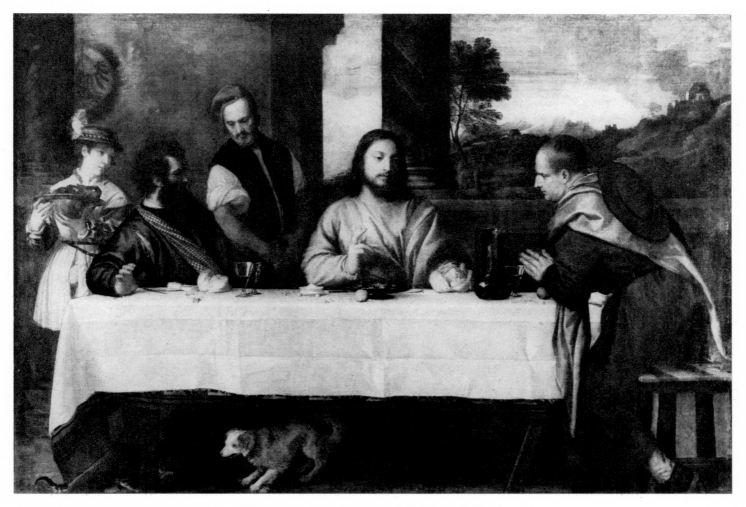

47. THE SUPPER AT EMMAUS. C. 1535–40. Oil on canvas, 66 1/2 × 96 1/8″. *Musée du Louvre, Paris*

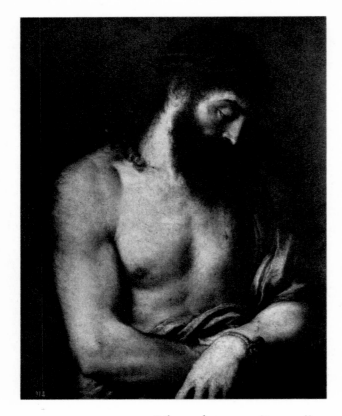

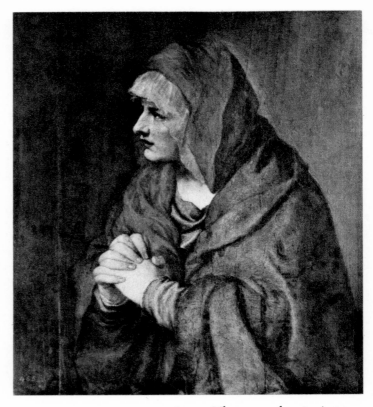

48. ECCE HOMO. 1547. Oil on slate, 27 1/8 × 22″.
Museo del Prado, Madrid

49. MATER DOLOROSA. c. 1548–50. Oil on panel, 26 3/4 ×
24″. *Museo del Prado, Madrid*

stage director. The presentation of Christ to the people could be staged in the most elaborate and universalizing manner (colorplate 28), creating, in effect, a religious "theater" in which we in turn become spectators; or, in a single intimate image, we may confront directly the tormented Savior himself, suffering for our sins (fig. 48). In another group of devotional images Titian sympathetically rendered various aspects of the *Mater Dolorosa*, either intently yet apprehensively approaching her bloodied son on our behalf (fig. 49), or, in another version of the sorrowing mother (also in the Museo del Prado, Madrid), recoiling in grief and even gentle terror at the sight. A precise nuancing of expression distinguishes each of these paintings, a sure control of the psychology of emotional response that would be orchestrated to powerful effect in the larger canvases of lamentation (colorplate 41).

Titian's Christian protagonists suffer their torment with persuasive feeling (colorplate 37) and extraordinary poise (fig. 50). *The Fall of Man* is recounted with a graceful choreography of movement (fig. 51); again, glance and gesture combine with the counterpoint of figural pose in a full drama of temp-

tation, human weakness, doubt, and fear. Adam, with a tellingly indecisive move, dimly recognizes the tragic consequences of Eve's innocent acceptance, a fate signaled by the shadow cast over her upturned face.

It is, of course, the functioning of light and shadow that adds the fullest dimension to Titian's dramatic conceptions, and no painter was better equipped to harness nature itself in the service of his expressive goals. In his rendering of *Christ on the Cross* (fig. 52), for example, the traditional signs of heavenly response reported in the Gospel accounts—"there was darkness over all the land" and "the veil of the temple was rent in twain"—participate as natural phenomena, with all their mimetic power, in the dramatic import of the event.

Ancient Myths: The Poesie

The mythology of Greco-Roman antiquity provided the other great body of narrative themes for the Renaissance artist. We have already seen how Titian, beginning with his work for Alfonso d'Este (colorplates 17–20), set about visually reconstructing those

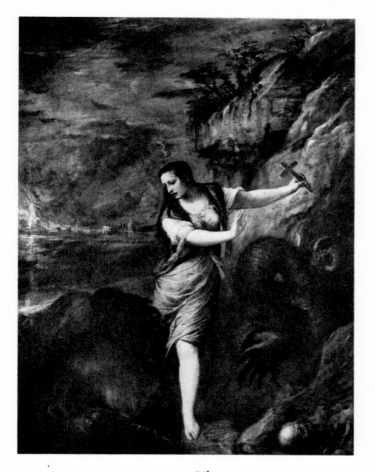

50. SAINT MARGARET. c. 1565. Oil on canvas, 95 1/4 × 71 5/8". *Museo del Prado, Madrid*

51. THE FALL OF MAN. c. 1560–65. Oil on canvas, 94 1/2 × 73 1/4". *Museo del Prado, Madrid*

52. CHRIST ON THE CROSS. c. 1565. Oil on canvas, 84 1/4 × 42 7/8". *Monasterio de San Lorenzo, El Escorial, Spain*

53. TITYUS. 1549. Oil on canvas, 99 5/8 × 85 3/8″. *Museo del Prado, Madrid*

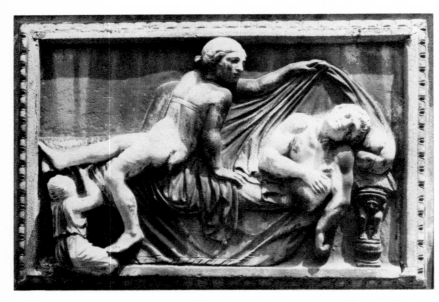

54. PSYCHE DISCOVERING CUPID ("THE BED OF POLYCLITUS"). Renaissance copy of antique relief. Marble. *Palazzo Mattei, Rome*

legends and images. In his later years, following his Roman visit, he had many more occasions to renew and deepen his study of the ancient myths. In 1548 he received a commission from Mary of Hungary, sister of Charles V and Regent of the Netherlands, for a series of subjects drawn from Ovid's description of the punishment of four sinners in Hades (*Metamorphoses*, iv. 455–61): Tityus, condemned to have his liver perpetually devoured by a vulture; Tantalus, forever reaching in vain for food and drink; Sisyphus, eternally carrying and losing the enormous rock; and Ixion, whirling on his wheel. Only the *Tityus* (fig. 53) and the *Sisyphus* (Museo del Prado, Madrid) survive, having suffered damage by fire and subsequent restoration, while the *Tantalus* is preserved exclusively in an engraved copy.

The powerful conception of these heroic images, characteristic of Titian's style toward mid-century, continues the concern with figural monumentality and dynamic compositional structure so forcefully established in the ceiling paintings for Santo Spirito in Isola (figs. 38–40). By now, however, Titian had acquired direct knowledge of Roman art, especially of the *terribilità* of Michelangelo, but that encounter, instead of leading him toward closer emulation of the Roman manner, seems to have given him rather a new confidence in himself, confirming the *colorito* of his own art. The *Tityus*, for example, which seems to have suffered less damage than its companion, conveys the drama of its theme as much through its varied brushwork, at once fluid and assertive, as through the thrusting diagonals of its compositional pattern.

The great development of mythological narrative in Titian's later years, however, occurred within a feminine mode, beginning with the *Danaë* that he painted in Rome (colorplate 31). A second, still more sensuous version of this subject (fig. 55) was in progress in 1553 and in the possession of Philip II by the following year. Together with the painting of *Venus and Adonis* (colorplate 36), it initiated a series of mythological representations—*poesie*, as the painter himself called them—that comprised the most important of Titian's projects for the Spanish monarch. A program for the series may have been developed during Titian's stay in Augsburg in 1550–51, but the only documentary evidence for such a

program is a letter of 1554 in which the artist announces shipment of the second painting, the *Venus and Adonis*: "And since the Danaë, which I have already sent to Your Majesty, is seen from the front, I wanted to vary in this other *poesia*, showing the figure from the opposite side, so that the room in which they are to hang will be more appealing. Soon I will send you the *poesia* of Perseus and Andromeda, which will offer still another view, different from these; and the same with Medea and Jason." Whatever other iconographic significance may be programmed in this series, it is clear that the most obvious attraction of these paintings, their signifying sensuality, comprises an important part of the meaning. Whetting his most Catholic patron's appetite for the erotic, Titian was in effect exaggerating an essential ingredient of his art, the female nude, to a monumental scale. The very idea of offering multiple views of the figure was an issue in that favorite studio theme of the Renaissance, the *paragone* between painting and sculpture—and we have noted

Titian's full acceptance of that challenge. But the vision of a room surrounded entirely by female flesh escalated the terms of the comparison beyond the reach of an art deprived of the sensuous appeal of color.

The Jason and Medea mentioned in the letter was evidently never executed, its place as a pendant to the *Perseus and Andromeda* (fig. 56) assumed by *The Rape of Europa* (colorplate 42), two seascapes clearly conceived to balance one another. In 1559 Titian sent to Philip II the pair of *Diana and Actaeon* and *Diana and Callisto* (figs. 58, 59), while another related picture, *The Death of Actaeon* (National Gallery, London), mentioned in the correspondence as still unfinished, was never sent.

The *Danaë* and probably also the *Venus and Adonis* were invented during Titian's stay in Rome, under the direct inspiration and challenge of Roman models; responding to that challenge, each of these compositions is constructed about a single dominant figure or figural group that works subtly against the

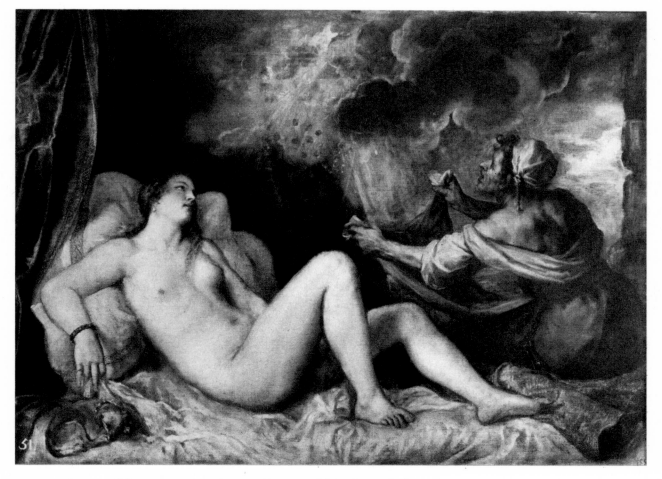

55. DANAË. 1554. Oil on canvas, 50 3/8 × 70". *Museo del Prado, Madrid*

41

56. PERSEUS AND ANDROMEDA. C. 1554–56. Oil on canvas, 70 1/2 × 77 1/2″. *The Wallace Collection, London*

57. PERSEUS AND ANDROMEDA. X-ray photograph

insistent control of the picture plane. As he developed the subsequent *poesie*, however, Titian situated his actors, now displaying greater freedom of movement, within more expansive spatial settings; the dramatic interaction of the figures, especially in the Diana pictures, elaborated a more complex narrative, and the temporal element, too, is enriched. In Actaeon's ill-starred discovery of Diana and her nymphs at their bath, for example, the moment of surprise is precisely recorded in the varied responses of the figures. But the mortal hunter recoils not only at the sight of the vengeful goddess; he perceives as well, in the stag's skull set upon the rusticated pillar, his own tragic fate—to be transformed into that animal and devoured by his own hounds.

Titian's paintings respond to Ovid's poetry in the most profound sense; more than mere illustrations, they are interpretations of the texts. Titian proves to be a close and deeply sympathetic reader, and his choice of the term *poesie* to categorize these pictures is an apt one; perhaps in no other images does the ancient rhetorical simile *ut pictura poesis*, the parallel between painting and poetry, so come to life. In this case especially, the self-consciousness of the

artist, his awareness of the power of his art, matches and answers that of the poet. Ovid had described Diana's realm, the valley called Gargaphia, in picturesque detail: "In its most secret recesses there was a well-shaded grotto, wrought by no artist's hand. But Nature by her own genius had imitated art; for she had shaped a native arch of the living rock and soft tufa" (*Metamorphoses*, iii. 157–60). The quasi-Gothic ruin in the background of Titian's painting and the rusticated pillar represent, as Erwin Panofsky observed, a Renaissance reading of Ovid's lines, for rustication and the rejected Gothic style itself were associated with the artlessness of natural forms; in Italian practice, they were reserved for structures such as fountains and grottoes. Reading the Ovidian texts, then, with an imagination that can be described as art historical, Titian reclaimed for art the arched form devised by nature's genius in imitation of art.

Titian's reading of Ovid, however, extended well beyond the matching of the poet's conceits and artifice; the painter recognized, perhaps more truly than any other reader of the Latin poet, the tragic depths of those ancient tales, the pathos underlying

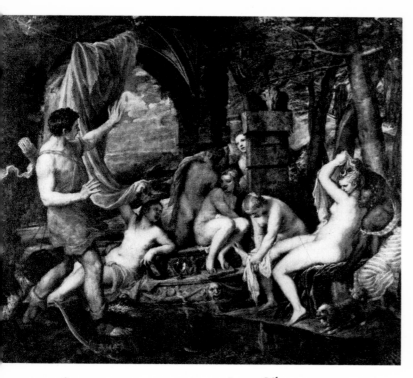

58. DIANA AND ACTAEON. 1556–59. Oil on canvas, 74 × 81″. *National Gallery of Scotland, Edinburgh (on loan from the Duke of Sutherland Collection)*

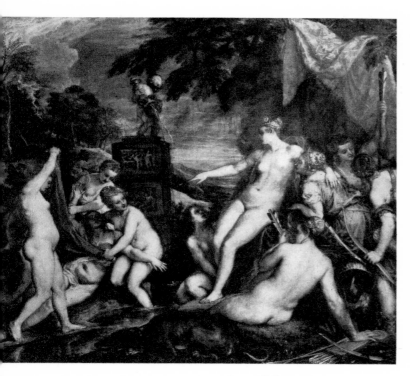

59. DIANA AND CALLISTO. 1556–59. Oil on canvas, 74 × 81″. *National Gallery of Scotland, Edinburgh (on loan from the Duke of Sutherland Collection)*

the brilliance of the lines. In Titian's images Ovid's characters play out their roles with a feeling heightened by the resonance of Titian's own art, its *gravitas* and chiaroscuro, achieving the full stature of tragedy (see colorplate 46).

THE TRIUMPH OF PAINTING

Vasari, so critical of Venetian *colorito* in general and, in the anecdote concerning the *Danaë*, at least, of Titian in particular, nonetheless responded with perceptive enthusiasm to the magnificent spectacle of the master's late style. After praising the *poesie* sent to Philip II, especially for the vivacity of coloring that made the figures appear alive and natural, he continues:

> It is quite true that Titian's method in these late works is rather different from that of his youth: his early paintings are executed with a certain fineness and incredible diligence and can be viewed both from close up and from afar; these recent works, on the other hand, are executed in bold strokes, broadly applied in great patches (*macchie*), in such a manner that they cannot be looked at closely but from a distance appear perfect. And this method has been the reason that many, wishing to imitate Titian and so demonstrate their ability, have only produced clumsy pictures. This happens because they think that such paintings are done without effort, but this is not the case and they delude themselves; for Titian's pictures are often repainted, gone over and retouched repeatedly, so that the work involved is evident. Carried out in this way, the method is judicious, beautiful, and magnificent, because the pictures seem to come alive and are executed with great skill, hiding the effort that went into them.

Titian's stylistic development had indeed followed such a course. Precisely the diligence noted by Vasari in Titian's early works had distinguished his art from the painting of Giorgione. His appropriation of the Giorgionesque was a complex, deliberated, and rather long process, and when, especially in the landscapes

of the 1530s, he had fully established his own brand of *pittura di macchia*, with its broken strokes and patches, the model of Giorgione was far behind him.

Studio Technique and the Workshop

Unlike the solitary Michelangelo, Titian produced most of his art within the commercial context of a more communal enterprise: like most Venetian painters, he was the master of a large and active workshop. The studio was staffed by a variety of assistants, young apprentices and more advanced journeymen, as well as by other master painters who often served as specialists in one category or another —painting landscape backgrounds, for example, or architectural settings. Our inherited romantic and post-romantic notions of genius make it somewhat difficult for us to comprehend this aspect of art production in the Renaissance, which is rightly viewed as a continuation of medieval traditions. Such practice, however, does account for the variations in quality among the works attributed to and even signed by Titian. Naturally, patrons paid more for a completely autograph painting by the master, less for one executed with the extensive participation of assistants. The heavy demand for pictures by Titian could only be satisfied in this way, and we must remember that in buying a workshop replica of a design by Titian one was nonetheless acquiring a true Titian in a certain sense—the idea (*invenzione*), if not the actual execution of the master.

Production on this scale required, of course, a rather efficient organization of means and materials, and the typical Venetian workshop, as a commercial operation, maintained complete records of its pictorial production. In the case of the Titian shop, those records often assumed the form of full canvases, the compositions only generally blocked in (*abbozzato*); these could then be used as models for replicas or could themselves be brought to completion when an order was received. Many of the canvases left unfinished in the artist's studio at his death probably served such a function.

Vasari observed that, especially in his later career, Titian's creative procedures were rather extended, involving repeated attack of the canvas. And this observation is corroborated by the evidence of the works themselves and by the later account, recorded in the seventeenth century, of Jacopo Palma il Giovane (1548–1628), a painter who claimed to have studied with the aged master. According to this witness, Titian

blocked in his pictures with a mass of colors, which served as a bed or foundation for what he wished to express, and upon which he would then build. I myself have seen such underpainting, vigorously applied with a loaded brush, of pure red ochre, which would serve as the middle ground; then with a stroke of white lead, with the same brush then dipped in red, black, or yellow, he created the light and dark areas of the relief effect. And in this way with four strokes of the brush he was able to suggest a magnificent figure. . . . After having thus established this crucial foundation, he turned the pictures to the wall and left them there, without looking at them, sometimes for several months. When he later returned to them, he scrutinized them as though they were his mortal enemies, in order to discover any faults; and if he did find anything that did not accord with his intentions, like a surgeon treating a patient he would remove some swelling or excess flesh, set an arm if the bone were out of joint, or adjust a foot if it were misshapen, without the slightest pity for the victim. By thus operating on and reforming these figures, he brought them to the highest degree of perfection . . . and then, while that picture was drying, he turned to another. And he gradually covered with living flesh those bare bones, going over them repeatedly until all they lacked was breath itself. . . . For the final touches he would blend the transitions from highlights to halftones with his fingers, blending one tint with another, or with a smear of his finger he would apply a dark accent in some corner to strengthen it, or with a dab of red, like a drop of blood, he would enliven some surface—in this way bringing his animated figures to completion. . . . In the final stages he painted more with his fingers than with the brush.

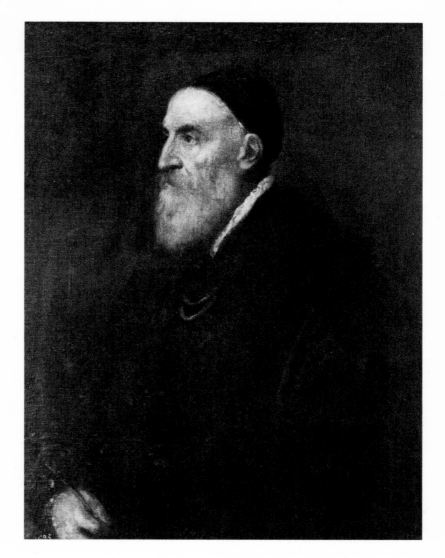

60. SELF-PORTRAIT. C. 1565–70. Oil on canvas, 33 7/8 × 25 5/8". *Museo del Prado, Madrid*

In this dialectical way Titian kept a painting in a continuing state of execution; organically, it took shape and grew only to be modified or totally transformed —and radiographic investigation attests to just how radical such surgery could be (figs. 56, 57).

The Late Vision

In Titian's late works the revolutionary techniques introduced by Giorgione at the beginning of the century achieve a truly monumental scale. Titian directly engaged his medium, adopting brushes "as big as a birch broom"—in the words of one visitor to the studio—and he painted with his fingers, extending himself as an implement. He came to know the substance of oil paint as intimately as Michelangelo knew his beloved marble, and, as all observers agreed, out of that substance he created life. Never decorative or of a merely aesthetic appeal, without

the bravura performance whose aim is to display *arte*, Titian's brushwork is indeed vital, filled with life; it is constructive in the most technical and organic sense, building forms, defining space, creating light.

Following the encounter with Rome and the relatively monochromatic formalism of the 1540s, Titian seems to have found in his native traditions of painting a new profundity of resource. In his canvases of the 1550s, especially in the later *poesie*, he appears to have rediscovered nature's fullest spectrum, an extraordinary range of wonderfully subtle yet glowing colors operating in vibrant juxtaposition within the tonal ground of his painting. And finally, in the ultimate creations of the last fifteen years of his life, color in the traditional pictorial sense seems almost to disappear; apparently submerged in the textured monochrome of those rich surfaces—the ground of unexpectedly cool tonality —its presence somehow implied rather than stated,

color seems now to emanate with new resonance from the very depths of the painted world.

Titian's Legacy

On August 27, 1576, while a terrible plague ravaged Venice, the old master died—although not of the epidemic. With special dispensation from the government, in view of the pestilential conditions in the city, his body was carried to the church of the Frari (see colorplates 47, 48). The elaborate obsequies planned by the painters of Venice for the church of their patron Saint Luke, on the model of the honors accorded Michelangelo by the Florentine artists, were never realized; crowning the catafalque was to have been a personification of Painting, in mourning for her great loss.

Shortly after Titian's death the master's son and chief assistant, Orazio, succumbed to the plague, and the entire workshop was dissolved. Titian left few immediate followers. His art—especially as it was embodied in his late style, the culmination of a lifetime devoted to painting—was not readily passed on to disciples. And once again the situation is perceptively characterized by Vasari: "While many came to Titian to learn," he writes, "the number of those who can truly be called his disciples is not at all large; for he did not actually teach much, but each learned more or less what he could, taking whatever he was able to from the example of Titian's works." His greatest followers in Venice were in fact the several younger contemporaries and competitors of independent genius—Jacopo Tintoretto, Paolo Veronese, Jacopo Bassano—painters fully capable of reading the lessons of the master and making them their own. Perhaps the only great painter who actually profited from a period in Titian's studio was a young Greek, Domenikos Theotocopoulos, better known as El Greco, who carried his experience with him to Spain.

Nonetheless, by the very example of his art, Titian set the course of European painting for centuries to come. Resolving in their own ways the terms of the *disegno-colorito* antitheses, artists such as Caravaggio and Annibale Carracci established the foundations of Baroque painting in Italy, always with an eye to the Venetian model. But Titian's truest and greatest disciples were in fact not Italian; they came from the Netherlands and France to study his art. Rubens and Poussin, each in his very individual way, built their respective styles on the example of Titian's coloring, his glowing landscapes, and the classically controlled energy of his dramatic choreography. In Spain, Velázquez enjoyed the enviable privilege of studying at leisure in the royal collections, unparalleled in their richness and range of Titian material; his own subtly inflected pictorial language, exploring the expressive nuances of the oil paint/canvas relationship, developed in continuous dialogue with Titian's paintings.

Only one painter, however, can be called a true heir to the Venetian's *ultima maniera*: of all the great art of the seventeenth century, only that of Rembrandt evokes the enigmatic vision of Titian's final canvases, and less owing to the direct study of them than to some deeper affinity. Although he never traveled to Italy, Rembrandt knew certain of Titian's works firsthand in Amsterdam, but these did not include any of the very late masterpieces. Rather, through his own knowledge, his own profound relationship to the medium, he arrived at a comparable vision.

The range of experiences contained within the wealth of Titian's *colorito*, in the variety of its aspects manifested over the course of his long career, has been available to painters for centuries, and the greatest masters of the European tradition have gone to that source and gained in pictorial wisdom. Even after the abandonment of dramatic affect and rhetoric in painting, and of the chiaroscuro techniques of tonal underpainting and the application of translucent glazes, the fundamental example of Titian's constructive brushwork continued to influence subsequent developments in painting: the varied touches of the Impressionists and the more deliberately structured strokes of Cézanne, both building chromatic fabrics out of juxtaposed colors, ultimately extend the aesthetic of the Venetian's *colorito* into modern art.

So long as we respond to the substantial quality of paint, to the sensibilities recorded in the individual brushstroke, to shimmering fields of broken color, and to the vibrant life of the pictorial whole, Titian's art will remain fundamental to our experience.

TITIAN'S GRAPHIC ART

Unlike most of the great Italian painters of the Cinquecento, including his younger Venetian contemporaries such as Tintoretto and Veronese, Titian has left no large corpus of drawings. From this lack of evidence modern scholars concluded that drawing was of only secondary importance for the master, and in this they were, perhaps unwittingly, following the bias already established in the sixteenth century and so forcefully enunciated by Vasari, who criticized the Venetian painters for their ignorance of *disegno*. With their emphasis on coloring, the Venetians, in the words of the eighteenth-century English painter and critic Sir Joshua Reynolds, "have enriched the cabinets of the collectors of drawings with very few examples. Those of Titian, Paul Veronese, Tintoret, and the Bassans, are in general slight and underdetermined. Their sketches on paper are as rude as their pictures are excellent in regard to harmony of colouring." Venetian *colorito*, especially as developed by Titian, did indeed place drawing in an ancillary position; the finished cartoon, the carefully elaborated and detailed design on paper ready for mechanical transfer to the painting surface, played a minor role in the preparation of the Venetians' canvases. But drawing was nonetheless an essential part of the preparatory process in Venice, and painters there never ceased to think visually with pen or chalk.

The extant autograph drawings by Titian number no more than a few dozen, and many of those attributions are highly debatable. The preservation of the drawings, however, must be considered fortuitous, a consequence of the dispersal of the workshop material following Titian's death, and of the habits and expectations of collectors, rather than of the actual original situation. Among the preserved drawings the sheer variety of types suggests the many purposes drawing served in Titian's studio: there are models and sketches for full compositions; studies of individual figures and anatomical details for portraits and narrative compositions; drawings of natural motifs, of landscape and animals. And the style of these drawings, although always relatively free and open—"slight and underdetermined," in Sir Joshua's negative terms—varied with their function. Nevertheless, we are always reminded that the final decisions, the ultimate elaboration and realization of a pictorial idea, were made not on paper with the pen or chalk but with the brush on the canvas itself.

There is one category of graphic art, however, in which Titian found a full and self-sufficient means of expression: the woodcut. His activity as a designer of woodcuts—focused in the earlier part of his career, beginning in or, perhaps, even before Padua with *The Triumph of Faith* (fig. 80)—attests fully to his significant development of an independent and powerful graphic language. The boldness of his penstroke (fig. 65) is amply recorded in the woodcut reproductions of his designs, and nowhere more impressively than in *The Submersion of Pharaoh's Army in the Red Sea* (fig. 81). Inspired by the pictorial richness of Dürer's woodcuts, Titian invested the medium with a new and vigorous freedom. Operating on a large field, he especially demonstrated the expressive possibilities of the monumental print—woodcuts of mural size composed of many blocks. The very scale of these projects hosted and inspired that boldness of drawing which had exasperated and challenged the older generation at the beginning of the sixteenth century.

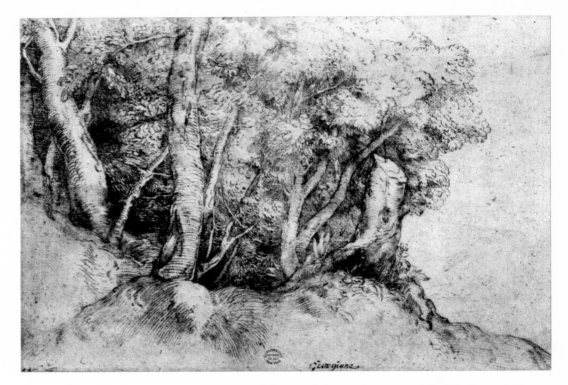

61. A GROUP OF TREES. C. 1513–15. Pen and brown ink, 8 5/8 × 12 5/8″. *The Metropolitan Museum of Art, New York. Rogers Fund, 1908*

62. LANDSCAPE WITH CASTLE. C. 1515–20. Pen and brown ink, 8 1/2 × 13 5/8″. *Musée Bonnat, Bayonne, France*

63. STUDY FOR SAINT PETER. C. 1516. Black chalk heightened with white, on blue paper, 6 1/4 × 5 1/2''. *British Museum, London*

64. SKETCHES FOR SAINT SEBASTIAN. C. 1518–20. Pen and brown ink, 6 3/8 × 5 3/8''. *Staatliche Kupferstichkabinett, Berlin-Dahlem*

65. STUDY FOR SAINT SEBASTIAN (for the ALTARPIECE OF THE RESURRECTION in Brescia). C. 1518–20. Pen and brown ink, 7 1/4 × 4 1/2''. *Städelsches Kunstinstitut, Frankfort*

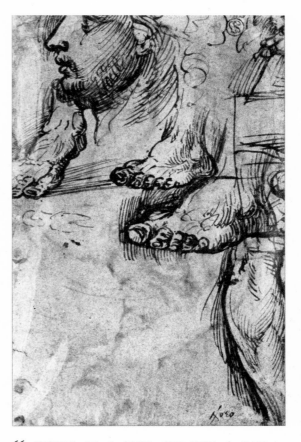

66. STUDIES OF A HEAD AND FEET. C. 1520. 7 1/4 × 4 1/2''. *Städelsches Kunstinstitut, Frankfort.* Verso of fig. 65

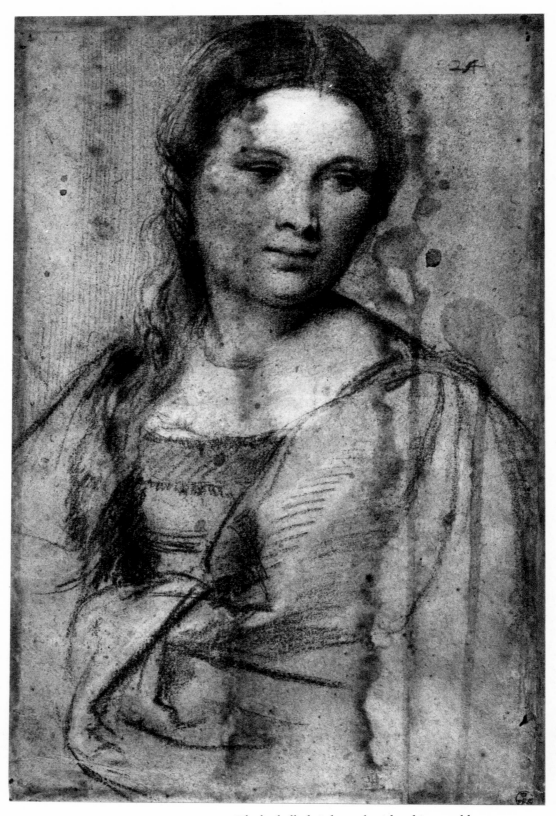

67. PORTRAIT OF A WOMAN. C. 1512–15. Black chalk heightened with white, on blue paper, 16 1/2 × 10 3/8″. *Galleria degli Uffizi, Florence*

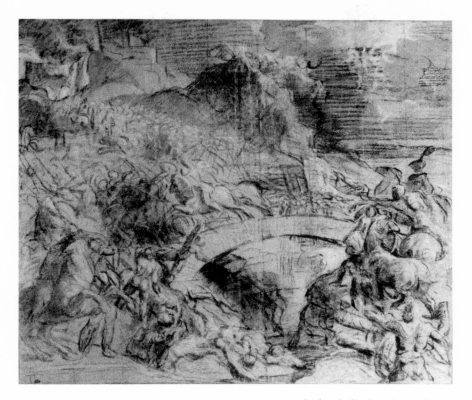

68. STUDY FOR THE BATTLE OF SPOLETO. C. 1537. Black chalk heightened with white, on blue paper, 6 1/4 × 7 1/8″. *Musée du Louvre, Paris*

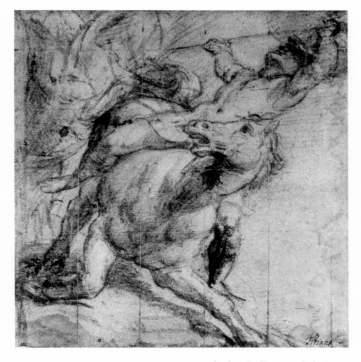

69. FALLING HORSEMAN. C. 1537. Black chalk on faded blue-gray paper, squared in red chalk, 10 3/4 × 10 3/8″. *Ashmolean Museum of Art and Archaeology, Oxford, England*

70. STUDY OF A HELMET. C. 1535. Charcoal heightened with white, on blue paper, 17 3/4 × 14″. *Galleria degli Uffizi, Florence*

71. STUDY FOR THE PORTRAIT OF THE DUKE OF URBINO. C. 1536. Pen and brown ink,
9 1/2 × 5 5/8''. *Galleria degli Uffizi, Florence*

73. DOG. C. 1535. Oil sketch on brown paper, 8 3/4 × 11 1/2″.
Nationalmuseum, Stockholm

72. STUDY FOR SAN BERNARDINO IN THE VOTIVE PICTURE OF DOGE
ANDREA GRITTI. 1531. Black chalk heightened with white, on
blue paper, 15 × 10 3/8″. *Galleria degli Uffizi, Florence*

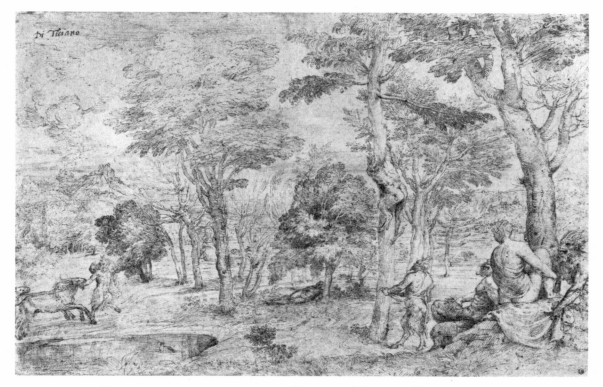

74. LANDSCAPE WITH NYMPHS AND SATYRS. C. 1535–40. Pen and brown ink, 10 1/2 × 16 1/8″. *Musée
Bonnat, Bayonne, France*

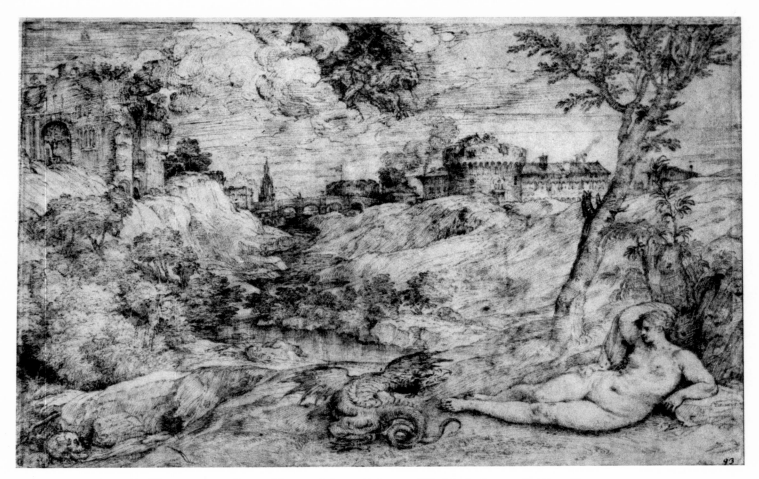

75. ROGER AND ANGELICA(?). c. 1540–45. Pen and brown ink, 9 5/8 × 15 5/8″. *Musée Bonnat, Bayonne, France*

76. STUDY FOR THE SACRIFICE OF ABRAHAM. 1543. Black chalk heightened with white, on blue paper, squared in red chalk, 9 1/8 × 10 1/8″. *École des Beaux-Arts, Paris*

77. STUDY OF LEGS (for THE MARTYRDOM OF SAINT LAWRENCE). c. 1547–48. Charcoal heightened with white, on blue paper, 15 7/8 × 10″. *Galleria degli Uffizi, Florence*

78. ANGEL OF THE ANNUNCIATION (study for THE ANNUNCIATION). c. 1560–65. Black chalk heightened with white, on blue paper, 16 1/2 × 11″. *Galleria degli Uffizi, Florence*

79. MYTHOLOGICAL COUPLE IN EMBRACE. c. 1565. Charcoal and black chalk heightened with white, on blue paper, 9 7/8 × 10 1/4″. *Fitzwilliam Museum, Cambridge, England*

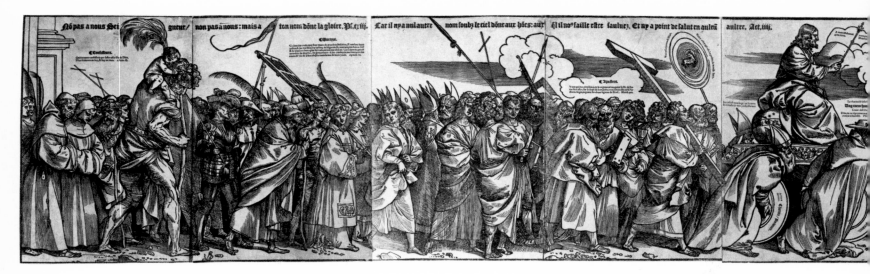

80. After Titian. THE TRIUMPH OF FAITH.
c. 1508/11. Woodcut in ten blocks,
height 1′3 1/2″; total width 8′10 5/8″.
Worcester Museum of Art, Massachusetts

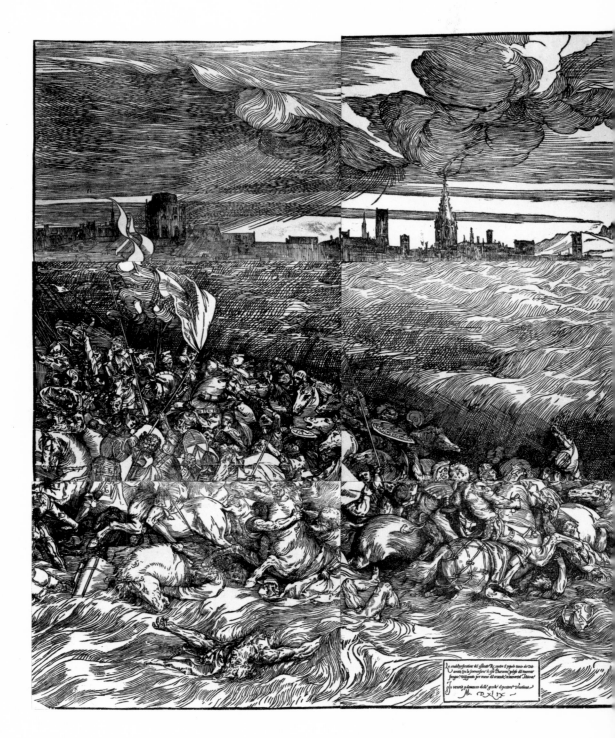

Et ainsy no^s as tu ouure tou(tes noz oru res.Esa.m. Lar tu es celup qui doit operez toutes choses en tous. j. Cor. rij.

81. After Titian. THE SUBMERSION OF
PHARAOH'S ARMY IN THE RED SEA.
c. 1514–15. Woodcut in twelve blocks,
height (of three blocks) 47 1/2''; width
(of four blocks) 85 1/2''. *The Cleveland
Museum of Art. John L. Severance Fund*

82. Ugo da Carpi, after Titian. THE SACRIFICE OF ABRAHAM. c. 1514–15. Woodcut in four blocks, 31 1/2 × 42″. *Staatliche Museen, East Berlin*

83. After Titian. SAINT ROCH. c. 1523. Woodcut, 22 1/4 × 15 7/8″. *British Museum, London*

84. Ugo da Carpi, after Titian. SAINT JEROME IN PENITENCE. c. 1516. Chiaroscuro woodcut in two tones, 6 3/8 × 3 7/8″. *Graphische Sammlung Albertina, Vienna*

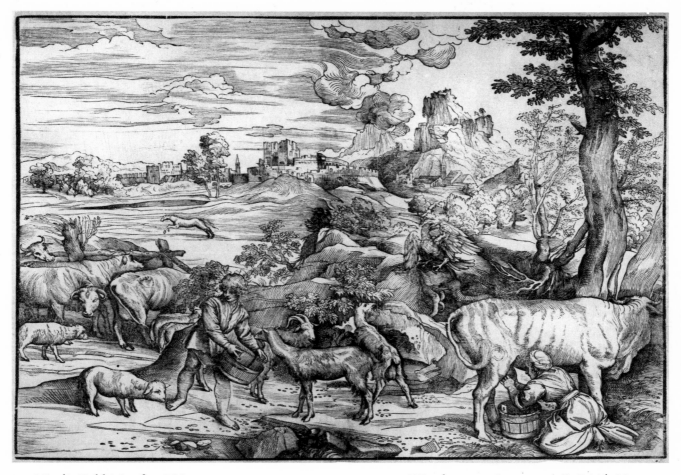

85. Nicolò Boldrini, after Titian. LANDSCAPE WITH MILKMAID. C. 1525. Woodcut, 14 3/4 × 20 1/2″. *British Museum, London*

86. Nicolò Boldrini, after Titian. SAINT JEROME IN A LAND-SCAPE. C. 1525–30. Woodcut, 15 7/8 × 21 1/2″. *The New York Public Library. Prints Division*

87. Nicolò Boldrini, after Titian. SAINT FRANCIS RECEIVING THE STIG-MATA. C. 1530. Woodcut, 11 1/2 × 17″. *Fogg Art Museum, Harvard University, Cambridge, Massachusetts*

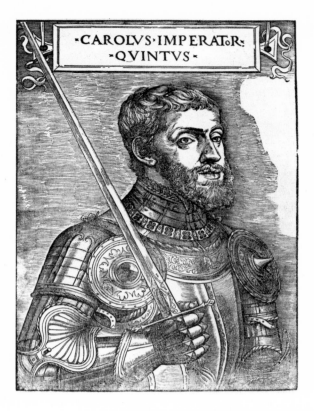

89. Nicolò Boldrini, after Titian. SIX SAINTS. c. 1535–40. Wood-cut, 15 1/4 × 21″. *British Museum, London*

88. Giovanni Britto, after Titian. PORTRAIT OF EMPEROR CHARLES V. c. 1535–40. Woodcut, 19 1/2 × 13 7/8″. *Davison Art Center, Wesleyan University, Middletown, Connecticut*

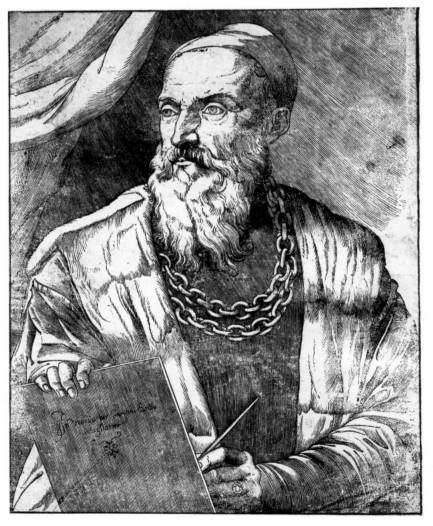

90. Giovanni Britto, after Titian. SELF-PORTRAIT. 1550. Woodcut, 16 1/4 × 12 3/4″. *Rijksmuseum, Amsterdam*

BIOGRAPHICAL OUTLINE

c. 1488/90 Tiziano Vecellio is born in the mountain town of Pieve di Cadore, in 1488 according to the reckoning of Dolce, while Vasari, who writes that the painter was about seventy-six when he visited him in 1566, would place the date of birth c. 1490.

c. 1497 At the age of nine, still according to Dolce, Titian is sent to Venice and apprenticed to Sebastiano Zuccato. Probably c. 1500 Titian entered the workshop of Gentile Bellini, where he received his basic training as a painter. This was followed by further experience, possibly as an already graduated master, with Giovanni Bellini.

1508 December 11: Giorgione's frescoes at the Fondaco dei Tedeschi were evaluated by a committee of painters. Titian's name is not mentioned in the document, but by his own, later, testimony he served in some capacity as assistant to Giorgione on the second phase of that project.

1510 Death of Giorgione. December 1: Titian's name appears in an entry in the account book of the Scuola del Santo in Padua.

1511 April 23: Titian begins work on the fresco cycle of the miracles of Saint Anthony. December 2: receives final payment for the three paintings.

1513 Titian is invited through Pietro Bembo to join the papal court at Rome, but instead volunteers his services to the Venetian state, offering to replace the fourteenth-century mural of *The Battle of Spoleto* in the Sala del Maggior Consiglio; in return he asks only for the next broker's patent (*senseria*) to fall vacant at the Fondaco dei Tedeschi. In May his offer is accepted and he opens a workshop at San Samuele.

1514 March 20: in response to the complaints of other painters the Council of Ten rescinds this appointment; by November Titian regains the commission and promise of the *senseria*.

1516 January 31–March 22: Titian is at the court of Ferrara. At Santa Maria Gloriosa dei Frari in Venice the high altar is erected. Death of Giovanni Bellini.

1517 Titian is awarded the *senseria* with its attendant privileges; as successor to Bellini, he is now official painter to the Venetian government.

1518 May 19: the *"Assunta"* is unveiled.

1519 April 28: Titian signs a contract with Jacopo Pesaro for a painting to be placed on the altar dedicated to the Immaculate Conception at the Frari. By October 17 he is again in Ferrara.

1520 Date of the altarpiece painted for Alvise Gozzi for San Francesco in Ancona.

1521 Trip to Brescia.

1522 Completion of the altarpiece of the Resurrection, commissioned by the papal legate Altobello Averoldo for Santi Nazaro e Celso in Brescia.

1523 By February Titian is again in Ferrara, to complete work on *Bacchus and Ariadne*. Beginning of his contacts with the Gonzaga court at Mantua. Andrea Gritti is elected doge of Venice; Titian executes a number of frescoes in the Palazzo Ducale.

1524 From November until early the following year Titian is again in Ferrara.

1525 Titian marries Cecilia, the woman with whom he has been living and the mother of his three children, Pomponio, Orazio, and Lavinia.

1526 May 27: Titian receives final payment for *The Madonna di Ca' Pesaro*, initiated in 1519.

1528 Trip to Ferrara.

1529 Trips to Ferrara and Mantua.

1530 February 25: Titian attends the coronation of Charles V in Bologna. By April 27 *The Martyrdom of Saint Peter Martyr* altarpiece is completed for Santi Giovanni e Paolo in Venice. August 5: death of Cecilia.

1531 September 29: Titian, along with Lorenzo Lotto and Bonifazio dei Pitati, is among the twelve members of a commission charged with supervising a fund left to the guild of painters by Vincenzo Catena for the purpose of dowering the daughters of impoverished masters. Also in September Titian moves from his studio at San Samuele to a house at Birri Grande, in the parish of San Canciano, where he will live until the end of his life.

1532 Beginning of Titian's relationship with the Della Rovere court at Urbino.

1533 In the early part of the year Titian is again in Bologna with Charles V. May 10: the painter receives a patent of nobility from the emperor.

1538 August: the battle picture for the Sala del Maggior

Consiglio is finally completed (it is destroyed by fire in 1577); for his long procrastination Titian is deprived of the *senseria* and the commission for the next painting in the cycle is awarded to his rival, Pordenone.

1539 January: death of Pordenone. June 23: the *senseria* is restored to Titian.

1541 December: Vasari arrives in Venice, staying until early the following year.

1543 Titian is in Ferrara for a meeting between Charles V and Pope Paul III.

1545 By September Titian is in Pesaro and Urbino, on his way to Rome.

1546 March 19: Roman citizenship is conferred upon Titian; he returns to Venice, with a stop in Florence.

1548 January: Titian leaves for the court at Augsburg for the gathering of the Imperial Diet; he is back in Venice by October. December: Titian meets the emperor's son Philip in Milan.

1550 November: Titian returns to Augsburg; he is back in Venice by August of the following year.

1555 Titian's daughter Lavinia marries, and he provides a dowry of 1,400 ducats.

1564 October: Titian receives a contract to paint three ceiling pictures for the Palazzo Pubblico in Brescia.

1565 Titian is in Pieve di Cadore to supervise the execution of his designs for frescoes in the apse of the local church (completed by pupils in 1567, they are destroyed in the nineteenth century along with the church).

1566 Titian is granted a copyright privilege for engravings after his works by Cornelis Cort. May: Vasari visits Venice to gather further information for the amplified edition of his *Lives*. Titian, along with several other Venetian artists, is elected to membership in the Florentine Accademia delle Arti del Disegno.

1568 Completed the previous year, the canvases for the Palazzo Pubblico in Brescia are installed (they are destroyed by fire in 1575).

1569 Titian has the *senseria* transferred to his son Orazio.

1571 August 1: in a letter to Philip II Titian declares himself to be ninety-five years old. Philip agrees that Titian's pension drawn against the treasury of Milan be transferred to Orazio.

1576 August 27: Titian dies.

COLORPLATES

COLORPLATE 2

CHRIST CARRYING THE CROSS

c. 1505–6

Oil on canvas, 27 5/8 × 39 3/8"

Scuola Grande di San Rocco, Venice

Originally in the church of San Rocco, this canvas was painted for the confraternity of that saint, which had been founded in the plague year of 1478 and designated a *scuola grande* some eleven years later. In the early sixteenth century the church itself was rebuilt, and the Scuola di San Rocco, recovering from an initial state of relative poverty, was about to embark upon a period of expansion that would culminate in the construction and decoration of magnificent new quarters. Much of that building activity was evidently financed by this small painting, for soon after its execution and public display the picture acquired a reputation as a miracle-working image and attracted large sums in votive offerings. Frequently copied in various media, it was used by the confraternity as its *gonfalone*, the banner carried in the great public processions of Venice as well as at the funerals of members of the brotherhood. (In the woodcut broadside designed by Titian and sold to raise additional money for the construction of the *scuola* [fig. 83], above the central figure of the patron saint appears, as a vision, the composition of Christ carrying the cross—further evidence of the intimate identification of the image with the confraternity.) The intense popularity of the picture and its frequent use and exposure led, by 1519, to concern for its physical conservation; its present condition, much abraded and somewhat retouched, has naturally complicated the problem of attribution.

Already in the sixteenth century Vasari expressed some uncertainty and confusion on the subject. In the first edition of his *Lives* (1550) he attributed the picture to Giorgione; in the second, expanded edition (1568), however, although retaining this attribution in the life of Giorgione, in the biography of Titian he assigned it to the younger master: "For the church of San Rocco [Titian] then made a picture of Christ with the cross on his shoulder, with a rope around his neck drawn by a Jew; this image, which many have

believed to be by the hand of Giorgione, is today the main object of devotion in Venice and has received in alms more *scudi* than Titian and Giorgione earned in their lifetimes." The anecdote almost certainly echoes Vasari's interview with Titian himself in 1566, when the biographer was in Venice gathering new data for the second edition, and his corrected attribution is further confirmed by other contemporary Venetian sources. Although there exists no other definitive documentation for a secure attribution, and the Giorgione-Titian problem has continued to vex critics, strong stylistic arguments can be made on behalf of Titian's authorship.

Perhaps above all, the physicality of the composition relates it to the art of Titian. At the core of its powerful affect is the physiognomic contrast between the aggressively profiled tormentor and the gentle pathos of Christ; the Savior's face is defined with a linear precision, especially evident along the brow and nose, that is characteristic of Titian's approach and quite unlike the softer mode of Giorgione. Further, the dense impacting of forms within the field, pressed by the frame and proximate to the picture plane, heightens the sense of actuality while constraining the movement of the figures. This density and constraint, reflecting developments in Northern painting, is also alien to the spatial atmosphere of Giorgione's creations. Such motifs as the flanking profiles cut by the frame point in an entirely different direction—to the tragic classicism of Mantegna (fig. 8). And such reference allows us to locate the picture with some precision in the early career of Titian, at the moment of his emergence from the workshop of Mantegna's brother-in-law, Gentile Bellini. The manner of execution, dry and reminiscent of a tempera technique, further suggests that this is a very early work by the recently graduated master, perhaps his first known painting.

64

PORTRAIT OF A YOUNG MAN

c. 1506

Oil on canvas, 22 7/8 × 18 1/8"

Staatliche Gemäldegalerie, Berlin-Dahlem

Although this portrait has carried a nearly undisputed attribution to Giorgione since the nineteenth century, it can be recognized instead as another of Titian's earliest works. "When he first began to follow the manner of Giorgione," Vasari writes of the young Titian, "not being more than eighteen, he painted the portrait of a friend, a gentleman of the Barbarigo family; it was considered extremely beautiful, the flesh appearing real and natural and the hairs so meticulously rendered that you could count each one separately, and the same was true of the details on the silvered satin jacket. In short, it was so well executed, with such care, that had Titian not signed his name in umber one would have taken it for a work by Giorgione."

While it is hardly possible to prove absolutely that the Berlin picture is identical with the Barbarigo portrait of Vasari's description, the resemblance is striking. Despite the state of the painting, which has suffered restoration and which originally may have been on panel, the diligence that so impressed Vasari is apparent, that rendering of texture and substance that would continue to characterize Titian's naturalism. Vasari's words have at times been read with reference to the London *Portrait of a Man* (colorplate 9), and comparison with that picture reveals the personality of the young Titian asserting itself with greater insistence in the Berlin portrait. The two share a common appreciation of rich sartorial material, and both are psychologically based on a direct confrontation between sitter and observer. If the Berlin image seems comparatively less confident in its control of these elements—the hand in particular appears somewhat tentative—this itself might be ascribed to the inexperience of a young artist, not yet eighteen, as Vasari says.

The cool clarity of the pictorial structure speaks a language quite different from the warmer suggestiveness of Giorgione's portraits, with their softer tonalism and affecting spatial involvement (fig. 5). Informing every detail of the erect and sharply articulated head is a sense of form and personality characteristic of Titian's art: the curve of the eyebrows into the contour of the nose, the directness of the glance, the firm mouth. These qualities, which distinguish the master's more mature portraits, appear here—about 1506—for the first time.

The suspiciously lettered inscription on the parapet, *VV*—which Vasari may have recalled as a signature *in ombra*—occurs with variations on many portraits of the early sixteenth century. Deriving from the traditions of ancient Roman funerary portraiture, as Nancy de Grummond has recently demonstrated, it stands for *Vivus Vivo:* "The living [made it] for the living"—an assertion of the vitality of the effigy and a promise of the continuing life bestowed by the portrait on the mortal sitter.

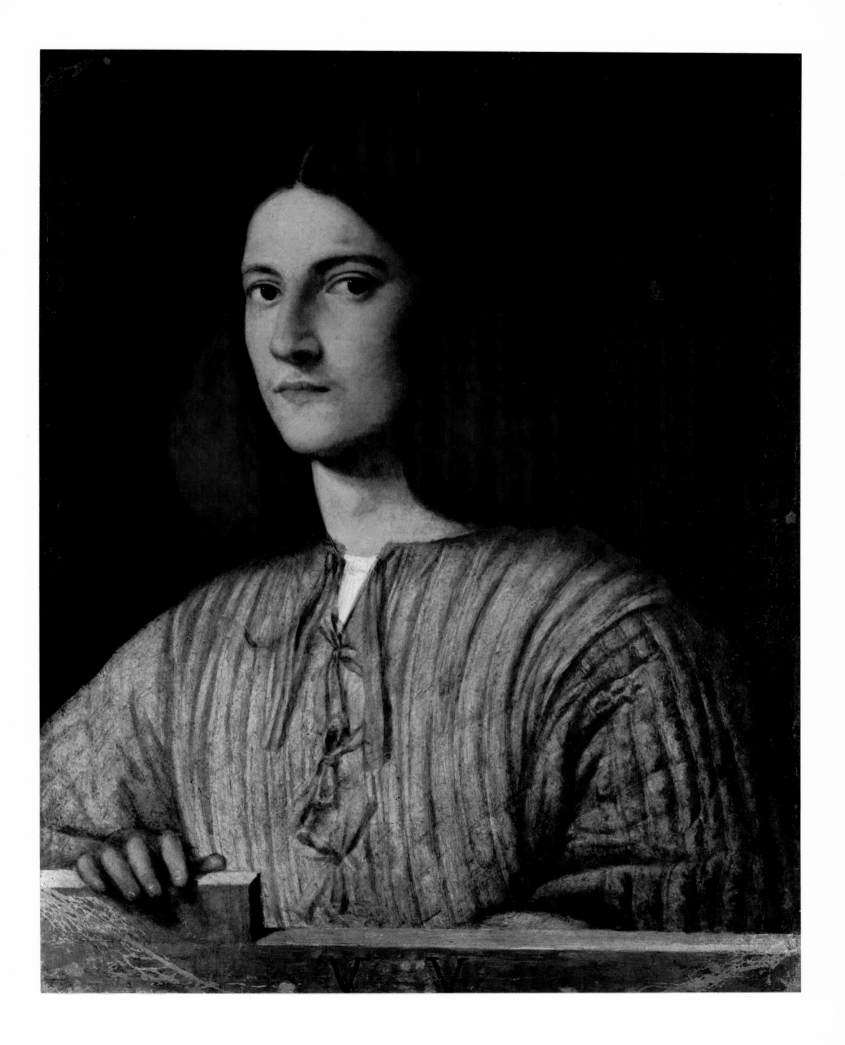

COLORPLATE 4

SAINT MARK ENTHRONED
WITH SAINTS COSMAS AND DAMIAN,
ROCH AND SEBASTIAN

c. 1508–9

Oil on panel, 90 1/2 × 58 1/2"

Santa Maria della Salute, Venice

The iconography of this altarpiece, originally in the church of Santo Spirito in Isola, clearly suggests its association with the crisis of a plague in Venice. Saints Roch and Sebastian are specifically evoked during such epidemics, and Cosmas and Damian are patron saints of physicians. It has been generally assumed that Titian executed the panel upon his return from Padua in 1511, following the terrible plague of the previous year. However, there is good reason to date the picture earlier and to acknowledge it as Titian's first independent monumental commission; the formal and stylistic components of the design confirm an earlier dating, certainly before the Paduan sojourn. (We might note that Venice experienced plagues in 1503–4 and 1506–7, as well as in 1510.)

The composition itself appropriately modifies the traditional scheme of the *sacra conversazione* as established in Venice in the great altarpieces of Giovanni Bellini (fig. 2), substituting for the enthroned Madonna and Child the figure of the patron saint of Venice. Furthermore, as Giorgione had done earlier in his Castelfranco altarpiece, Titian placed the group before an outdoor setting, but he displaced the architectural backdrop to one side so that Saint Mark is fully silhouetted against the bright sky—an effect, first stated here, that he would continue to exploit. The colonnade to the right, in addition to its structural function as a stabilizing and monumentalizing unit, suggests the ostensible cause of the shadow cast across Mark. The shadow itself is the key to the drama of the altarpiece, for the gloom enshrouding its patron speaks most eloquently of the state of Venice itself. To the traditional iconography of plague imagery Titian has thereby added a new, dramatic dimension: the pestilential crisis is not merely symbolized but enacted, and the main protagonists of this drama are perhaps less the assembled saints than light and shadow.

Titian is here still responding rather directly to the models of the two dominant painters in Venice, Giovanni Bellini and Giorgione. The figures of Roch and Sebastian in particular testify to his study of Giorgione's art—in their romantic physiognomies, softened by a gentle *sfumato*, and in the pathos of their angular contrapposto, with its absence of classical poise and assertiveness—while the enthroned Mark resembles in pose the figure of Solomon in *The Judgment of Solomon* (in the Bankes Collection at Kingston Lacy, England), an unfinished canvas that has been attributed variously to Giorgione or to Sebastiano del Piombo. The Saint Mark altarpiece, then, documents for us a moment in Titian's career between the experience of the Fondaco frescoes and the coming to maturity in Padua.

68

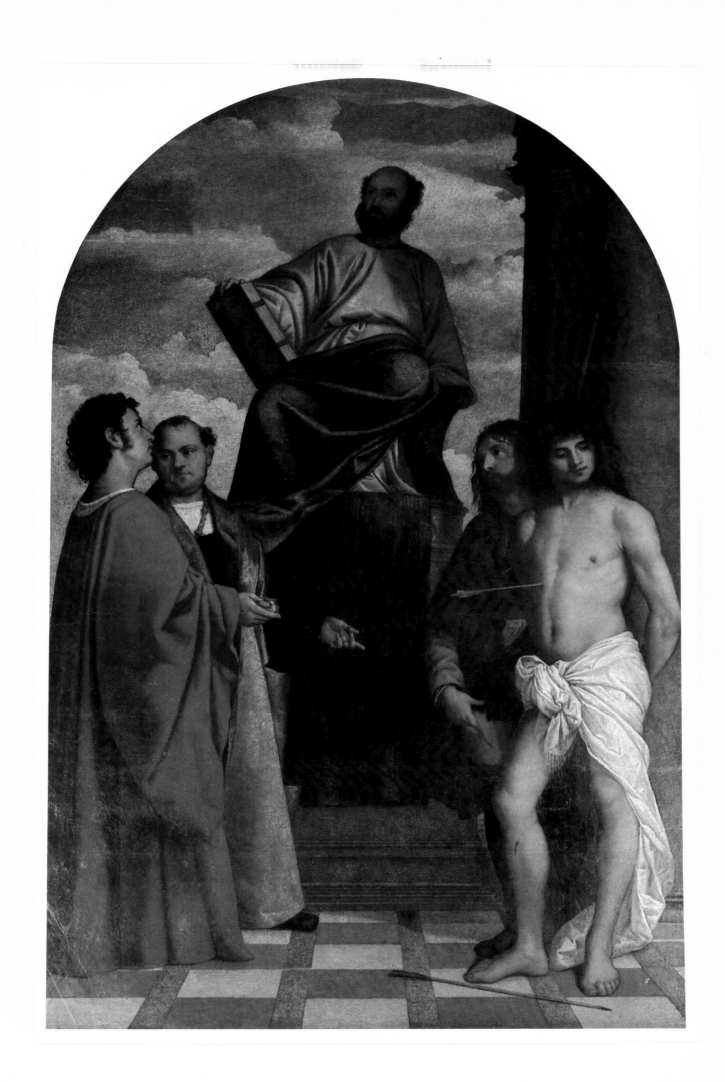

COLORPLATE 5

MADONNA AND CHILD
("THE GYPSY MADONNA")

c. 1510

Oil on panel, 26 × 32 7/8″

Kunsthistorisches Museum, Vienna

Working with pictorial ideas developed by Giovanni Bellini and extended by Giorgione, Titian unequivocally establishes his own stylistic personality in this early panel. The motif of the half-length Madonna and Child seen behind a parapet and set against a rich cloth of honor had been a staple in the artistic production of Bellini and his shop; typically, however, the composition was more iconic and centralized, the cloth hanging directly behind the figures and revealing on both sides a landscape view. Titian's design, operating significantly within a dominantly horizontal format—more narrative and less iconic—shifts both cloth and parapet to one side, thereby creating an asymmetrical composition of more dynamic contrasts. The full, organic forms of the figures are plotted against the precise yet varied rectilinear gridwork of the pattern and folds of the cloth of honor, and further stabilized by the horizontal fragments of wall and parapet.

The landscape, an idyllic scene in a Giorgionesque mode, with a lone armored figure beneath a tree, assumes a greater importance within the overall pictorial field, and the contrasts of distance and size assume significant roles in the functioning of the image. The broad stretch of landscape also performs an important spatial function: it is necessary to accommodate—visually, if not actually—the volume of the Madonna's impressive form. The pyramidal structure of her shape, quite clearly speaking a High Renaissance formal language not unlike that of Raphael's Madonnas, distinguishes Titian's conception from those of his Venetian predecessors, and this breadth of form allows a new gravity to both Virgin and Child. The small figure of Christ stands firmly, in a contrapposto of classical confidence, and his face, thinly painted, reveals a knowing intelligence that matches the composure of his mother. Titian's sense of weight, never a merely formal device, is from the very beginning of his development committed to the expression of dramatic or psychological values.

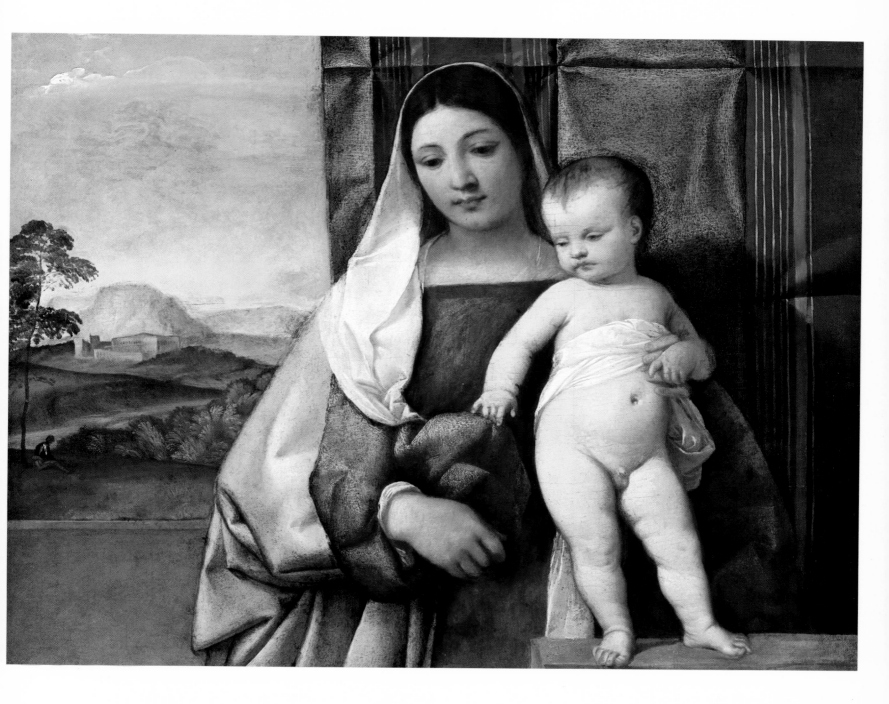

THE MIRACLE OF THE
NEWBORN INFANT

1511

Fresco, 11' 1 7/8" × 11' 7 3/4"

Scuola del Santo, Padua

The three paintings that Titian contributed to the decorative cycle in the confraternity of Saint Anthony of Padua represent his earliest securely documented works (figs. 13, 14). He was already in Padua by December 1, 1510, when his name appears in the account books of the *scuola*; by April 23 of the following year he began work on the actual frescoing and on December 2 received final payment for the three murals. *The Miracle of the Newborn Infant* is the largest of the group and, judging by its monumentality and classical control, quite probably the last in order of execution.

Its story concerns a wife wrongly accused of adultery and absolved by the testimony of her own child, miraculously given the power of speech by Saint Anthony. In staging the event before a double backdrop of architecture and landscape Titian demonstrated the intelligence and imagination of his response to the classical tradition. Presiding over the trial is the statue of a Roman emperor, whose effigy, as Erwin Panofsky observed, was placed in every tribunal of the empire. With this presence Titian established a basic theme of the picture, and the anachronistic juxtaposition of ancient pagan ruler and medieval Christian saint afforded him the means of enlarging upon that theme. In the contrast between those two worlds, which would become a favorite theme for him, pagan antiquity, significantly represented by a fragmented image, yields to Christian truth, the higher justice of God, whose presence is symbolized by the cross in the niche to the upper right of the emperor.

Titian's composition also unites two pictorial traditions. Its isocephalic arrangement of figures across the surface recalls the narrative tableaux of an earlier generation, that of Gentile Bellini and Carpaccio; in a superficial way it resembles those processional canvases that covered the walls of the Venetian confraternities (fig. 4). But in Padua Titian came to know another tradition, that of monumental mural design in fresco, and his immediate task in the Scuola del Santo surely made more relevant for him the decorations of Mantegna in the Church of the Eremitani and, of still greater significance, Giotto's work in the Arena Chapel. Indeed, the example of Giotto's dramatic construction—as so clearly documented in the relationship between his *Lamentation* and Titian's *Miracle of the Youth's Leg* (fig. 14)—seems to have been a major inspiration to Titian. The classicism of Padua, then, confirming Titian's own compositional predilections, served to modify Venetian traditions of narrative painting.

In *The Miracle of the Newborn Infant* coordinates defined horizontally by the line of heads and vertically by the wall edge neatly divide the field into four quarters, structuring the overall composition. The distinct profiles of the accused mother, the testifying infant, and the supporting monk, bracketing the central confrontation, reinforce the planarity of the pictorial construction. Although the group of figures appears to be comprised of strictly parallel forms, it is distinguished by a variety of poses, gestures, and angles of vision. Clearly and deliberately disposed, the figures are arranged on a generally semicircular plan, a spatial organization epitomized by the volume of the white cape of the striding youth to the left. Although his modishness of type and costume is reminiscent of a Giorgionesque world (fig. 7), this figure, in the largeness of his form and the classically confident purpose of his movement, proclaims with telling clarity the qualities of Titian's art that distinguish it

CONTINUED ON THE FOLLOWING PAGE

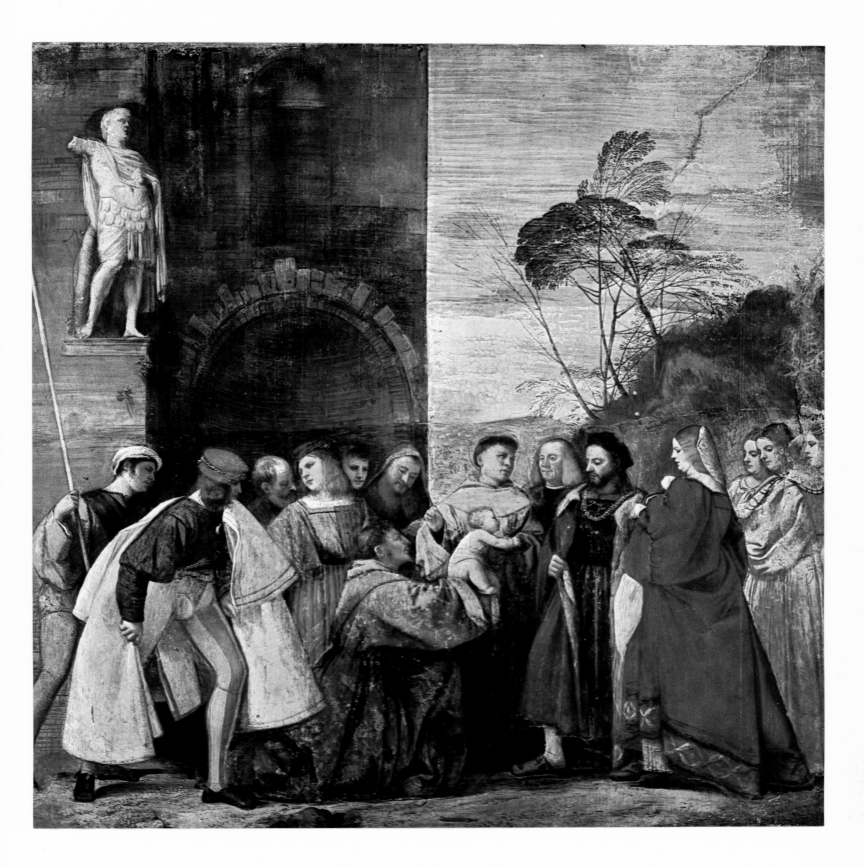

THE MIRACLE OF THE
NEWBORN INFANT, detail

from Giorgione's. Throughout the composition a counter-point of motifs—juxtaposed heads and postures, space-traversing glances, curves and angles—unites figures with one another and foreground with background; perhaps no detail in this regard is more revealing of Titian's pictorial control than the group of trees, silhouetted against the sky, whose intricate linear patterns contain and summarize the essential relationships of the figural grouping below.

Painting in fresco requires working rapidly on the wet plaster. This particular mural reveals thirteen *giornate*—that is, thirteen separate areas of applied plaster representing as many days of work. The experience of the medium and the very scale of the project seem to have inspired in Titian a new freedom of execution. The brush moves swiftly and surely over the surface, applying the colors in broad patches and knowing accents, the liquid strokes recording the varied pressure and inflection of the guiding hand. With this boldness and assertion Titian achieved a freedom in handling of paint that he would not attain until later in painting in oil.

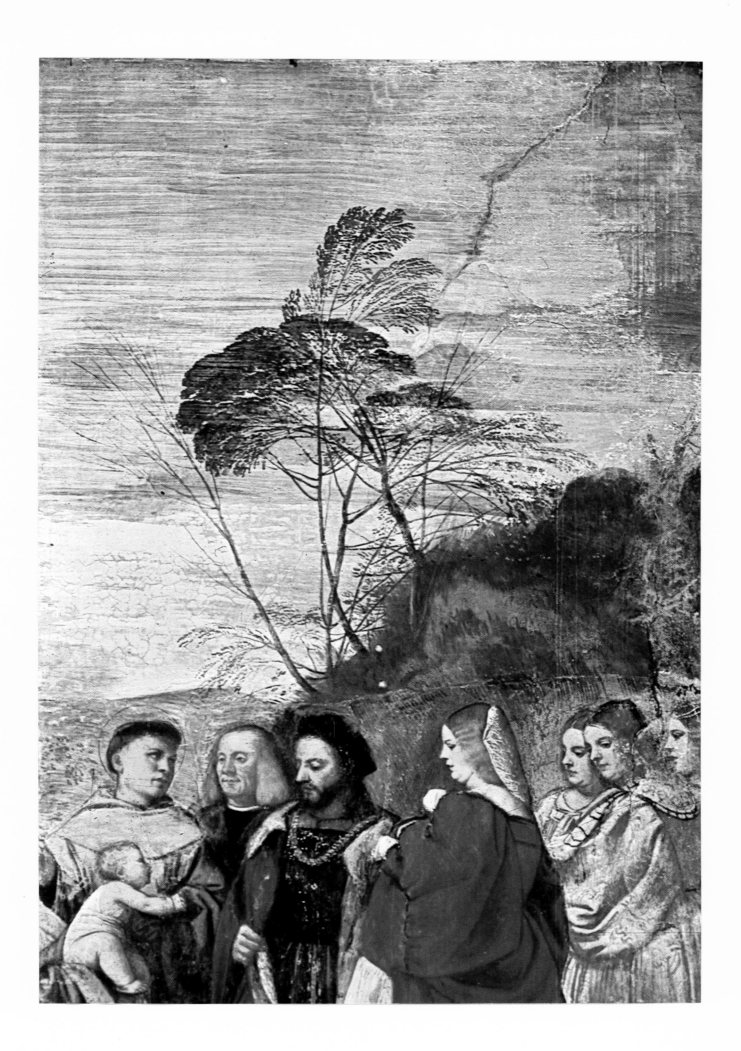

PORTRAIT OF A WOMAN ("LA SCHIAVONA")

c. 1511–12

Oil on canvas, 47 × 38 1/8"

Signed (on the parapet): T.V.

National Gallery, London

The appellation *"La Schiavona"* (the Slavic woman) originates in a letter of 1640, the earliest documentary reference to the portrait, and most likely represents a romantic response to the picture. The actual identity of the sitter is unknown, although she bears some resemblance to the heroine of the Paduan fresco of *The Miracle of the Newborn Infant* (colorplate 7). Her fullness of form, so clearly stated in the broad oval simplicity of the head, establishes the tone of the composition both in its large-scale structure and in the definition of individual smaller formal components such as the folds and patterns of drapery. The expressive as well as physical gravity informing this figure, in combination with the direct gaze of her dark eyes, gives her an extraordinarily vital presence.

In the course of executing the portrait Titian worked actively with the design, modifying it in a number of important ways. At one point he had planned an oculus window opening in the upper right area, and originally both arms of the sitter were at her sides. With the decision to raise one side of the parapet Titian found a more organic solution to the problem of compositional contrapposto, creating not only an element to balance the off-center placement of the figure but also a greater degree of variation and interest in her pose. The red and blue veining of the marble surface reflects the disposition of colors in the earlier state of the composition; those two colors find their purest concentration in the small stones of the woman's rings, summarizing and serving as the source of the picture's basic chromatic structure.

The decision to raise the marble parapet is one of Titian's most imaginative responses to certain inherited traditions of portraiture. Functioning as a deliberately ambiguous barrier between the observer and the fictive world of the picture, the parapet was a favorite device in earlier Renaissance portraiture; as the sitter reached beyond it by gesture or glance, a line of communication, a means of access, was opened to the viewer (see colorplates 3, 9). Seen in nearly three-quarter length, *"La Schiavona,"* however, assumes a somewhat less intimate and more distant position, and Titian seems to have been interested in exploring even further these implications of monumentality. By raising the parapet he reinforced its function as barrier, and he made explicit its implicit identity with the picture plane by turning it into a pictorial field of its own.

Rendering the portrait of the sitter a second time, Titian invented a pictorial conceit of the highest order and richest expressive resonance. The profile portrait, a marble relief *all'antica*, not only adds, quite literally, a new dimension to the image, offering yet another view of the subject, but also a full range of cultural associations: it quite obviously compliments the sitter by allusion to the noble *virtù* of classical antiquity; by its own historical reach into the past it suggests the future preservation of her effigy and hence her fame—one of the primary social functions of portraiture. The conceit also afforded Titian a field for more personal and professional expression: creating a work of art within the work of art, he accepted the challenge of the *paragone*, the comparison of the arts; by creating a work of sculpture—significantly, in a looser and more painterly technique than he had used in the actual portrait—he turned his picture into a triumphal declaration of the power of the art of painting itself.

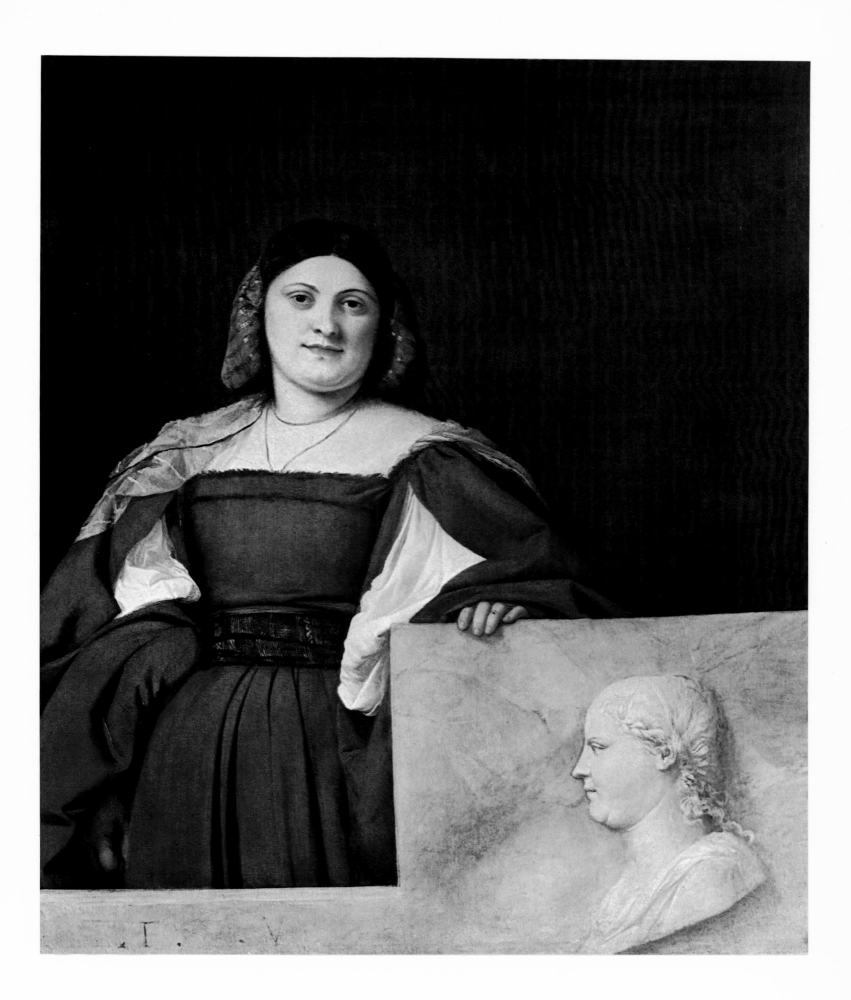

PORTRAIT OF A MAN

c. 1512

Oil on canvas, 32 × 26″

Signed (on the parapet): T.V.

National Gallery, London

In its chromatic as well as its compositional relationships, the cool elegance of this portrait perfectly describes the classical ideal of style Titian had defined for himself in the course of his Paduan year. While in a general way the aesthetic of the image shares some qualities with Giorgione's inventions in portraiture—the use of the parapet, the spatial complexity of the contrapposto, even a certain softening of the physiognomic features—these have been developed along more rigorously structured lines. The vertical stability of the axis of the figure, emphasized by the level turn of the head, establishes a critical central coordinate against which spatial variations are measured. The movement of the figure, controlled by an overt respect for planar relationships, seems less serpentine than faceted. The magnificently sleeved arm, while significantly breaking over the edge of the parapet and hence, by implication, beyond the picture plane, thrusting forward and back into space, nonetheless maintains the continuity of that plane—partly by the value distribution of the luxurious blue satin.

Within the broad stability of the pyramidal construction there is a highly sophisticated visual play of internal correspondences. The two great areas of light, the face and the costume, are each enframed by a darker element, which at once contains them and defines the larger silhouette of the figure. The fur-lined cloak draped with such studied casualness over the far shoulder creates a deep resonance of tone against which the satin sleeve is played off—as the profile of the cloak itself comments on the outline of the sleeve. The illuminated face of the sitter receives added strength from the dynamic profile of the surrounding hair and beard, which complement the larger shapes of the full figure.

If much of the impact of this portrait depends upon its large-scale relationships, these all serve to accentuate the psychological locus of the image, the highly articulate face and especially the direct encounter of those sharply alert and intelligent eyes. The very assertiveness of this entire configuration, the quality of the pose as well as the calm confidence of the physiognomic expression, has led to the tantalizing suggestion that this unknown sitter may in fact represent Titian himself. (An older identification as the poet Ludovico Ariosto has long been abandoned.) The picture was known to Rembrandt and Van Dyck in the seventeenth century, and did, indeed, inspire self-portraits by those masters.

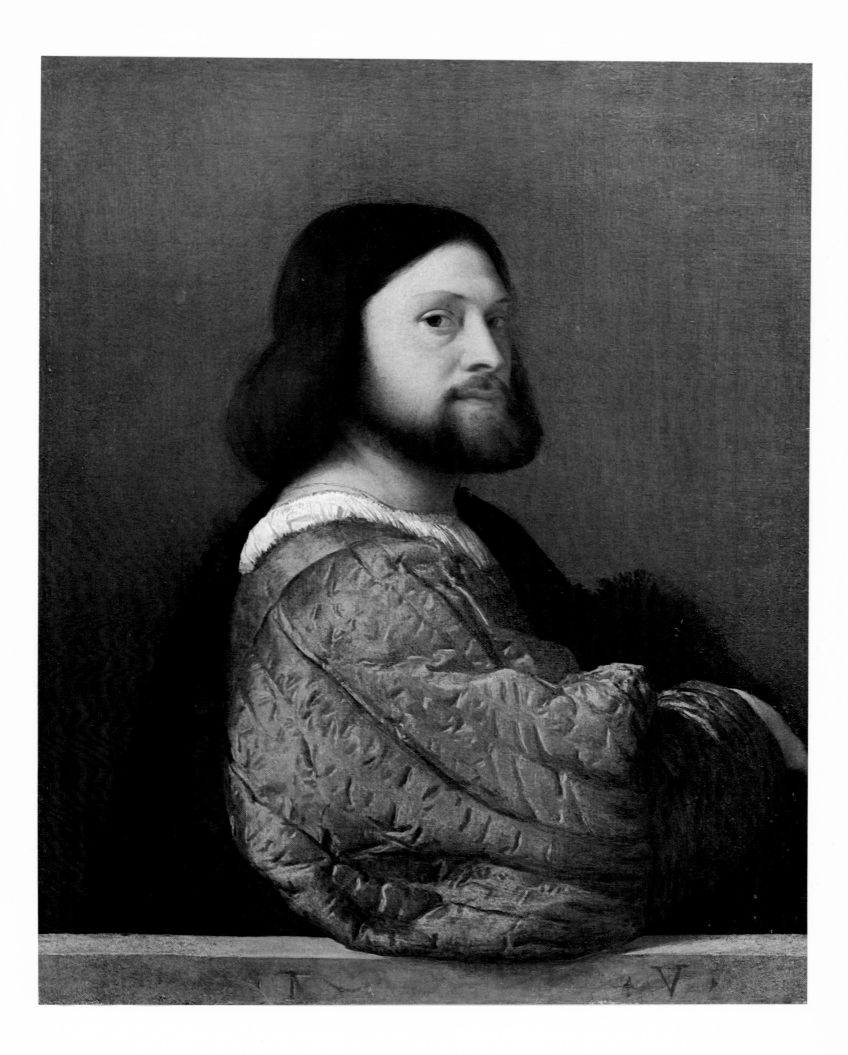

SACRED AND PROFANE
LOVE

c. 1514

Oil on canvas, 3' 10 1/2" × 9' 1 7/8"

Galleria Borghese, Rome

Commissioned by Nicolò Aurelio, whose coat of arms it bears, on the occasion of his marriage to Laura Bagarotto in 1514, this celebrated painting did not receive the title by which it has come to be known until 1693, in an inventory of the Borghese collection; in the earliest preserved description of the work, from 1613, it is called "Beauty adorned and Beauty unadorned." Modern scholarship has continued to debate the significance of the subject, but most observers have instinctively recognized the composition as a form of dialogue. More precisely, the picture is organized according to what might be termed a dialectical structure: the field is clearly divided into two parts that are deliberately contrasted in every detail but at the same time, by virtue of the overall pictorial conception, they are synthetically resolved into a full unity. That the key factors in this dialectic are the two women is self-evident; the presence of Cupid and the roses between them confirms the amorous nature of the theme and the identification of these beauties as twin Venuses, a common theme in classical mythology and in both ancient and Renaissance philosophical speculation.

The sister deities, each dominating one half of the composition, represent two levels of love, the human and the divine, and each of the elements distinguishing them contributes to the articulation of this hierarchical relationship. The more exalted Venus is nude—heavenly beauty needs no material adornment—and stands higher in the field, framed against the background sky. She is set quite literally above earthly nature; the vertical instability of her body, requiring the actual support of her arm and the visual buttressing of her crimson mantle, continues heavenward in

the elevated eternal flame of her lamp—a vertical movement significantly reflected in the background accent of the distant bell tower. In contrast, her more earthly sister is solidly seated and hence actually on a lower level, more immediately enclosed by nature. She is sumptuously dressed in the material splendor of this world, and her attributes pertain to sanctioned human love: the myrtle she holds symbolizes the lasting happiness of marriage (see colorplate 26). Between these twin Venuses Cupid mixes the waters in the well, thereby suggesting an ideal synthesis of the two or a perfect harmony. Below celestial and human love, a third type is depicted on Titian's invented sarcophagus relief: bestial love—pure lust, which seeks not beauty and its procreation but rather mere satisfaction of sexual appetite—is symbolized by the unbridled horse and the accompanying acts of passionate violence.

Titian's composition, then, is a calculatedly structured and highly differentiated unity. The dense, closed forms and gravity of the left side contrast with the openness and volatility of the right; a system of horizontal coordinates, a basic stabilizing factor in the design, paralleling the long horizontal format of the canvas, defines a vertical hierarchy of upper and lower zones and hence of relative values. Within the substance of the picture's fictive world Titian further distinguishes levels of materiality, an upward scale from stone through jeweled cloth to unadorned flesh. To his sophisticated audience, the recognition of the formal source of the standing nude—a type common on ancient sarcophagi—would have seemed an ideal conceit to complete this cycle of references.

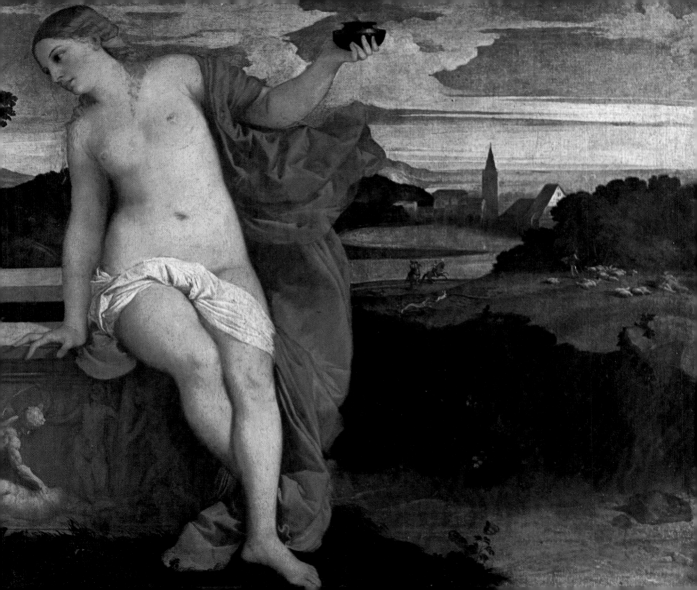

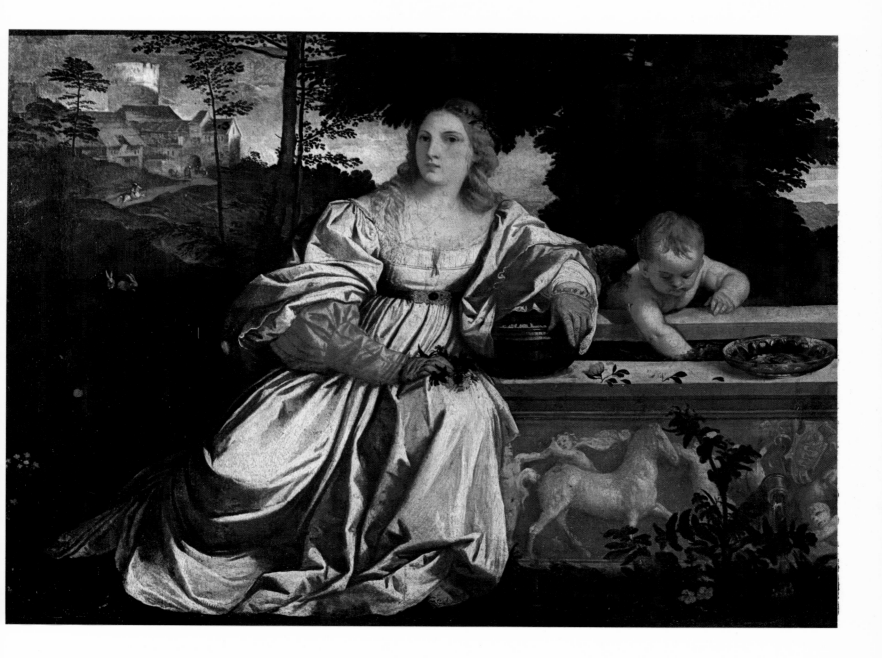

COLORPLATE II

FLORA

c. 1516–20

Oil on canvas, 31 1/8 × 24 7/8″

Galleria degli Uffizi, Florence

In a series of paintings executed following his return from Padua, Titian explored the Giorgionesque half-length figural prototype. Characterized by a certain intimacy, the motif offers a close-up view of its subjects, who, cut off by and appearing immediately behind the frame, present themselves directly to the beholder. Working within this compositional context, Titian developed a type of image informed by classical restraint as well as by a gentle sensuality; the actual themes were as varied as the tender horror of Salome with the severed head of the Baptist (Galleria Doria-Pamphili, Rome), the genre-like and probably allegorical scene of a woman at her toilet (Musée du Louvre, Paris), and the classical Flora.

Whether or not she actually represents one of the celebrated courtesans of Renaissance Venice, Titian's Flora established an influential model of sensual invitation. The subject herself—the nymph, once ravished by Zephyr, who in turn became seductress—and her visual presentation—the alluring dishabille frequently found in ancient Roman portraits—both derive from aspects of the classical tradition. Her *camicia*, or undergarment, is loosened to reveal the beauty of her bare bosom, gently touched by her falling tresses; with one hand she holds her gown protectively against her and with the other offers a bunch of flowers—and, by implication, herself. Significantly, however, her glance does not meet ours, and hence that offer is not made directly to the observer. This averted gesture and the direct appeal of her uncovered flesh combine to enhance the quiet eroticism of the image. Her form fills the pictorial field, and the auburn beauty thus seems accessible by her

proximity, yet she is removed; the distracted gaze of her dark eyes suggests another dimension of experience, a realm of awareness beyond our reality and to which we can aspire only by a reach of the imagination. Playing thus with dualities—nearness and distance, sensual allure and idealized beauty—Titian creates a world of poetry, the aesthetic perception of which further heightens the attraction of this Flora.

Within the broad composition a gentle but insistent contrapposto affirms the organic vitality of the figure; the folds of her garment record the direction of that movement. The ample body itself is encircled by rose-colored satin drapery that winds about her as it distributes its color. Similarly, rippling waves of hair undulate about the ideally simple form of the head, adorning its smooth perfection with a quality of controlled disarray. Titian has exploited the dishabille of his subject to discover contrasts of texture—flesh, hair, lawn, satin, and, of course, flowers. And each of these respective areas is in turn rendered with indulgently nuanced tone—naturally enough, the great expanse of flesh above all. Presented with this variety of tactile sensations, we are guided in our appreciation by the gentle touch of Flora's fingers; eventually, however, we accept the immediate satisfaction of this sensory experience as surrogate for the promise of the ultimately inaccessible pleasure of Flora herself. Perhaps no other painter has succeeded in so precisely controlling the erotic appeal of such imagery, in maintaining the delicate equilibrium between obvious suggestion and the invitation of and to poetry.

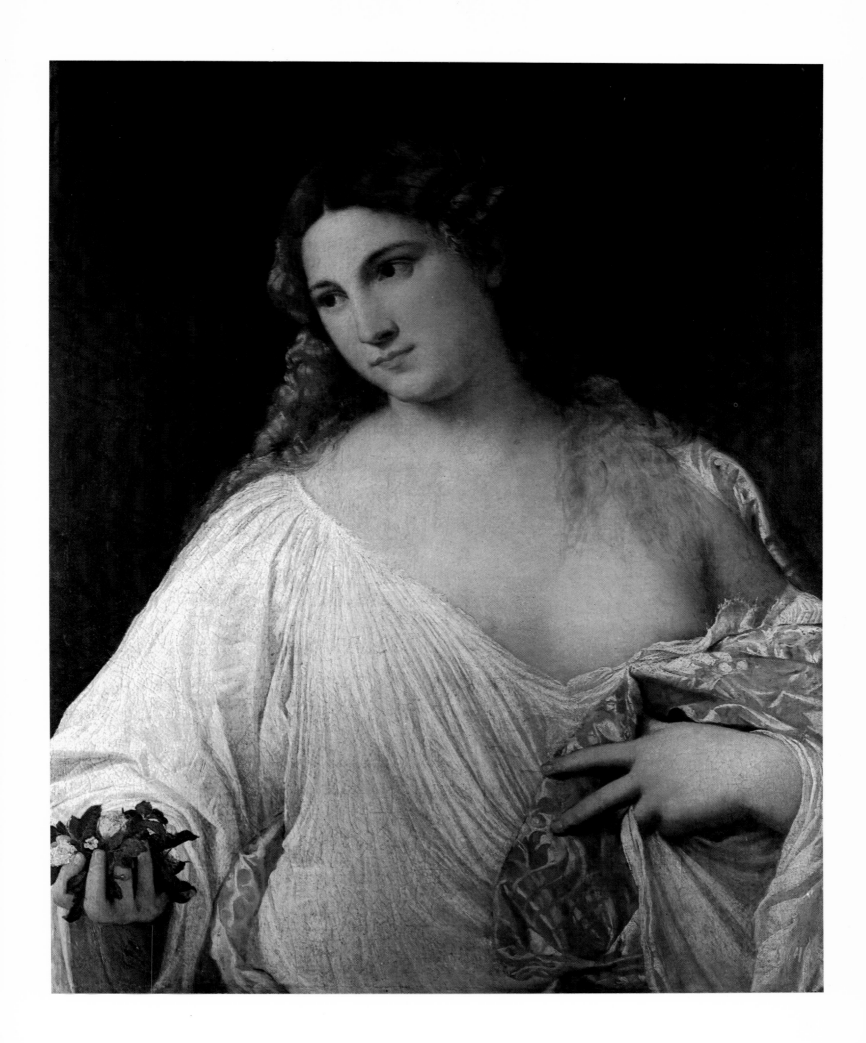

COLORPLATE 12

THE ASSUMPTION AND CORONATION
OF THE VIRGIN ("L'ASSUNTA")

1516–18

Oil on panel, 22' 7 1/2" × 11' 9 3/4"

Signed (on the sarcophagus): TICIANVS

Santa Maria Gloriosa dei Frari, Venice

Dedicated on May 19, 1518, this great altarpiece established a new standard of monumentality in Venetian painting. Titian was surely already at work on the project—in the monastery itself—by 1516, the date of the inscription on the architectural enframement. Indeed, the very ambitious scale of the undertaking suggests that he himself was responsible for the conception of the entire ensemble, for it is difficult to imagine anyone but the painter daring to conceive at this date in Venice a single painted panel measuring nearly twenty-three feet in height; the precise adaptation of the altarpiece to its architectural site further attests to the highest quality of intelligence and imagination, architectural as well as pictorial, on the part of its creator.

Santa Maria Gloriosa dei Frari is a fourteenth-century construction, and the painting on the high altar had to be seen against the conflicting activity of its Gothic apse and the dappled light of its window tracery and stained glass. Titian fully accepted the challenge of the site. Moreover, he further accommodated his design to the viewing axis of the church: the altar is seen initially through the open arch of the fifteenth-century choir screen (fig. 17), the gilded foliate frame of which is repeated in that bordering Titian's panel; deliberately associated in a single vision, altar and screen create a scenographic effect that unifies the spatial experience of the entire church.

The composition of the *"Assunta"* is calculated to correspond to the major divisions of the apse elevation and, at the same time, to counter the visual interference of its small-scale patterns. Completing the upper semicircle of the arched frame by a mirroring chain of angels and clouds, Titian divided the field into two large geometric shapes: a heavenly circle above—containing the ascending Virgin, the receiving God the Father, and the angelic host—and, below, the practically rectangular block of amazed and worshiping apostles. The large-scale visual order of this binary structure, characterized by clarity and an apparent simplicity, succeeds in dominating the apsidal space of the Frari—as Titian had insisted it would to the apprehensive monks, who had been worried by the very magnitude of the forms. Within the painting itself, however, an intricate system of exchanges operates subtly to weave a dynamic internal order. The clear silhouette of the apostles, for example, binds them into a cohesive unity, and yet the rhythm of that silhouette, its measured accents and intervals, functions to create an openness, suggesting a spaciousness within the group of figures and relating them to the vision above. And beyond these qualities of design, color plays a major role in relating the two zones of the composition. The triangle of reds distributed over the field, in the dress of the Virgin and the robes of the two apostles in the foreground, imposes a unifying chromatic pattern upon the separate areas.

Color functions on a symbolic as well as a visual level, reinforcing the distinction between the upper and lower sections. Beneath the lower edge of the heavenly circle, behind the apostles, the sky is a natural blue, while within the circle the Virgin and God are set against a background of gold; earth and heaven, two very different realms, are illumined by two very different lights, natural and divine. The golden dome of heaven, a venerable architectural symbol that finds especially eloquent expression in the altarpieces of Giovanni Bellini (fig. 2), sheds its metaphoric status and assumes its original supernatural form. The geometric structure of Titian's composition—like Raphael's in the *Disputa* (Stanza della Segnatura, Vatican, Rome) or *The Madonna di Foligno* (Musei Vaticani, Rome)—unequivocally acquires a higher significance, distinguishing the

CONTINUED ON THE FOLLOWING PAGE

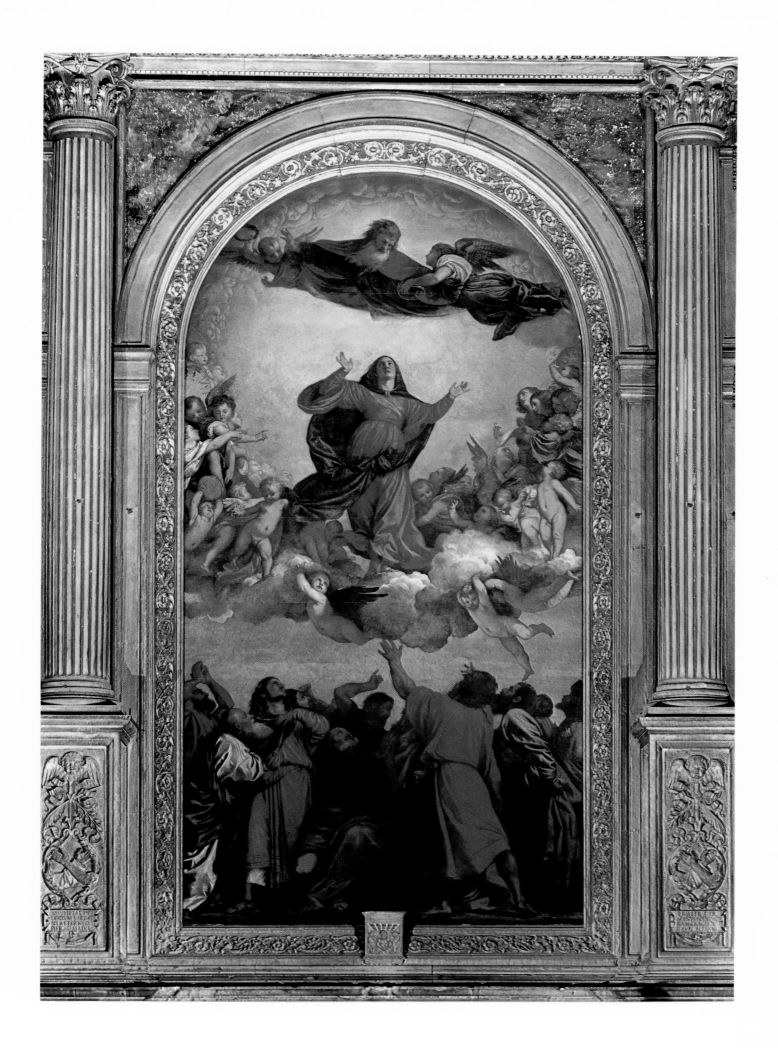

THE ASSUMPTION AND CORONATION OF THE VIRGIN ("L'ASSUNTA"), detail

divinity of the perfect circle from the mundanity of the lower rectangle.

Titian's picture, of course, is hardly an abstract geometric demonstration of theological doctrine; rather, he continues his discovery of the pictorial and dramatic possibilities latent in inherited iconographic traditions. Whereas the masters of an earlier generation as well as his own contemporaries tended to represent the Virgin's ascension with a certain iconic stasis, Titian has endowed the theme with dramatic vitality. No longer merely recalled in a fixed image, the event seems actually to occur before our eyes; the Virgin is now a true protagonist, rather than a symbol, moving with dignified energy and gravity, and her miraculous ascent heavenward evokes a variety of responses from the apostolic chorus on earth. And we, in turn, are invited to identify with those actors, convinced by their naturalism and moved by their gestures—above all by that of the red-robed apostle seen from behind, reaching into space and at the same time up to heaven—to become witnesses ourselves to the miracle.

The special glow illuminating this monumental altarpiece depends in part on the fact that it is painted on panel; the hard, smooth surface supports the clarity of formal contour with particular precision, and the colors themselves maintain a special translucency. Capitalizing on these effects, Titian distributed his lighting over the composition, using it as an organizing motif and to emphasize the palpability of form; picking out the highlights of the massive clouds or a knee or shoulder of an angel, this light at once individuates forms while bathing them in a glowing unity.

Although many preparatory drawings, sketches for the full composition as well as studies of individual figures, must have preceded the painting of the "Assunta," only a single autograph study, for Saint Peter (fig. 63), has survived. In this drawing, executed in black-and-white chalk on blue paper, Titian sought the broad patterns of light and dark that inform the figure on the panel: the saint emerges from the surrounding shadow by virtue of the highlights of his beard and drapery.

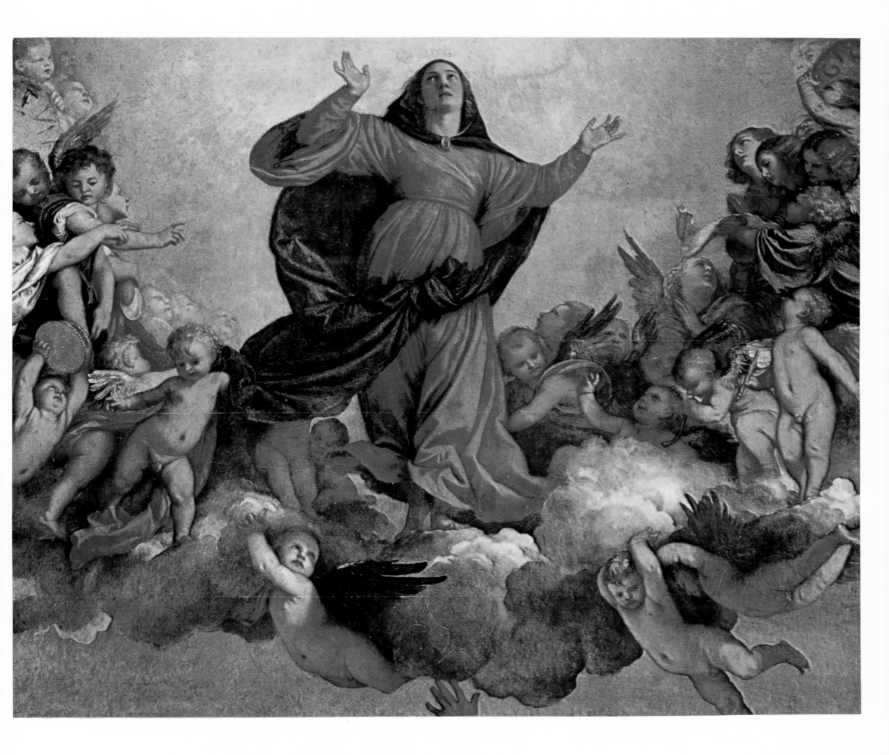

THE MADONNA DI CA' PESARO

1519–26

Oil on canvas, 15' 11" × 8' 10"

Santa Maria Gloriosa dei Frari, Venice

Titian received his first payment for the altarpiece of the Pesaro family on April 28, 1519; the painting was evidently completed by May 27, 1526, when final payment was made. Jacopo Pesaro, shown here kneeling in prayer before the enthroned Virgin and Child and Saint Peter, had earlier commissioned a smaller votive picture from Titian (Koninklijk Museum voor Schone Kunsten, Antwerp). In the painting for the family altar in the Frari the donor is again depicted in his role as Bishop of Paphos and commander of the apostolic fleet that had defeated the Turks at Santa Maura in 1502; the warrior behind him, leading Turkish prisoners, carries a victorious banner emblazoned with the Borgia coat of arms, an allusion to Pope Alexander VI, and the emblem of the Pesaro.

The asymmetry of the composition, one of Titian's most striking inventions and a response to the exigencies of the particular site, transforms the traditional *sacra conversazione* into an intricately dynamic situation. Through their carefully calculated gestures and glances, descending from the double apex of the Madonna and Child—united by her veil—the figures participate in a cohesive and closed system of relationships while, at the same time, maintaining their individual identities and freedom of movement. The subtlety of this network of correspondences is epitomized by the gentle eloquence of Saint Francis, his eyes in adoring dialogue with the infant Jesus, his hands exposing his stigmata while presenting—with his companion, Saint Anthony of Padua—the members of the Pesaro family. The dominant profiles of the elder members of this group, which is comprised of several generations of Pesaro, initiate a lateral movement parallel to the picture plane. Slight but significant formal variations in the family portrait add a further dimension to the distinctions of age. The three eldest Pesaro are seen in purest profile, recalling an already archaic portrait formula; such a historical reference may signify that some are in fact deceased. The young man at the extreme right, by contrast, is shown in a less rigid, three-quarter view. And the boy, youngest of all and

strikingly illuminated, looks directly out at us; the most vital member of the group, he establishes immediate contact with the real world, inviting us into the pious realm of his family's religious privilege. In stages, then, through the individual Pesaro—from the group at the right to Jacopo Pesaro opposite, by way of the interceding saints—we, too, gain access to the enthroned Madonna and Child. The image thus serves both its donors and the worshipers before their altar.

That altar, dedicated to the Immaculate Conception, is set against a wall of the Frari visible along the nave of the church, so that the picture before it must function both as wall painting and as altarpiece. Titian, who had already worked with this viewing axis in designing the *"Assunta"* (colorplates 12, 13, and fig. 17) for the high altar, created a composition that would accommodate itself both to this diagonal view and to the worshiper's direct confrontation with it, immediately before the altar; the painting thus operates on two levels: as votive picture and as altarpiece.

Titian's particular concern with the spatial construction of the picture led him to explore a variety of solutions before he arrived at the final setting with its two massive columns—whose dramatic effect has been undermined by later repainting and "correction." Among his original ideas for this space was a highly imaginative, asymmetrical variation of an earlier type of Venetian altarpiece (fig. 2). The cloud-borne angels carrying the symbol of salvation were to have floated into a vaulted chamber (fig. 18). Titian had conceived a barrel vault, springing from the wall behind the throne; in the details of its ornament and its polychrome revetment, the wall itself continued the architectural style of the surrounding frame into the nominal space of the picture. Furthermore, the perspective scheme also acknowledged the diagonal approach to the painting; by locating its vanishing point outside the picture to the left Titian implied that the pictorial space extended that of the Frari itself.

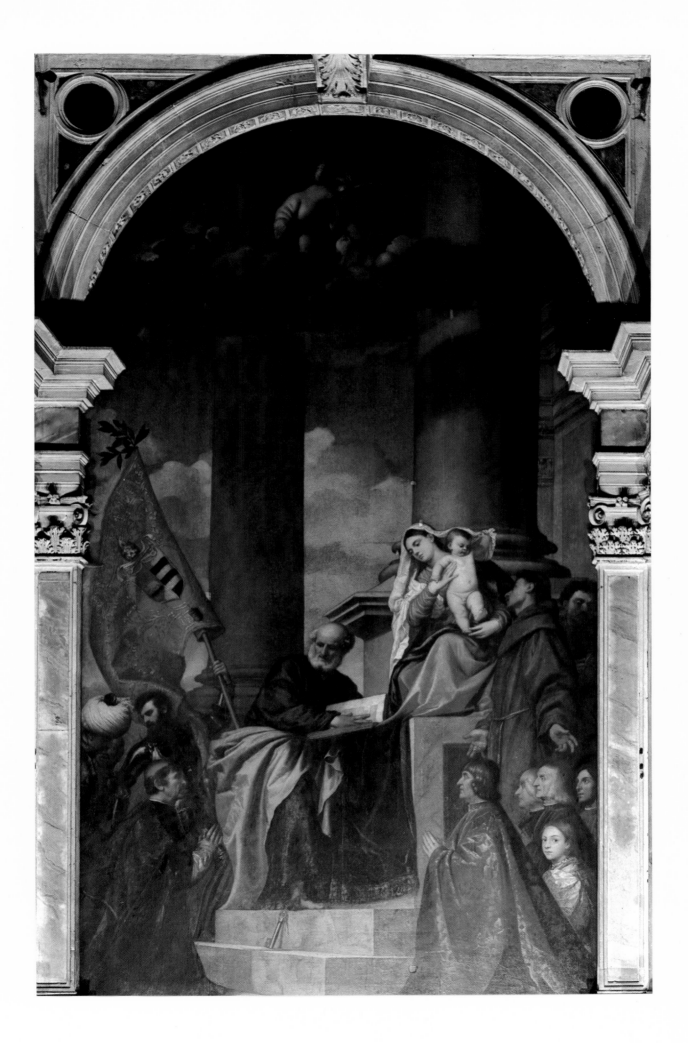

MAN WITH A GLOVE

c. 1520–22

Oil on canvas, 39 3/8 × 35"

Signed (lower right): TICIANVS F.

Musée du Louvre, Paris

In his portraits of the 1520s Titian began to modify the basic models of traditional portraiture, abandoning the parapet and lengthening the format of the image to include more of the figure—a change in style to be noted throughout Italy at this time. Rather than the parapet or other supporting architecture or furniture, the organization of the design, as in this portrait of an unidentified subject, depends on an ever more deliberated use of light and dark; structure derives from the precise distribution of crisply distinguished areas of illumination within a generally dark field. And as the light becomes more focused, it becomes more searching, picking out only the head, with its supporting taper of white shirt, and the hands. Titian concentrates now on the expressive essentials. The full import of the portrait is carried by the face of the sitter, keenly alert yet averted, and by his hands, articulated in the varied substances of flesh and leather; at once distancing and inviting, the hands serve to define the frontal plane, assuming the function of the discarded parapet.

The full figure, dressed casually with fashionable understatement, is partially lost in the shadow, but nonetheless asserts its presence; it fills the field, and the folds of the garment record the subtle contrapposto of the pose.

Limiting his palette to a very few basic colors—essentially black, white, red, and variously combined grays and browns—Titian restricts the possibilities of chromatic display, while establishing rules that will allow the full demonstration of his painterly prowess: red necklace against white shirt states a keynote that distills the essential relationship of mouth to face. Against the broad surfaces of most of the field, the articulated brushwork of shirt, collar and cuffs, and gloves assumes special eloquence through the contrasting smaller scale of the strokes and the rapidity and variety of their minute observation.

By such means, in both its large and small dimensions, the picture engages us. Pose and shadow establish a discrete distance between sitter and observer, yet the selective illumination affords us a means of entry, defining substances of direct tactile appeal. Emerging from the surrounding shadows, the figure turns from us, his contours still lost in the gloom, and yet the actuality of his individual features invites us to enter those very shadows, to fill that darkness with our own projections. It is no wonder that Titian's contemporaries thought his portraits more real than life itself, for in regarding them one must indeed live them.

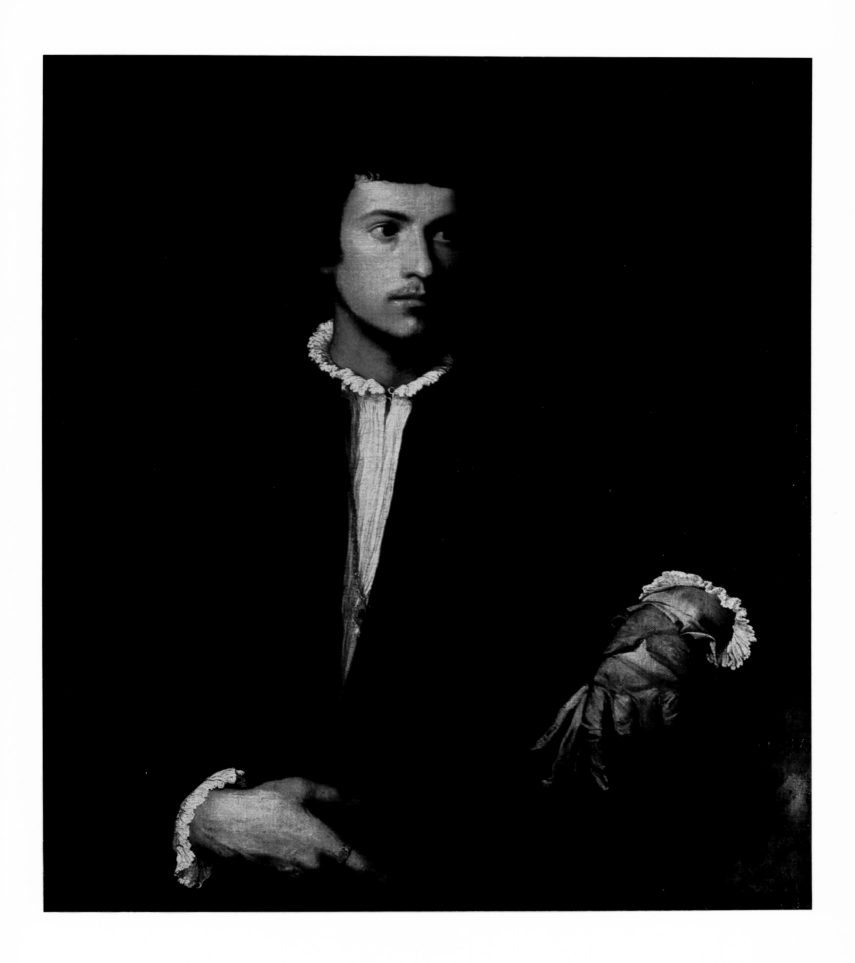

SAINT SEBASTIAN

1520–22

Oil on panel, 67 × 25 1/2"

Signed and dated (on the column drum):

TICIANVS FACIEBAT MDXXII

Santi Nazaro e Celso, Brescia

Saint Sebastian, one of five panels comprising the *Altarpiece of the Resurrection* (fig. 35) commissioned by the papal legate Altobello Averoldo for the Brescian church where it still stands above the high altar, was completed, or nearly so, by 1520. In that year the picture was seen in Titian's studio by Jacopo Tebaldi, Venetian agent for Alfonso d'Este of Ferrara, who was so impressed by the image that he suggested that his master try to acquire it. Tebaldi responded to the figure with an almost naïve directness and, despite his disclaimer of expertise in these matters, with a certain sensitivity: "the whole frame [of the figure] writhes in such a way," he wrote, "as to display almost all of the back. In all parts of the person there is evidence of suffering, and all from one arrow that sticks in the middle of the body. I am not a judge, because I do not understand drawing, but looking at the limbs and muscles the figure seems to me to be as natural as a corpse." The Ferrarese agent thus isolated two of the fundamental components of the work: the naturalism of the body and the artifice of its pose. Out of the dialectic between these terms arises the peculiar power of Titian's creation.

Accepting the rather conservative format of the polyptych, Titian turned its individual panels into fields in which to demonstrate his skill—particularly within the context of the *paragone* of the arts of painting and sculpture. Just as the resurrected Christ of the central panel derives from the classical model of the *Laocoön* (fig. 34), the figure of Saint Sebastian seems a response to a contemporary "classic"— Michelangelo's *Bound Slave* (fig. 37), executed for the tomb of Pope Julius II. Here, too, Titian asserted the power of painting to transform stone into flesh. Tebaldi's specific observation concerning the display of the back recalls the celebrated challenge of the *paragone* and testifies to the success with which Titian's brush answered the sculptors' criticism that painting could represent only one view of the body in a given image.

Two sheets of drawings (figs. 64, 65) record Titian's search for a solution to the figure of the saint, for the progressive refinement of pose that would combine the artificiality of the mannered *figura serpentinata* with the vital ponderation of nature. Indeed, the second of these preparatory studies, in its combination of vigorous penmanship— adding force to the substance of the body—and sinuosity of pose, already suggests the qualities that will distinguish the finished painting.

Within the overall structure of the polyptych, the naked Sebastian, powerful yet bowed, relates directly to the triumphant figure of Christ in the central panel, whose gesture actually appears to address the martyr. The middle-ground scene, tucked under the extended knee of the saint, represents Roch (colorplate 4), another plague saint, being cured by an angel. Roch is almost lost in shadow, but the angel is brightly illuminated and in its radiance corresponds to the suffering Sebastian in the foreground. Through an emphasis on mortal agony and miraculous healing, this single panel epitomizes the major themes of the entire altarpiece—triumph and salvation.

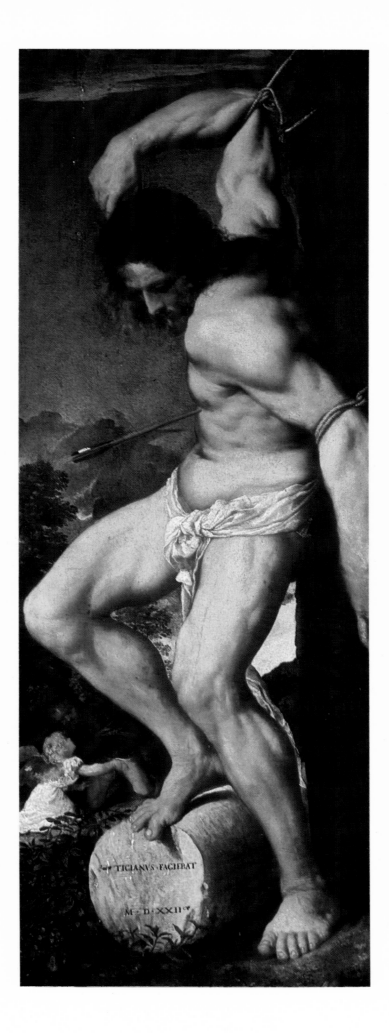

THE WORSHIP OF VENUS
("CUPIDS")

1518–19

Oil on canvas, 67 3/4 × 68 7/8″

Signed (along the edge of the white drapery, lower center):

Ticianus. F

Museo del Prado, Madrid

In 1513 Alfonso d'Este, Duke of Ferrara, initiated a series of commissions that would, in the course of the following decade, turn his *camerino*, or small studio, in the castle at Ferrara into one of the most remarkable rooms of the Renaissance. It would be decorated with canvases by Giovanni Bellini, by his court painter Dosso Dossi, and, above all, with three pictures by Titian. Bellini's *Feast of the Gods* (fig. 21) was completed in 1514 (to be revised later by Titian) and Dosso's *Bacchanal* (National Gallery, London) probably shortly thereafter; both paintings represent episodes from Ovid's *Fasti*. By 1516 Alfonso was negotiating with Raphael and the next year with Fra Bartolommeo to continue this cycle of mythological celebrations. The latter artist was evidently asked to paint a *Worship of Venus*, but he died in October of 1517; the commission then passed to Titian, who was also given a preparatory drawing left by Fra Bartolommeo. In April of 1518 Titian acknowledged receipt of canvas and stretcher, and in October of the next year he shipped the nearly finished picture to Ferrara, where he would bring it to completion *in situ*.

The subject is taken from the *Imagines* of the elder Philostratus, a series of *ekphrases*, or rhetorical descriptions, of ancient paintings purportedly in a Greek villa outside of Naples. The task of the modern artist was to recreate, in effect, lost paintings of antiquity known only through the descriptions of a second-century Sophist. Philostratus' text was deliberately evocative, offering interpretation together with description, and inviting the reader to participate fully in the image. *The Worship of Venus* is based on a painting called *"Cupids"* (*Imagines*, i.6), the description of which opens: "See, Cupids are gathering apples. . . . Do you catch aught of the fragrance hovering over the garden, or are your senses dull? But

listen carefully; for along with my description of the garden the fragrance of the apples will come to you.

"Here run straight rows of trees with space left free between them to walk in, and tender grass borders the paths. . . . On the ends of the branches apples golden and red and yellow invite the whole swarm of Cupids to harvest them. . . . But the Cupids need no ladders. . . , for aloft they fly even to where the apples hang."

Delighting in the detail of the description, Titian remained quite faithful to the text, catching its spirit of playfulness and humor as he realized the little dramatic activities of the Cupids: "Not to speak of the Cupids that are dancing or running about or sleeping, or how they enjoy eating the apples, let us see what is the meaning of these others. For here are four of them, the most beautiful of all, withdrawn from the rest; two of them are throwing an apple back and forth, and the second pair are engaged in archery, one shooting at his companion and the latter shooting back. Nor is there any trace of hostility in their faces; rather they offer their breasts to each other, in order that the missiles may pierce them there, no doubt."

At the right of the picture, near "the overarching rock from beneath which springs water of the deepest blue, fresh and good to drink, which is distributed in channels to irrigate the apple trees," is the shrine of Venus, established by the nymphs; to Venus they offer such gifts as the mirror held aloft in thanks "because she has made them mothers of Cupids and therefore blest in their children."

In his letter of April 1, 1518, to the duke, Titian wrote, "I am sure that Your Illustrious Signoria could not have thought of a subject more grateful or more after my own heart than this one."

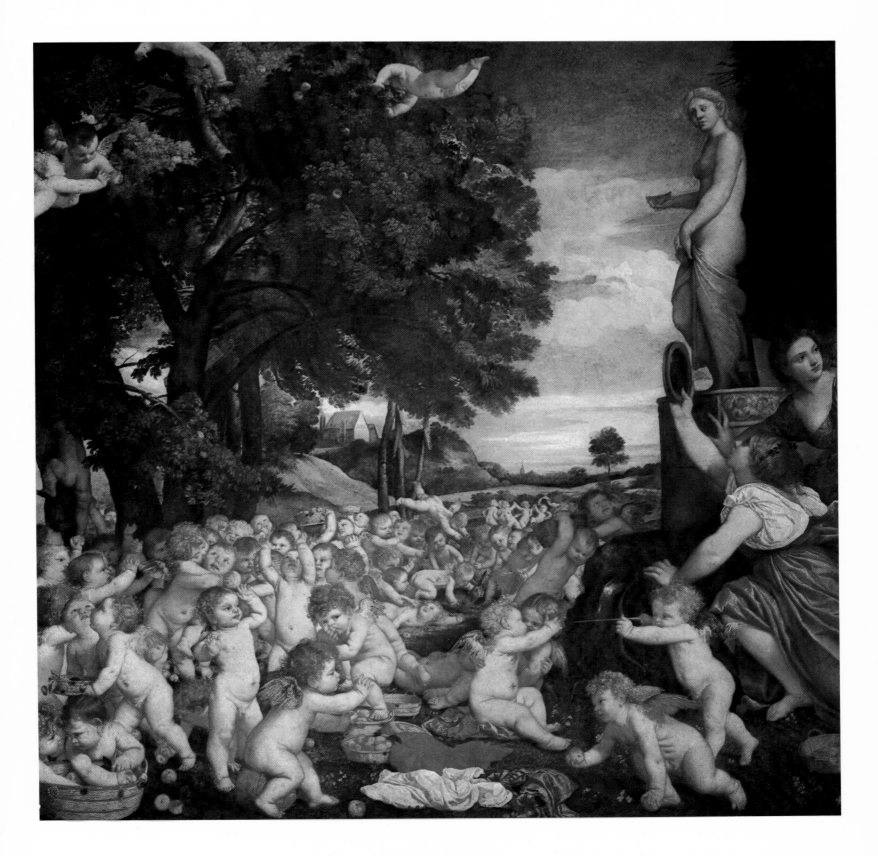

BACCHUS AND ARIADNE

1520–23

Oil on canvas, 69 × 75″

Signed (on the urn, lower left): TICIANVS F.

National Gallery, London

For the decorative cycle of Alfonso d'Este's *camerino* Raphael had been asked to paint a *Triumph of Bacchus* but the picture was never delivered, and when the artist died in 1520 the commission was apparently immediately transferred to Titian. He worked on his design in Venice, and, after the usual procrastination, the nearly finished canvas was sent to Ferrara in January of 1523; again, the painter was to complete the picture on the spot.

Titian's composition represents the encounter of Bacchus—returning triumphant from India—and Ariadne, on the shores of the island of Naxos, where the girl had been abandoned by Theseus. Here, too, classical texts served the painter as the basis of the subject, especially Catullus' *Carmina* (lxiv. 257–65) and Ovid's *Ars Amatoria* (i. 525–64). The passage in Catullus, an extended *ekphrasis* describing scenes embroidered on the coverlet of the marriage bed of Peleus and Thetis, establishes the distraught situation of Ariadne:

> Here Ariadne on the surf-booming shore of Naxos gazes at Theseus and his shipmates making off and, still incredulous of what she sees, feels love, a wild beast, tear at her: no wonder, for, having woken from deluding sleep, she finds herself abandoned pitiably on the bare sands, while he, oblivious, batters the sea with oars, leaving behind meaningless promises for the gale to play with. There on the seaweed fringe the weeping princess stares seaward like a maenad carved in stone, while her heart heaves and swells across the distance. Gone from her yellow hair the fine-woven bonnet, thrown off the light blouse and the delicate scarf that bound her milk-white breasts—her garments fallen loose at her feet and lapped by the salt tide. For all she cares now bonnet and blouse and scarf can float away. . . .

The actual meeting is the subject of another scene:

In another part of the tapestry youthful Bacchus was wandering with the rout of satyrs and Nysa-born Sileni, seeking thee, Ariadne, and fired with thy love. . . . who then, busy here and there, were raging with frenzied mind, while "Evoe" they cried tumultuously, "Evoe" shaking their heads. Some of them were waving thyrsi with shrouded points, some tossing about the limbs of a mangled steer, some girding themselves with writhing serpents: some bearing in solemn procession dark mysteries enclosed in caskets, mysteries which the profane desire in vain to hear. Others beat timbrels with uplifted hands, or raised clear clashings with cymbals of rounded bronze: many blew horns with harsh-sounding drone, and the barbarian pipe shrilled with dreadful din.

Ovid, too, enjoys the tumult of the bacchanals, offering as well the additional detail of drunken old Silenus, who "scarce sits his crook-backed ass." But it is only in Ovid that Titian found a description of the dramatic confrontation between the lamenting maid and the exuberant god and a reference to the metamorphosis effected by divine love:

> She shuddered, as when dry stalks are shaken by the wind, as when the light rush trembles in the watery marsh. "Lo, here am I," said the god to her, "a more faithful lover; have no fear, Cnossian maid, thou shalt be the spouse of Bacchus. For thy gift take the sky; as a star in the sky thou shalt be gazed at; the Cretan Crown shall often guide the doubtful bark!" He spoke, and lest she fear the tigers leapt down from the chariot; the sand gave place to his alighting foot; and clasping her to his bosom (for she had no strength to fight) he bore her away; easy it is for a god to be all-

CONTINUED ON THE FOLLOWING PAGE

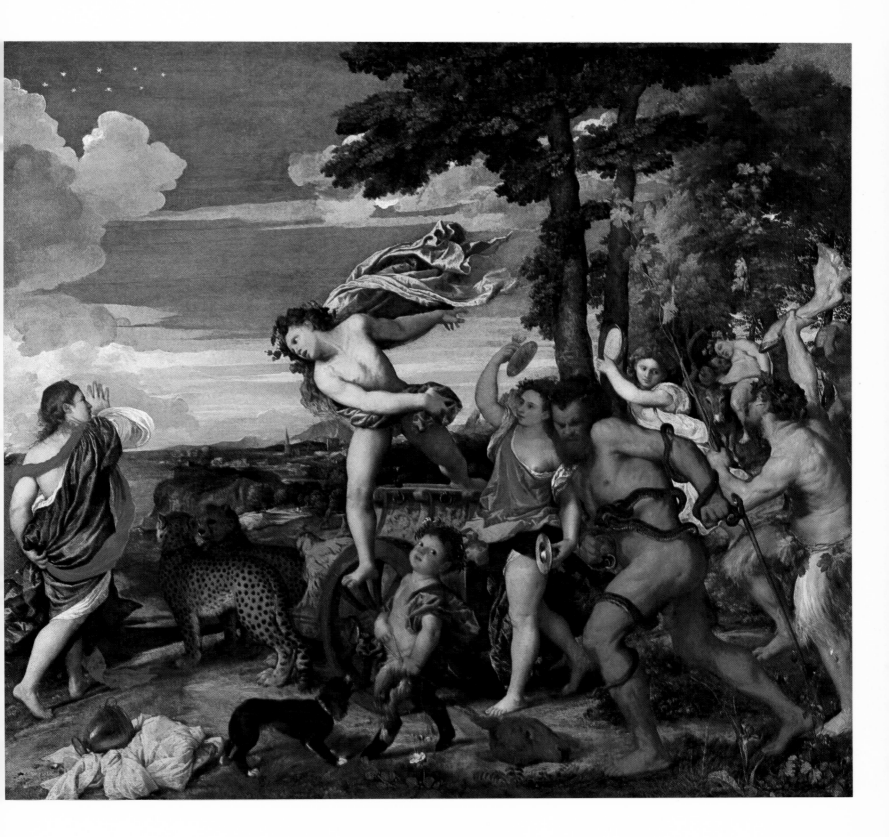

BACCHUS AND ARIADNE, detail

powerful. Some chant "Hail, Hymenaeus!" some shout "Euhoe!" to the Euhian; so do the bride and the god meet on the sacred couch.

With these texts as source material and inspiration, Titian retold the story in paint, selecting particular details such as Ariadne's disheveled state and the leap of Bacchus as pivotal motives for the pictorial construction of his narration. The triumphant Bacchic procession sweeps in from the right and, turning then into space, comes to rest before the grieving Ariadne. His panther-drawn chariot at a halt, Bacchus himself continues the forward momentum, bounding from the car toward the girl, but with a turn that already softens the thrust. Linked most firmly by their glances, these two figures respond to one another in a choreography of answering gestures, and their movements in turn define a temporal situation at once momentary and eternal. Still reaching seaward toward the disappearing sail of Theseus' ship, Ariadne looks over her shoulder to her future husband; the major coordinates of her graceful contrapposto thus extend in two directions. Yet the figure of Ariadne itself is circumscribed within a rather contained silhouette; the draperies swirl about the stable vertical axis of her body, their billowing profiles restated in the cloud above her. The clouds themselves reiterate the encounter taking place below, a heavenly reinforcement of the earthly drama: the long horizontal stratus articulates the narrative line of Bacchus' movement and meets the solid cumulonimbus above Ariadne. The culmination of the rising sequence of forms at the left is the Cnossian crown of stars, symbolizing the imminent fate of Ariadne, the promised gift of Bacchus, the immortality attained through the love of the god.

Evoked in the lines of Keats's "Sleep and Poetry" ("the swift bound/Of Bacchus from his chariot, when his eye/ Made Ariadne's cheek look blushingly"), Titian's *Bacchus and Ariadne* is, in every sense, an encounter, a meeting of forces both physical and psychological. On a literal level the narrative resolves all conflict in the symbolic constellation, but it is above all the composition itself that defines the conflicting terms of this dialectic and, by its very structure, achieves their final resolution in the synthesis of a harmonic unity.

THE BACCHANAL
OF THE ANDRIANS

1523–24

Oil on canvas, 68 7/8 × 76"

Signed (along the edge of the woman's blouse, lower center):

Ticianus. F

Museo del Prado, Madrid

"The stream of wine which is on the island of Andros, and the Andrians who have become drunken from the river, are the subject of this painting. For by act of Dionysus the earth of the Andrians is so charged with wine that it bursts forth and sends up for them a river." From this description in Philostratus' *Imagines* (i.25) came the third of Titian's paintings for Alfonso d'Este's *camerino*. Selecting among the details of the ancient *ekphrasis*, Titian re-created the image of the peculiarly blessed island and its inhabitants, "the men, crowned with ivy and bryony . . . singing to their wives and children, some dancing on either bank, some reclining." On the hill in the right middle ground "the river [god] lies on a couch of grape-clusters, pouring out its stream." And the Andrians have guests on this occasion: "Dionysus also sails to the revels of Andros and, his ship now moored in the harbor, he leads a mixed throng of Satyrs and Bacchantes and all the Sileni." Deities and mortals, respectively distinguished by their nudity and clothing, mingle and share the benefits of the river. With a grand gesture Bacchus himself pours the wine, while one of the revelers raises against the bright sky a crystal pitcher of the divine red liquid, as if for our inspection. Celebrating their unique stream, the Andrians sing "that this river alone is not disturbed by the feet of cattle or of horses, but is a draught drawn for men alone. This is what you should imagine you hear and what some of them really are singing, though their voices are thick with wine."

Music—and its physical embodiment and reflection, dance—is indeed the organizing principle of Titian's picture, ordering and ennobling the energies of drunken revelry. For the song of the Andrians a fitting text, in French, was chosen; it is legible on the sheet of music in the foreground: *Qui boyt et ne reboyt Il ne scet que boyre soit* ("Who drinks and does not drink again knows not what drinking is"). These words are appropriately set as a canon, the music attributed to the Flemish composer Adrian Willaert, who was at the Ferrarese court at the time. A cyclical pattern— implicit in the rhythm and meaning of the inscribed text, fundamental to the imitative structure of the music, and, on a more general level, inherent in the significance of the seasonal cycle of the vine—informs the action of the painting: dancing, singing, drinking, urinating . . . to begin again, *da capo*.

Beyond the sensual framing device of the classically inspired sleeping nymph, beautiful victim of the Bacchic gift, the Andrians whirl through the paces of their dance, frenzied yet controlled. The rhythms of the choreography, participating in the chromatic clarity that bathes the entire scene, lend an element of grace to the more practical motions of the visitors at the left. Thus, the entire composition of varied actions becomes a fully orchestrated unity, absorbing totally within its structure the blatant quotation from Michelangelo's cartoon of *The Battle of Cascina* (fig. 28)—the reclining male nude in the center of the group.

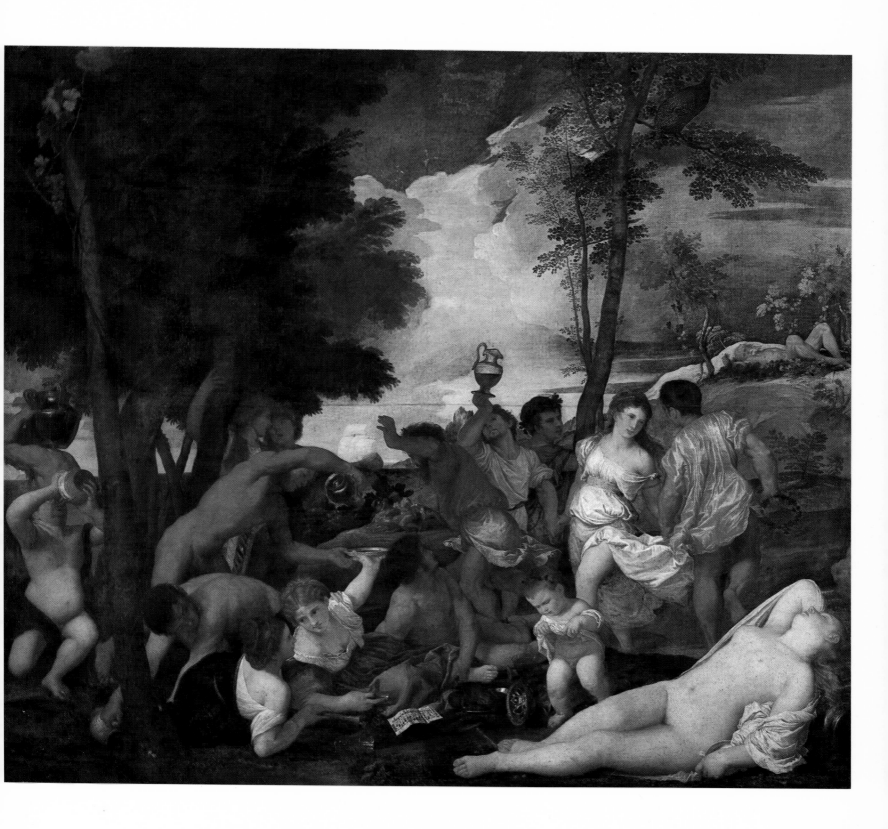

THE ENTOMBMENT

c. 1525–30

Oil on canvas, 58 1/4 × 80 3/4"

Musée du Louvre, Paris

Probably executed for Federico Gonzaga of Mantua, this moving image is a perfect demonstration of the classical ideals of High Renaissance dramatic composition. Titian has set the theme of the burial of Christ in an appropriately pathetic mode, and within the basic unity of the composition he has sought a subtle variety of expression. Ultimately inspired by the death-scene reliefs on ancient sarcophagi, the general compositional scheme—distinguishing the dominant and active masculine group bearing the body and, to one side, the reactive, lamenting women—may recall Mantegna's engraving, and Raphael's famous painting of the same subject of 1507; but what especially marks the dramatic manner of Titian is the insistent realism, which complicates the controlled formulas of classical mourning by endowing the ideal figural types with new human substance.

The protagonists themselves, highly individualized, are thoroughly unified by the pathos of their shared experience, the central focus of which is the body of Christ; only John looks back at the two Marys, fulfilling by his glance the filial relationship charged by Christ on the cross and, by thus linking the two groups, completing the fully unified cycle of the design. The tragic formula that Titian had developed in the early Saint Mark altarpiece (colorplate 4)

and for *The Jealous Husband* (fig. 13) he applied here with still greater profundity: Christ's head and torso are hidden in shadow, and, as his body turns in space we are invited to follow into those depths, to encounter, partly with our imagination, the face of the Redeemer, bloodied by the crown of thorns displayed below. Precisely this sort of direct invitation to involvement adds that dimension of mimetic conviction to the controlled structure of Titian's classicism, as does the master's search for textural substance and variety in areas of flesh and drapery, sky and foliage, stone and earth.

The pale, lifeless flesh of the lower part of Christ's body, further drained of color by the white winding-sheet, contrasts with the vigorous limbs supporting him. His wounds are clearly displayed in understated fashion—the opening in his side, for example, is quietly silhouetted against the glowing horizon. The figural groups, set before an asymmetrical landscape background, fill and thus dominate the pictorial field. Our immediate involvement is naturally with these mourners, whose distraught state finds reflection in the darkening clouds. They move slowly and with gravity, and this very ponderation at once mutes and, by compression, intensifies their pathos.

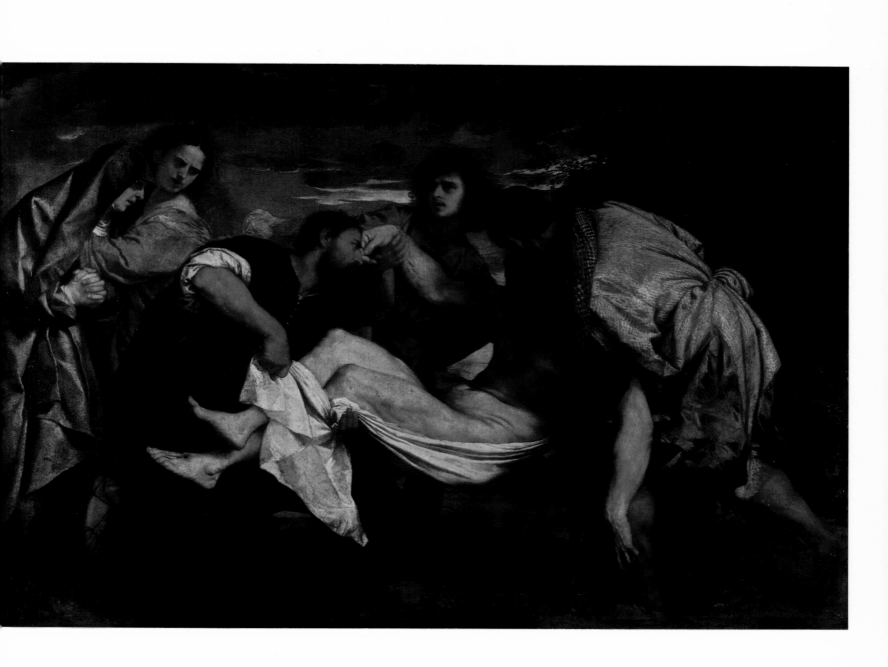

MADONNA AND CHILD WITH SAINT JOHN THE BAPTIST AND SAINT CATHERINE

c. 1530

Oil on canvas, 39 5/8 × 56"

National Gallery, London

Returning to a theme developed by Giovanni Bellini and with the experience of the Peter Martyr altarpiece (fig. 20) just behind him, Titian continued to explore the formal and expressive possibilities of landscape, expanding its active function as protagonist. In this painting, which may have come from the collection of Alfonso d'Este at Ferrara, the landscape initially asserts its importance by the sheer amount of surface it occupies. Although the compactly composed figure group, set in the immediate foreground, dominates the composition, it reaches out, through gesture and color, to participate in a highly deliberated fashion with its surroundings. Mary, the presiding figure of the group, draws the young Baptist into the central scene, the mystic and here extremely intimate marriage of Saint Catherine to the Christ Child. The intense blue of the Virgin's dress moves out into the distant mountain range—although modern cleaning may have deprived these blues of their modifying glazes—and the rays of heavenly light behind her modify the yellows of Catherine's gown.

Chromatic structure of this kind becomes increasingly important in Titian's art about this time, and it was especially the painting of landscape that encouraged a looser brushwork of more open and hence potentially more variable touches; through this breaking up of surfaces the master found a means toward a more subtle and complex mode of pictorial construction. At the same time he discovered a greater resonance in landscape, not only in its formal possibilities but in its expressive potential as well. Whereas his earlier landscape settings were rich with rhetorical significance, here landscape is invested with a still

more precise eloquence, a suppleness of expression commensurate with the quiet profundity of the figures.

Perhaps the crucial element, or experience, in this controlled exploration is light, which, again through the growing sophistication of Titian's brushwork, assumes an increasingly subtle function. And for this Titian found inspiration in the inherited iconographic traditions within which he was working. The metaphorical image of Mary as a cloud containing the divine light—an image Titian had earlier realized in his *Annunciation* for the Malchiostro Chapel in the Cathedral of Treviso—is brought to visual life here in the motif of light breaking through the clouds behind the Virgin, pouring down upon her. This natural symbol of the Incarnation is made all the more poignant by the axial relationship to the vertically upraised arm of the Child.

The equation of sky with heaven receives further statement in the background scene to the right: the appearance of the angel to the shepherds. Alluding to the Nativity, this annunciation to the shepherds affirms the symbolic significance of the heavenly illumination as the birth of the *Sol splendidissimus*, the most brilliant sun. Although Saint John, Saint Catherine, and the shepherds belong to different historical moments in the life and afterlife of Christ, Titian has achieved an apparently natural iconographic unity by means of the landscape, which becomes not only the unifying setting for these figures and situations but, in a larger sense, both symbol of and commentary on the presence of the divine in this world.

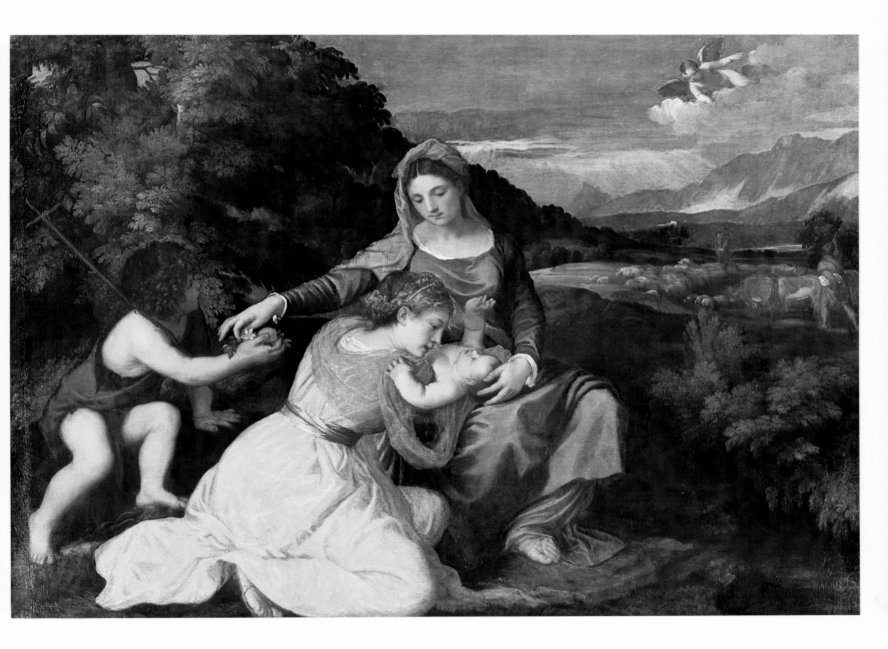

COLORPLATE 23

SAINT MARY MAGDALEN
IN PENITENCE

c. 1530–35

Oil on panel, 33 × 27 1/8"

Signed (on the ointment jar, lower left): TITIANVS

Palazzo Pitti, Florence

For fairly obvious reasons, this conception of the penitent Magdalen proved to be one of Titian's most popular inventions; many versions by the master himself—as well as studio replicas—are known, and date from diverse moments in Titian's career. The example in the Palazzo Pitti, the earliest extant, comes from the collection of the duke of Urbino. The original idea, however, may have been occasioned in 1531 by a commission from Federico Gonzaga, who presented the now unidentifiable painting to Vittoria Colonna, Marchioness of Pescara and close friend of Michelangelo. The duke of Mantua referred to the image as of a "fair woman, as tearful as possible," and in a letter of April 14, 1531, Titian describes the subject as having her hand to her breast and appealing to heaven for grace. Referring to a later version of the theme, executed for Philip II, Vasari writes with a certain relish of the Magdalen seen half-length, "disheveled, that is, with her hair falling about her shoulders and throat and over her breast; while she, lifting her head and fixing her gaze heavenward, exhibits her penitence in the redness of her eyes and the lamenting tears shed for her sins. The picture thus powerfully moves the beholder, and, what is more, although very beautiful, it moves not to lust but to compassion."

The sensuality of the conception is matched by the richness of Titian's execution. The picture in Florence enjoys that special depth and clarity of illumination traditionally associated with painting on panel. Its basic note is sounded by the extravagant waves of lush hair covering and revealing the body of the reformed sinner. Indeed, the hair—a standard part of the iconography—evidently afforded Titian the opportunity for a technical challenge upon which he lavished particular care; the hair is not painted over the flesh, but rather is met by it. These golden tresses

mediate the tonal range of the painting, from the warm cream of the flesh to the deep brown of the thinly painted hill in the right background—an array of warmth set off by the cloud-articulated field of deep blue sky in the upper left. While the forms of the Magdalen's body—echoed by her ointment jar in the lower left corner—are revealed through the modesty of her covering gesture as is the physical truth of her sinful past, the trembling passion of her communion with the divine is signified by the rippling patterns of her radiant hair, its febrile motions conveying a state of fervent hope and nervous expectation.

Titian's penitent Magdalen belongs to a special genre that he himself created for his contemporaries: a religious image, overt in the sensuality of its appeal, that at once inspires devotion and sustains delectation. Federico Gonzaga had ordered such an image to present to one of the most deeply religious women of the period, yet he himself only praised the artistry of it. These pictures were not intended as altarpieces, and Vasari's response—his surprise, even, that such beauty could move one to pious tears—is probably typical of the reaction at the time. Although the theme of the repentant prostitute lent itself particularly to such treatment, we must recognize in the fervor of the saint a passionate desire for God: her sensual longing must be read as a metaphor for spiritual yearning. Such existential hierarchies, clearly articulated earlier in the imagery of the sacred and profane Venuses (colorplate 10), were central to the religious imagination of the Renaissance and expanded the range of experiences accessible to painting. Titian's adaptation of the classical *Venus pudica* pose for the shameful Christian sinner added a further cultural reference to the image.

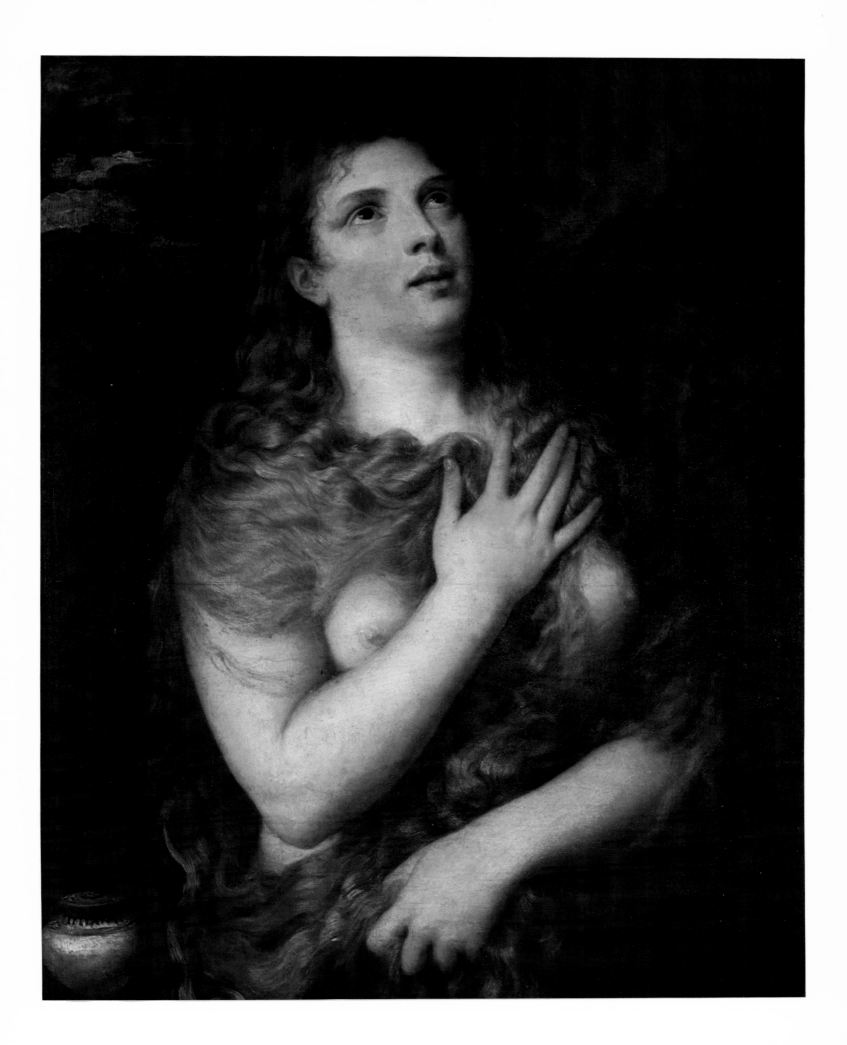

THE PRESENTATION OF THE VIRGIN IN THE TEMPLE

1534–38

Oil on canvas, 11′ × 25′4″

Gallerie dell'Accademia, Venice

This vast canvas still decorates the wall for which it was created in the Sala dell'Albergo of the Scuola Grande di Santa Maria della Carità—which was transformed into the galleries of the Accademia early in the last century. The original commission had been awarded in 1504 to a little-known Venetian painter, Pasqualino Veneto, who died, however, before carrying it out; not until thirty years later did the confraternity return to the project. The prehistory behind Titian's painting may be particularly significant, since it has often been observed that the master here invoked an archaic compositional tradition, that of the narrative tableaux developed in the late fifteenth century (fig. 4). The brothers of the Carità had indeed retained Pasqualino's design and perhaps insisted that certain of its aspects be followed. However that may be, Titian accepted the challenge; working within the context of that conservative heritage, he transformed the inherited material, elevating it to new levels of formal monumentality and expressive subtlety.

The flowing procession of the narrative line, the basic parallelism of the spatial structure, the asymmetry of the backdrop, the mixing of contemporary portraits (of the officers of the *scuola*) and architecture with a historically distant subject—these devices are all characteristic of the art of an older generation, that of Gentile Bellini and Carpaccio. Measured against this background, Titian's variations stand out in high relief: the rhythms of his procession are more dynamic and, within the constraints of the processional format with its insistent regularity, his figures move with energy and variety, distinguishing themselves by the quality of their poses and gestures. Dominating the varied crowd, however, and focusing its diverse energies, is the diminutive figure of Mary ascending the steps of the temple; she is the unifying factor in this disparate assembly, whose members either actually accompany her on this historical occasion (her parents, the attendant virgins, the welcoming priests), bear witness to the event (the sixteenth-century followers of the procession), or, like us, observe the full spectacle from a certain distance (the spectators watching from the palace windows and balcony above).

Throughout the composition Titian has emphasized the plane, and elements of spatial recession have been deliberately muted. The progress of the procession is plotted against the structural coordinates of the architecture which pace the rhythm across the length of the field—a movement measured by the clear modular units of the staircase wall, and again by the smaller rectangles of the diaper masonry in the middle distance. The foreground wall has been fitted with precision to the actual door of the room, its drafted masonry adapted to form the lintel (the door to the left was cut into the painting later, in 1572). Such pictorial artifice, immediately juxtaposing the fictive and the real, also implies an identification of the painted stone wall with the surface of the canvas—and hence with the wall of the *albergo* itself.

Before the painted wall Titian set two forms, an old woman and an antique torso. Because they are so deliberately isolated in an ambiguous zone, they acquire very special status. The old egg seller, in particular, placed below the Virgin and so pointedly looking in the opposite direction, counters the basic flow of the pageant's narrative impulse, while the torso remains hidden in the corner darkness. By their placement outside the space of the event, they represent, with the imaginative concreteness with which Titian endowed abstractions, the worlds of the Old Testament and of Greco-Roman antiquity, the era before Christian grace.

The wall-door relationship is only one of the ways by which Titian adapted his painting to its particular site. The *albergo* receives its light from windows on the wall adjacent to the painting on the left, and that source illuminates the fictive world of the picture as well. The light is picked

CONTINUED ON THE FOLLOWING PAGE

COLORPLATE 25

THE PRESENTATION OF THE
VIRGIN IN THE TEMPLE, detail

up immediately in the brightness of the imposing landscape, but it diminishes toward the right side of the canvas, losing its force in the shadows of the architectural setting of the temple precinct. In that relative darkness a new light stands out: the golden aureole radiating from the Virgin. The comparison between the two lights, natural and divine, is built into the composition itself as it is into the Marian liturgy: "For she is more beautiful than the sun, and above all the order of the stars; being compared with the light, she is found before it. For she is the brightness of eternal light, and the unspotted mirror of God's majesty." Titian took his clue not only from the liturgical texts, but from the *albergo* itself; in the middle of its Quattrocento ceiling is the figure of Christ Pantocrator, himself emitting golden rays, displaying an open book inscribed with the words from John 8:12: *Ego sum lux mundi* ("I am the light of the world"). This, then, is the light the Virgin carries into the temple.

Every element in Titian's *Presentation of the Virgin* contributes to the rich fabric of its meaning, which unfolds as inexorably as the procession. But iconographic complexity receives its unity and conviction from painterly style—indeed, it owes its existence to the powers of the pictorial imagination to explore and realize the visual potential of poetic metaphor. The very site of the mural surface invited a broadening, an opening up of Titian's style. Less objectbound and applied with new freedom, color creates an appropriately larger field effect in this work, and by an overall network of touches and accents the design achieves a chromatic coherence. On a large scale, cool and warm tones, blues and reds, are distributed and varied in an intricate exchange; finding their purest hues in the dense concentrations of costume, they are diffused in expanding areas of patterned marks—in the cloud-broken sky and the pink stones set into the palace wall like the great brushstrokes they in fact are. The emphatic respect for the picture plane, essential to the control of this monumental surface, literally provides the ground for the painting's unified pictorial structure. The execution of *The Presentation of the Virgin*, surely a critical experience for Titian, affords a prelude to the still looser brushwork of the master's later manner.

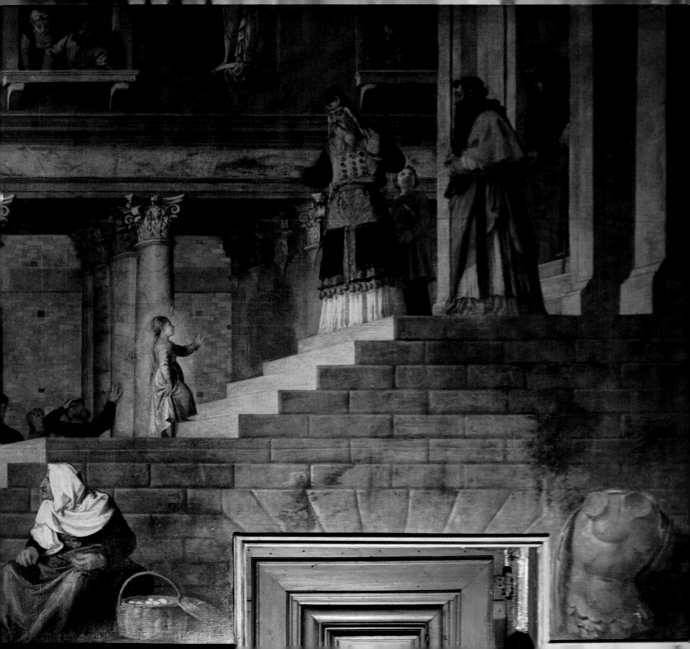

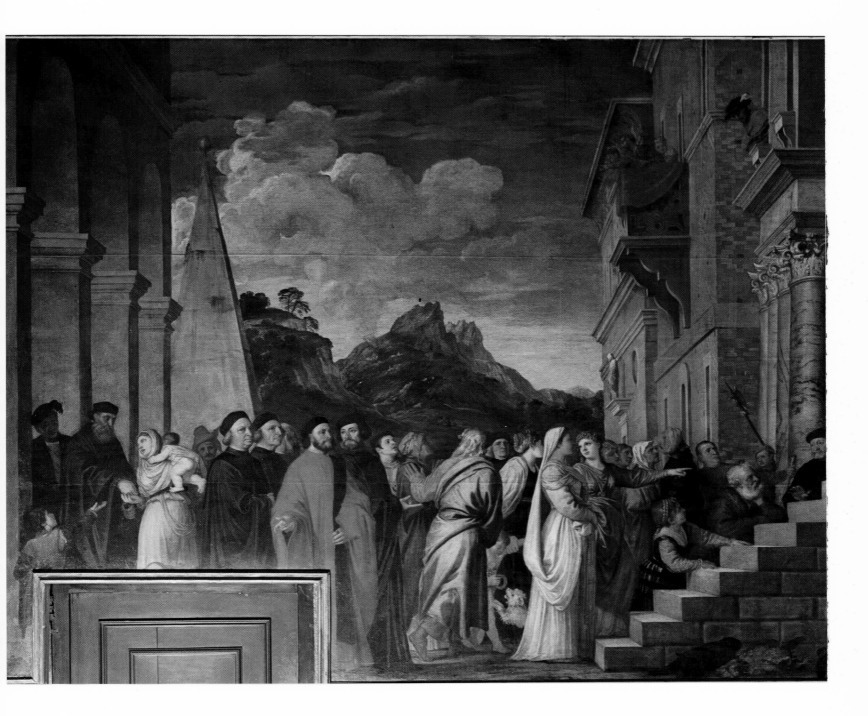

THE PRESENTATION OF THE VIRGIN IN THE TEMPLE, detail

up immediately in the brightness of the imposing landscape, but it diminishes toward the right side of the canvas, losing its force in the shadows of the architectural setting of the temple precinct. In that relative darkness a new light stands out: the golden aureole radiating from the Virgin. The comparison between the two lights, natural and divine, is built into the composition itself as it is into the Marian liturgy: "For she is more beautiful than the sun, and above all the order of the stars; being compared with the light, she is found before it. For she is the brightness of eternal light, and the unspotted mirror of God's majesty." Titian took his clue not only from the liturgical texts, but from the *albergo* itself; in the middle of its Quattrocento ceiling is the figure of Christ Pantocrator, himself emitting golden rays, displaying an open book inscribed with the words from John 8:12: *Ego sum lux mundi* ("I am the light of the world"). This, then, is the light the Virgin carries into the temple.

Every element in Titian's *Presentation of the Virgin* contributes to the rich fabric of its meaning, which unfolds as inexorably as the procession. But iconographic complexity receives its unity and conviction from painterly style—indeed, it owes its existence to the powers of the pictorial imagination to explore and realize the visual potential of poetic metaphor. The very site of the mural surface invited a broadening, an opening up of Titian's style. Less object-bound and applied with new freedom, color creates an appropriately larger field effect in this work, and by an overall network of touches and accents the design achieves a chromatic coherence. On a large scale, cool and warm tones, blues and reds, are distributed and varied in an intricate exchange; finding their purest hues in the dense concentrations of costume, they are diffused in expanding areas of patterned marks—in the cloud-broken sky and the pink stones set into the palace wall like the great brushstrokes they in fact are. The emphatic respect for the picture plane, essential to the control of this monumental surface, literally provides the ground for the painting's unified pictorial structure. The execution of *The Presentation of the Virgin*, surely a critical experience for Titian, affords a prelude to the still looser brushwork of the master's later manner.

COLORPLATE 26

VENUS OF URBINO

1538

Oil on canvas, 47 × 65"

Galleria degli Uffizi, Florence

Toward the beginning of his career Titian had brought to completion Giorgione's unfinished canvas of a nude Venus asleep in a landscape (fig. 12); some twenty-five years later he adapted the central motif of the recumbent nude to a new setting and transformed its meaning by domesticating that pastoral deity. Giorgione's Venus—withdrawn in a private dream of love that we can share, to a degree, only by an effort of the imagination—has been brought indoors; fully awake now and aware of her audience, she displays her charms in a deliberately public proclamation of love. Nudity, in the context of the interior setting and her jeweled adornment, is evidently not her normal state; she is, rather, naked, awaiting the garments that will clothe her.

This goddess clearly celebrates a different set of values, and her function, more social than poetic, is articulated by her surrounding attributes. She holds a bunch of roses, and on the window ledge in the background a myrtle plant, in perpetual bloom, is pointedly silhouetted against the glowing sky. These floral symbols, traditionally associated with Venus, define the very special kind of love she here represents: not merely carnal desire, but the more fruitful passion of licit love; not the quickly sated lust of the body, but the permanent bond of marital affection. The little dog curled up at her feet in contented slumber overtly symbolizes that ideal fidelity.

Adding a naturalistic anecdotal dimension to the sensuous symbolism of the main motif, the enframed background scene of maids at an open *cassone*, or marriage chest, confirms the social significance of the image. Guidobaldo II della Rovere, who was awaiting delivery of the picture to Urbino in 1538, may well have ordered it—some years earlier, to judge by his evident impatience—to celebrate his marriage of 1534.

Refining a favorite type of compositional structure especially important in his works of the 1530s, Titian here further explores a compositional problem to which he would return in later paintings (figs. 44, 45, colorplate 40). The architectural regularity and stability of the setting provides a contrasting backdrop for the organic curves of the female form. The measured coordinates of the architecture, the pavement, and the wall hangings are summarized in the neat bisection of the field by the dark screen, whose vertical edge focuses on the fertile center of the love goddess. Thus divided on a large scale, the field is unified by the distribution of color and by a host of smaller-scale formal correspondences, especially the various floral patterns—on the couch, and the background *cassoni* and tapestries—which derive visually from the cluster of roses and share the virtual size of those flowers although, in reality, they differ in actual dimensions.

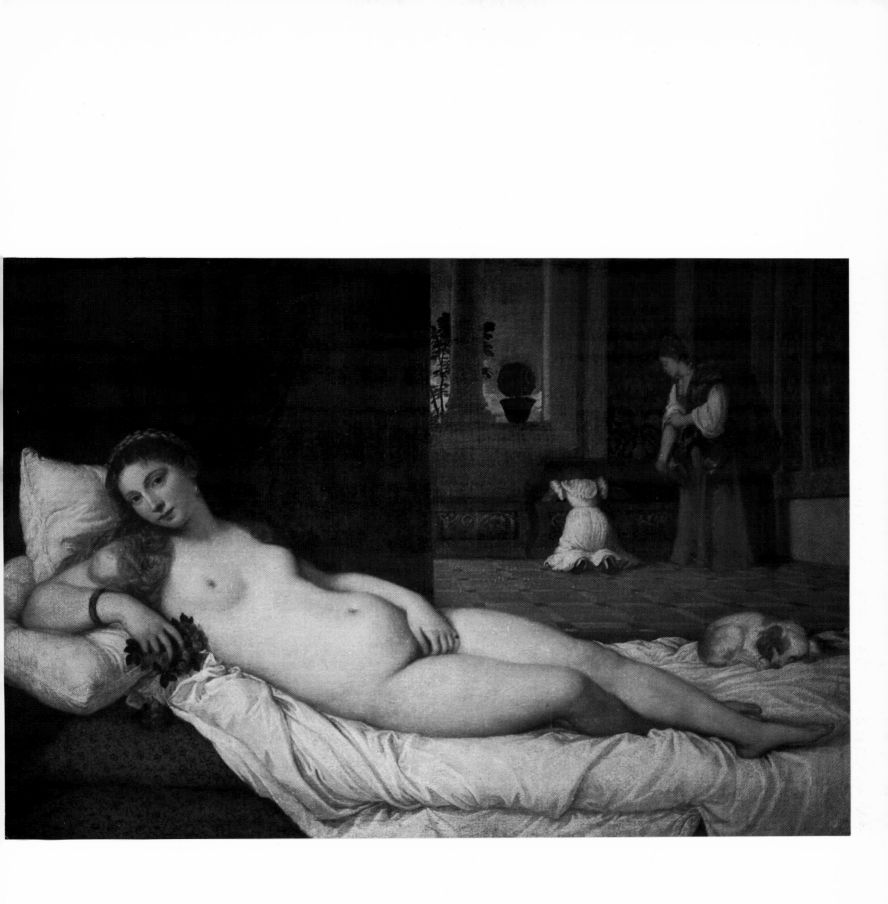

PORTRAIT OF
RANUCCIO FARNESE

1542

Oil on canvas, 35 1/2 × 29″

Signed: TITIANVS F.

National Gallery of Art, Washington, D.C.

Ranuccio Farnese (1530–1565), grandson of Pope Paul III, came to Venice in 1542 as prior of the Knights of Malta, whose cross is emblazoned on his cloak. In the same year that Titian completed this portrait, he also painted one of little Clarissa Strozzi (fig. 36), and these two images testify to the extraordinary sympathy of the master's brush for youthful subjects. In depicting the children of two of the most important families in Italy, Titian seems to have been aware of a certain incongruity between the soft sensitivity of the innocent faces and the outward displays of social status and wealth of costume.

This seems especially true of the Washington portrait. Pose, stance, and costume bespeak the elegant confidence of the courtier, and the *sprezzatura*, or studied casualness, implicit in such bearing is fully realized in the demonstration of tour-de-force painting that creates the rich surfaces and varied textures of the outfit; such virtuoso treatment of satin had been an impressive feature of Titian's earliest portraits (see colorplates 3, 9). A slight shift in axis from torso to head establishes a muted but effective serpentine movement that adds to the grace of the image, while the broad silhouette of the expansive cloak contributes an impressive monumentality to the figure. Crowning the brilliantly rendered body of this young noble is a head of great delicacy, a poised mask of outward control behind which we perceive a quivering sensibility. The crisp sparkle of the twelve-year-old's garments and the graphic highlights on the Maltese cross and the sword hilt set off and enhance the expressiveness of the quiet face with its large soft eyes, distended nostrils, and full mouth. Titian has transformed the conventional court portrait, with its emblematic display of position, into a more moving and private experience—a transformation that may ultimately tell us more about the painter than about his subject.

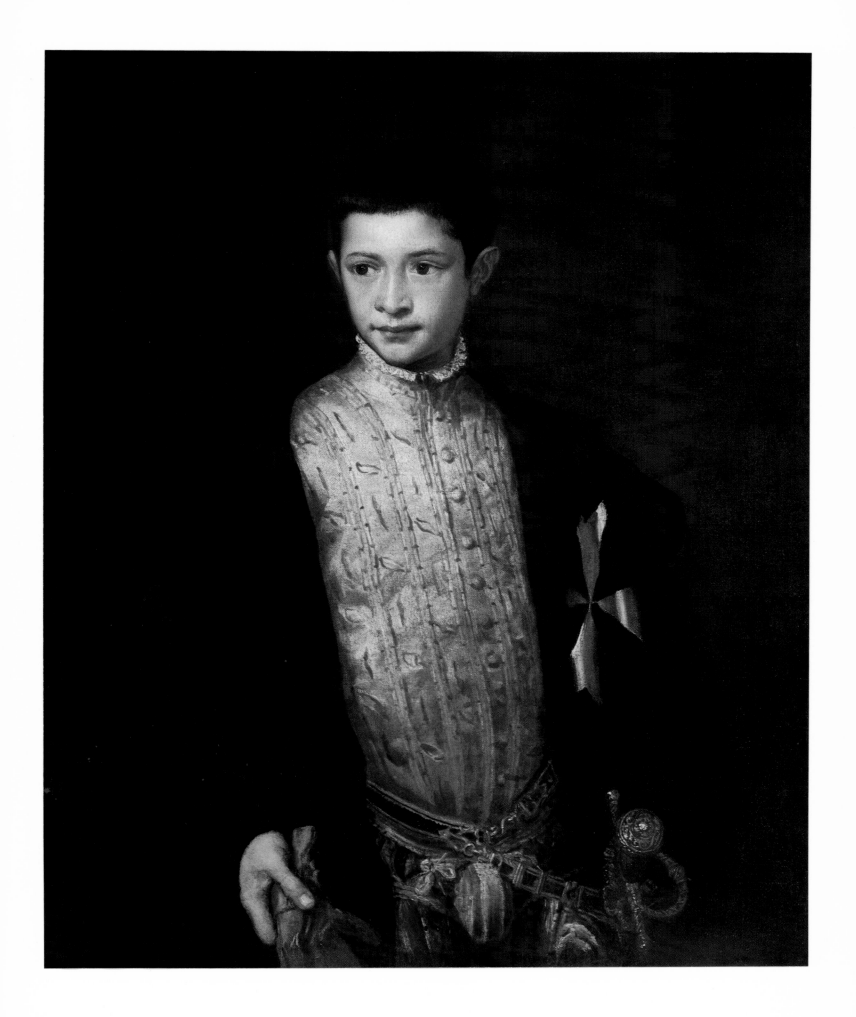

ECCE HOMO

1543

Oil on canvas, 7′ 11 1/4″ × 11′ 10 1/8″

Signed and dated (on the cartello):

TITIANVS EQVES CES F 1543

Kunsthistorisches Museum, Vienna

Painted for Giovanni d'Anna, a Flemish merchant resident in Venice, this *Ecce Homo* was probably initiated not long after Titian completed *The Presentation of the Virgin* (colorplates 24, 25) and is in many ways a studied revision of the earlier work. Although the linear flow of the *Ecce Homo* composition resembles the tableau tradition, it is no longer determined by the decorous movement of reverent processional but rather by the turbulence of confrontation, invested with a dynamism appropriate to the dramatic urgency of its subject. The picture reads from right to left, and this reversal of narrative convention contributes to a heightening of tension and conflict. The surging rhythms of the crowd are both measured and contained by an architecture of powerful plasticity.

The degree to which the forms break from the picture plane—especially the receding steps—distinguishes the *Ecce Homo* from *The Presentation of the Virgin*. So, too, does the coloring, and in this respect Titian invites direct comparison with the earlier painting, for in reversing the linear direction of the composition he inverted the sequence of chromatic accents as well: the blue and gold of Pilate's costume here is analogous to that of the Virgin on the steps, and the brilliant ermine-trimmed crimson of the Pharisee corresponds to the officer's robe in the Scuola della Carità canvas. But whereas in the earlier work colors were varied and distributed over the surface so that they became essential harmonic constituents of pictorial unity, here the colors—reds and blues in particular—assert themselves with greater density, contrast, and impact, reinforcing the physical integrity of the individual figures. The figures themselves insist upon creating their own immediate spatial ambience—by their very bulk or by their involved postures that claim the surrounding space.

Large-scale contrapposto relationships unite these actors into a single choral movement; through poses, gestures, and glances they form larger units or discourse across the space of the picture. The rhythm of the narrative impulse is controlled and articulated by a variety of figural devices, epitomized by the active diagonal vectors of swords and halberds; it flows from the vertical stability at the right frame and mounts the stairs toward the trio of Christ flanked by the soldier and Pilate. But that surging impulse never fully attains its goal; before it reaches the bowed captive its force is turned—broken, so to speak—by the opposing verticals at the left. Indeed, despite the visual power and apparent aggressiveness of this mob, the figures supposedly abusing Christ display a remarkable lack of hostility; their gestures are not threatening but are rather either purely indicative or positively adulatory, expressive of recognition and praise. Inherent in this spectacle of Christ's debasement, then, is his inevitable triumph.

Our involvement in the drama, already implicit in the spatial dynamics of the composition and especially in the intricate contrapposto of the *repoussoir* figure in front of the stairs, is explicitly invited by two motifs in particular: the girl in the middle of the crowd, her radiance communicating directly with us, her innocence poignantly juxtaposed to the ominous Pharisees; and, most disturbingly, by the shrieking youth holding an adoringly faithful dog, at the lower left. The youth's cry, directed beyond the frame, is the most piercing and tragic note sounded in the painting and acquires a peculiarly shrill eloquence as a result of his alignment with the figure of Christ above; this significant axis, in fact, is crowned by the sculptural decoration immediately above Christ: a carved mask sounding the basic tone of the piece, forever echoing the tragic pathos of Christ's imminent sacrifice.

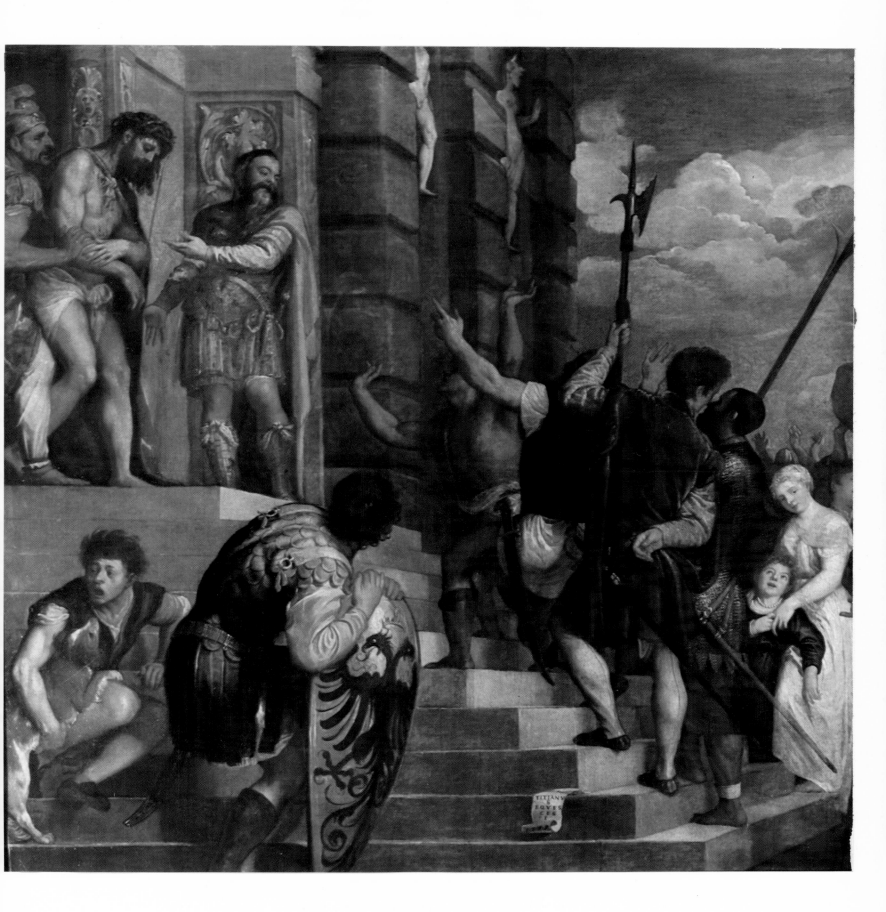

CHRIST CROWNED
WITH THORNS

c. 1542–45

Oil on panel, transferred to canvas, 9' 11 1/4" × 5' 10 7/8"

Signed (on the step): TITIANVS F.

Musée du Louvre, Paris

Titian painted this altarpiece for the Cappella della Santa Corona in the church of Santa Maria delle Grazie in Milan, and the style of the panel suggests a date in the 1540s. The mock coronation of Christ is enacted with a peculiarly intense physicality, as the hard surfaces—in part a function of the smooth panel ground—lend forceful explicitness to figures and setting. The canes pressing the crown of thorns into Christ's head at once serve as the immediately effective means of torture and, by their focused pattern, visually summarize the entire dramatic structure of the composition; set at acute angles, in poignant irony they cross the mock scepter held by the victim. Christ's powerful body, in its intricate and precarious contrapposto, participates fully in the violent design of the picture, of which it is, in every sense, the central focus. He is depicted with a classically inspired heroic grandeur; the extreme pathos of his expression derives specifically from the *Laocoön* (fig. 34), the most moving and influential ancient model of suffering.

Titian has staged the event with a calculated mimetic impact. The device of the figure seen from the rear, rushing into the pictorial space, involves the spectator in the cruel attack; this invitation to participate is quietly reinforced by the extra cane lying diagonally on the bottom step, ex-tending beyond the textured edge of the foremost plane and hence, by implication, into our world.

The architecture is as abrasive as the figures. The pier supporting the lintel and crowning arch weighs heavily above the head of Christ, visually reinforcing the pressure of the torturers' canes; the masonry itself, its rough-hewn surfaces as crude as the action taking place before it, adds its massive presence to the torment. And Titian's architectural vocabulary is precisely chosen: such heavy rustication was traditionally associated in the Renaissance with justice and the architecture of prisons.

Over the lintel inscribed TIBERIVS CAESAR is the bust of the emperor himself, whose effigy the Romans customarily placed in tribunals of justice (see colorplate 6). Above and beyond the immediate physical punishment of Christ, then, there is the larger conflict between heavenly and earthly jurisdiction, so eloquently epitomized in the juxtaposition of Christ and Tiberius. The contrapuntal relationship of their two heads, reflecting one another across the darkness of the open portal and directly linked by the linear continuity of the framing architecture, ultimately dominates and defines the full meaning of this image.

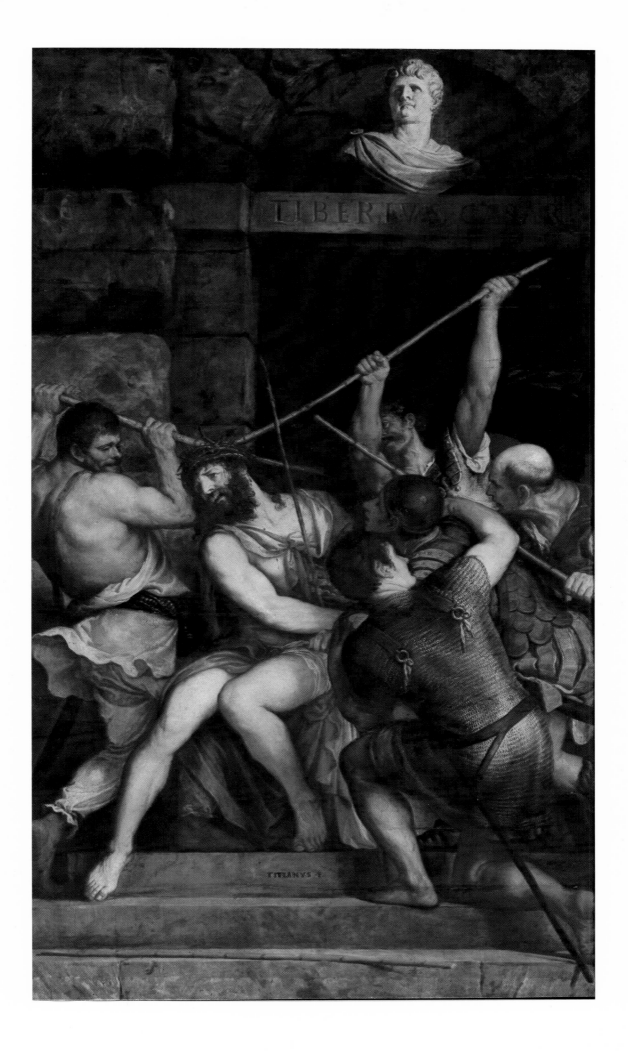

PORTRAIT OF
PIETRO ARETINO

1545

Oil on canvas, 42 1/2 × 29 7/8"

Palazzo Pitti, Florence

"The scourge of princes," as he styled himself, Pietro Aretino (1492–1556) rose from humble origins to international renown by the power of his pen. The author of plays and poetry, satires and religious narratives, his fame rested primarily upon his epistolary activity; through his letters—flattering and fawning, insulting and goading, and typically self-advancing—he was in contact with most of the major personalities in sixteenth-century Europe. From 1527, when he settled in Venice following the Sack of Rome, he formed a close friendship with Titian and with the transplanted Florentine sculptor and architect Jacopo Sansovino, the three of them comprising an elite triumvirate that dominated the cultural scene in Venice. Aretino's pen served his painter friend, praising Titian's work while pleading on his behalf for overdue payments; on the other hand, Titian's painting served more frequently as the material for Aretino's pen, as the excuse for a letter or sonnet or, usually sounding the theme of the triumph of art over nature, as the basic conceit of the literary invention itself (see page 28).

In October of 1545 Aretino sent this portrait as a gift to Cosimo de'Medici, Grand Duke of Florence and Tuscany. While praising the naturalism of the image—"it breathes, its pulse beats, and its spirit moves just as I do in real life"—he nevertheless complained of the painting's apparent lack of finish; had Titian been paid more, he continued unkindly, "the draperies would indeed have been brilliant, soft and stiff, actually appealing to the senses." Aretino's carping dissatisfaction, his apparent failure to appreciate the effective economy of Titian's brushwork, is somewhat surprising. Tuscan by birth and education, Aretino would similarly reprove such younger painters as Tintoretto and Andrea Schiavone for their bold and impetuous manner of painting, but we may wonder if he was not in fact cleverly apologizing to the ruler of Florence, anticipating differences in taste, for this masterly display of Venetian *colorito*. Writing to the humanist Paolo Giovio in April of the same year, in a letter significantly less modest, Aretino in fact had nothing but the highest praise for the portrait, that "miracle issuing from the brush of such a marvelous spirit."

The portrait itself is conceived in such a manner that Aretino cannot have failed to appreciate its ennobling effect. Decorated with a gold chain of honor presented to him by King Francis I of France, his expansive figure fills the field, defined by the grand sweep of his cloak, which he grasps like some ancient orator holding his toga. The same lines, spreading from the gloved hand to support and contain the bearded face, articulate a subtle contrapposto within the imposing bulk of the form, modifying the figure's orientation to our left and preparing the turn of the head in the opposite direction. The head itself, as Aretino apparently refused to recognize in his letter to the duke, is the proper focus of the image, for which Titian reserved a slower and more deliberate brush. The painter depicted his arrogant friend with all the confident power and keen intelligence that constituted Aretino's own self-image; in his letter to Giovio, the sitter confessed his pleasure in the portrait, referring to it, clearly with proud satisfaction, as *"una sì terribile meraviglia"* ("such an awesome marvel").

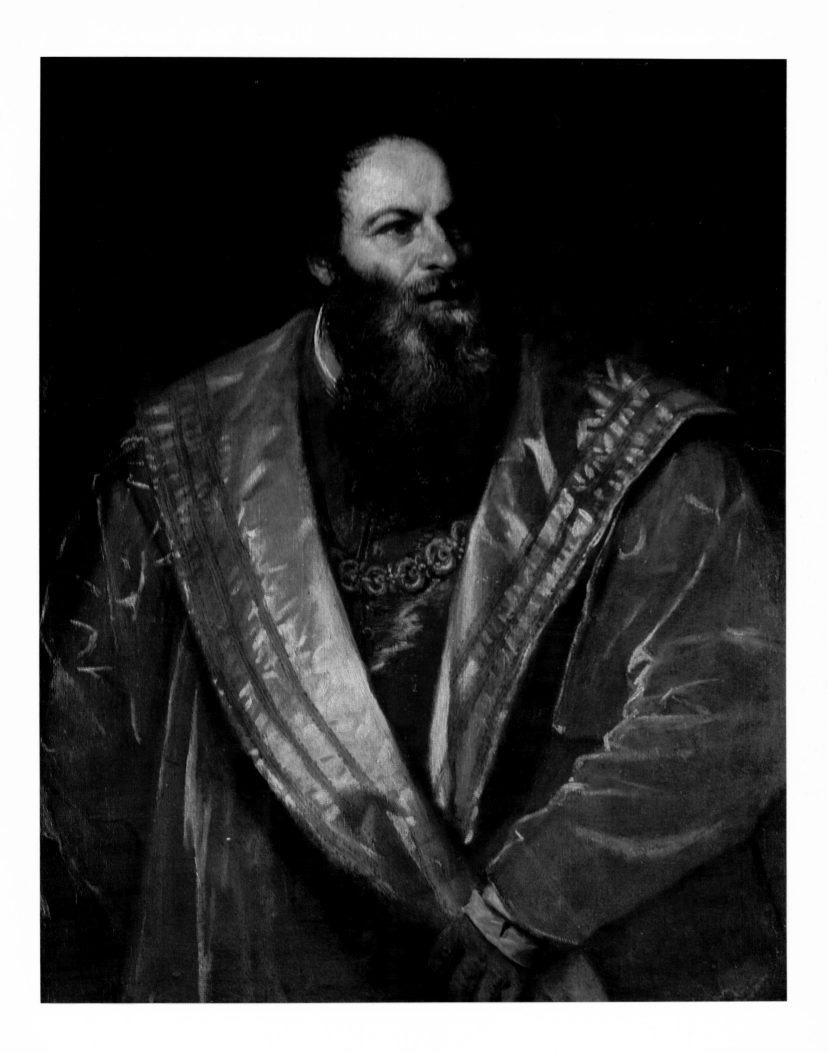

DANAË

1545–46

Oil on canvas, 27 1/8 × 46″

Gallerie Nazionali di Capodimonte, Naples

Danaë, ravished by Jupiter in the form of a shower of gold, initiates the long series of Ovidian interpretations that occupied much of the latter part of Titian's career. Painted for Alessandro Farnese during the artist's stay in Rome, the painting must have developed under conditions of highly self-conscious competition with Roman art—ancient and modern—and especially with the art of Michelangelo, whose own pictorial composition of *Leda and the Swan* may have sounded a specific challenge to which Titian was responding. According to Vasari, Michelangelo criticized Titian's work for its supposed lack of *disegno* (see page 32), but the *Danaë* is indeed a deliberate demonstration of Venetian *colorito*; its unifying tonalism and controlled coloring create that environmental illusion that defies sculptural discreteness—a *sine qua non* of the Central Italian aesthetic—even as it invites, by suggestion, tactile exploration.

The composition is carefully stabilized by the horizontal and vertical of couch and column; against those coordinates the reclining Danaë moves sinuously into a deeper space, her languid rhythms underscored by the serpentine activity of the bedclothes. Through its calculated twist, her body shifts from a profile position parallel to the picture plane to a more frontal presentation of her upper torso; the axis of that path continues along her neck, throwing her head back into shadow. At her feet Cupid moves contrapuntally in the opposite direction, emerging forward out of the darkness.

The scene is illuminated from the outside, but that natural lighting, describing the passive sensuality of Danaë, fails to penetrate the sanctum of the dark middle ground. There the ominous cloud of Jupiter rains its potent treasure upon her receptive body, the subdued radiance of the coins glittering in the surrounding shadow. Drawn by that mystery into the darkness beyond the immediate sensual appeal of the quietly ecstatic heroine, we become involved in the miraculous form of the metamorphosed amorous deity. By the tangibility of his painted world, its sensuous rhetoric, Titian endows the myth with a palpable and convincing reality.

In 1554 the master delivered to Philip II a revised version of the composition (fig. 55), in which the figure of Danaë acquires a new stature and maturity. Longer of limb, she is there rendered with a still greater tactile softness by the more open brushwork of Titian's later manner. Furthermore, Cupid has been replaced by the old nurse, who, with a gesture almost comic in its theatrical relief, holds out her apron to gather in some of the Olympian coinage.

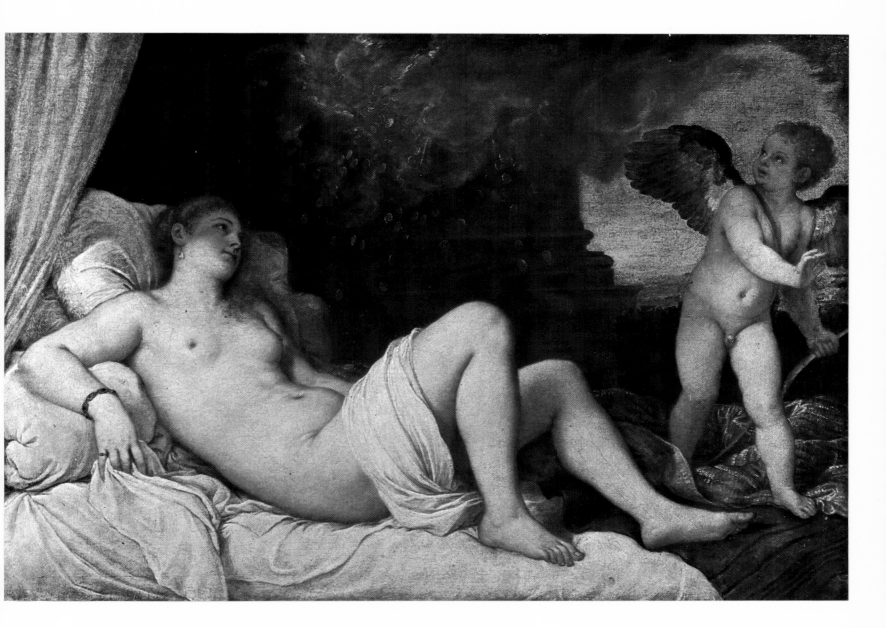

POPE PAUL III AND HIS GRANDSONS, ALESSANDRO CARDINAL FARNESE AND OTTAVIO FARNESE

1546

Oil on canvas, 78 3/4 × 68 1/2"

Gallerie Nazionali di Capodimonte, Naples

During his visit to Rome Titian apparently got to know his hosts, the Farnese, rather well; at least the evidence of this unfinished group portrait of the pope and his grandsons would seem to indicate that the painter was intimately aware of the political dissension and scheming that divided the family. The painting—which inevitably invites comparison with that other revealing pictorial document of an earlier papal court, Raphael's *Pope Leo X and His Nephews* (Galleria degli Uffizi, Florence)—presents the tired pontiff bowed, his left hand extraordinarily tense, flanked and even apparently threatened by his grandsons, especially by the predatory obsequiousness of the approaching Ottavio. In the following year, 1547, Paul's son, Pier Luigi Farnese, would be murdered by agents of the emperor, and shortly thereafter Ottavio would take full advantage of that deed to claim the rule of Parma and Piacenza with the aid of his father's murderer and the support of his brother Alessandro. Angered by these events, which deprived the papacy of that territory, Paul died a few days after a confrontation with Alessandro. The detached aspect of the cardinal's posture behind the pope in Titian's painting seems, as much as the more overtly expressive meeting of Paul and Ottavio, to anticipate these developments. We can only wonder at the reasons for Titian's failure to complete this indicting image.

Although Raphael's painting established a model of the most subtle psychological penetration, Titian probed still further into the expressive possibilities of the group portrait. He developed the categories of full-length portraiture and official audience setting into a composition of dramatic narrative, in which a profoundly emotional scene is acted out, however unwittingly, by the sitters. Glance and gesture, courtly conventions of behavior, and the smallest yet most revealing reflexes were minutely observed—presumably during the entire period of Titian's visit—and used to create a full drama. The clock, the lone object on the table, bears poignant witness to the action, measuring its duration as well as the mortality of its aged central protagonist.

Because it is unfinished, the canvas offers a record of Titian's method of composing directly—blocking in the composition with the brush, shifting figures (X rays reveal that Alessandro originally stood further to the left), and bringing diverse areas to relative completion. The psychological tension is heightened by—and, indeed, depends upon—a foundation of harmonious design, of sweeping movements seen against stabilizing fragments of horizontal and vertical coordinates. Most fundamental, however, is the painting's basic chromatic structure. Red, relieved and modified by white and black, serves as the ground for Titian's invention: most saturated in the scarlet of the table-cloth, it is extended and varied in the cardinal's robes and further cooled toward pale crimson in the pope's cape; almost yielding to brown in the background drapery, it is finally transformed from a deep wine into a darker brown and then black in Ottavio's costume. Titian seems to have set himself the challenge of running red through a full gamut of variations, and this close sequence of modulations unites the figures in chromatic proximity while conveying those subtle distinctions that are at the heart of the picture's meaning.

124

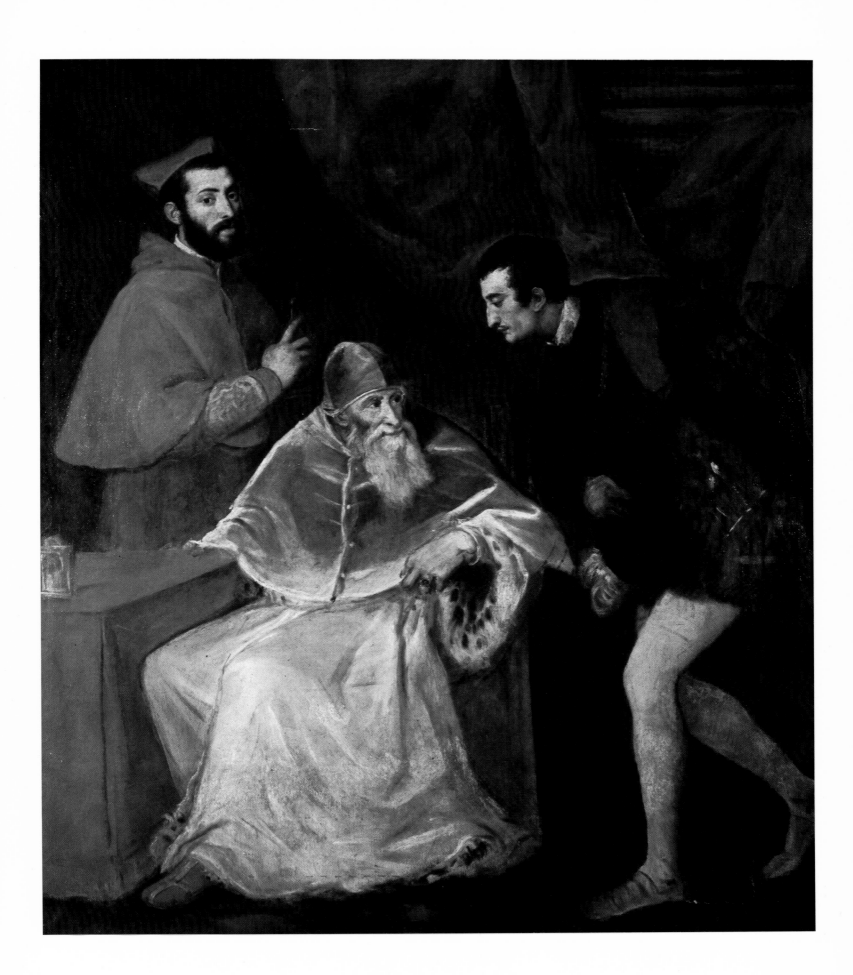

COLORPLATE 33

EQUESTRIAN PORTRAIT
OF CHARLES V

1548

Oil on canvas, 10' 10 5/8" × 9' 1 7/8"
Museo del Prado, Madrid

Painted between April and September of 1548, during Titian's stay at the imperial court at Augsburg, this monumental portrait commemorates a specific event: the battle of Mühlberg, where, on April 24, 1547, the Holy Roman Emperor Charles V (1500–1558) decisively defeated the forces of the Protestant League, led by Johann Friedrich, Elector of Saxony. Titian faithfully recorded the armor actually worn by the emperor on that occasion, as well as the particular horse and its caparison. Drawing upon a number of sources—including Pliny's reference to Apelles' much admired "portrait of Antigonos in armor advancing with his horse," ancient imperial representations in Roman art, the Renaissance tradition of equestrian monuments, and probably also Dürer's engraving *Knight, Death, and the Devil*—he created an image rich in references that celebrates the triumphant Holy Roman Emperor as *Miles Christianus*, the Christian knight, defender of the Catholic faith. Upon learning of the commission, Pietro Aretino volunteered some suggestions that, although understandably unheeded by his painter friend, do indicate the import expected of such an official picture: he suggested that Titian include personifications of Religion (holding a cross and chalice to heaven) and Fame (winged and with trumpets). The painting was indeed intended to represent more than the man, and in it Titian established a basic model for subsequent equestrian portraits throughout the Baroque era and beyond.

Yet Titian's picture distinguishes itself from the many images it later inspired. For all the grandeur of the composition, its size and monumentality of conception, its iconographic resonance, its historical allusion and official

significance, it remains remarkably unrhetorical, free of heroical pomp. Charles sits confidently in the saddle, in easy control of a steed full of energy but yet not excessively so. The landscape reveals no signs of the great battle; strangely peaceful, it surrounds the imperial warrior with a tranquility in surprising contrast to his armed appearance. The grove of trees behind him adds a strong support to the rider, while the horizontal striations of the clouded sky reinforce the unperturbed steadiness of his vision. The whole impression is one of purposeful control, even, strangely, of calm. Excitement here is a function of color—especially the modulated areas, the accents of red, and the dark pattern of the prancing horse—and of the quality of paint—brilliantly demonstrated by the armor, in particular, with its flashes of gold and white reflection.

The power of the picture, its unexpected affect, derives from the dynamics of internal tension: on a purely visual level, in contrasts in the brushwork, and, on a deeper level, in the contradiction between public monumentality and private experience. Within a thematic structure of heroic action, the protagonist seems rather removed, physically detached and emotionally distant—a reluctant warrior whose face appears somewhat oppressed by the surrounding glitter of his armor. Titian knew Charles personally and was evidently aware of his human weaknesses, the physical and emotional suffering that he depicted with such sympathy in the portrait of the emperor seated in an armchair (fig. 31). And in the equestrian image celebrating the triumph of the faith, Titian again represented the man as well as the victorious Catholic ruler.

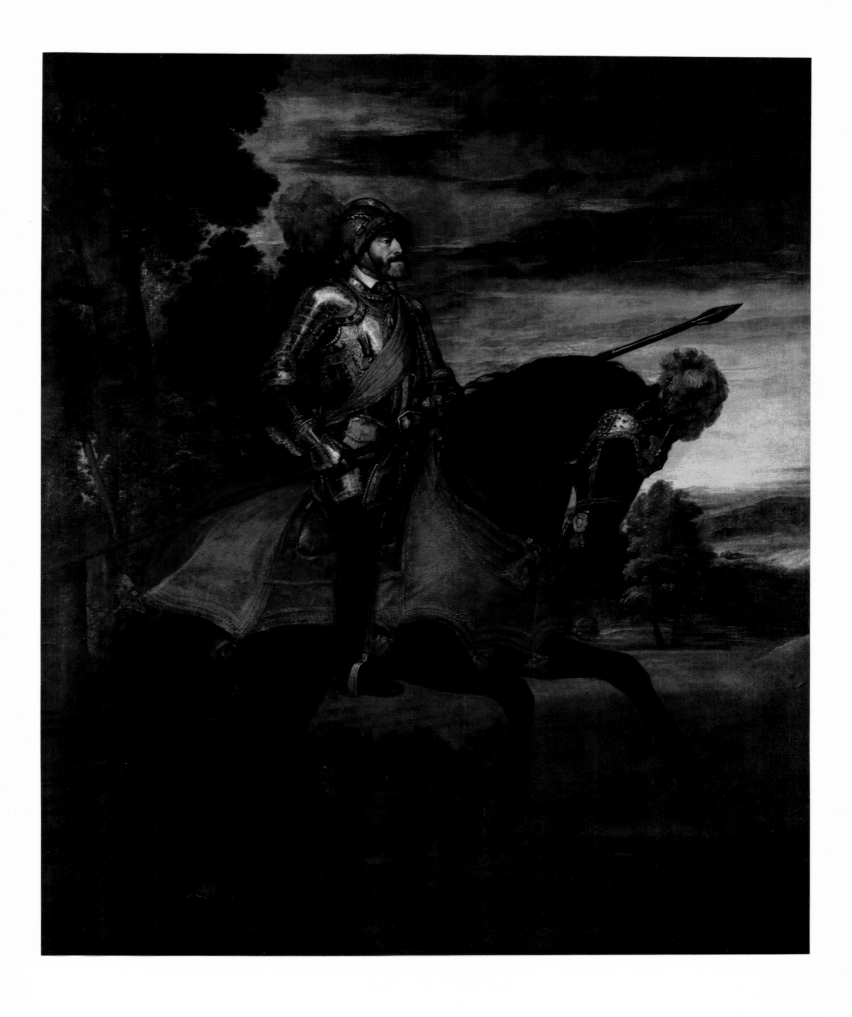

PORTRAIT OF
PHILIP II IN ARMOR

1550–51

Oil on canvas, 76 × 43 3/4"

Museo del Prado, Madrid

Titian first met Philip (1527–1598), the son of Charles V and the most important patron of his later career, in 1548 in Milan and then again during his second trip to Augsburg in 1550–51. There he painted this full-length portrait of the future king of Spain in armor. The format of the image repeats the type of state portrait that Titian had earlier adapted in his version of *Charles V with a Hound* (fig. 30), but here he adds to the official status of the full-length composition a certain air of pose and gesture that somehow undercuts—if it does not quite humanize—the hauteur of the subject. Standing rather stiffly in his richly ornate ceremonial armor, one hand resting upon the helmet on the table and poignantly juxtaposed to the empty gauntlet below, Philip does not quite dominate his surroundings with the same imperial confidence as his father does in the earlier portrait; indeed, the sheer amount of space around the figure and the slightly skewed position of the table deny him full control over his ambience. The column at the left, symbol of fortitude or heroic virtue, contributes a stabilizing element to the composition that is, in fact, absolutely essential to strengthen and ground its otherwise subtly precarious balance.

The painting itself offers a masterly demonstration of Titian's art. The rendering of shining armor had long been a favored studio topic for the display of painterly virtuosity, and here Titian makes the most of the opportunity presented by Philip's gold-damascened outfit. Moving with utmost assurance, varying its speed, touch, and thickness of paint, Titian's brush establishes patterns and relationships equivalent to the brilliance of the surfaces imitated; working up from the toned ground, through thinly painted cloth, to the rich impasto of highlights, it suggests the various substances of velvet, steel, and flesh. From within this pictorial exuberance, however, the pale face of Philip peers out, modeled in grays and blues with warmer touches of red reserved only for the full lips and cheeks, its pallor in revealing contrast to the surrounding richness.

Although he must have always shown proper courtly deference to royalty, Titian's attitude toward the prince in this portrait—as coolly observant as his portrait of Pope Paul III and his grandsons (colorplate 32)—seems almost to suggest some initial tension between the artist, already over sixty, and the not altogether attractive young prince; the sympathy that existed between Titian and the emperor was not immediately transferable to Charles's son. For his part, although he would prove a most appreciative and enthusiastic patron of the old master, Philip evidently did not quickly recognize the achievement represented by the portrait. Schooled in other tastes, he failed to respond to this display of Venetian *colorito*; writing to his aunt, Mary of Hungary, to whom he sent the picture, he declared: "It is easy to see the haste with which it was executed, and had there been time it would have been redone." The continuing example of Titian's subsequent work for him would eventually re-educate Philip, training his eye and introducing him to new dimensions of aesthetic experience.

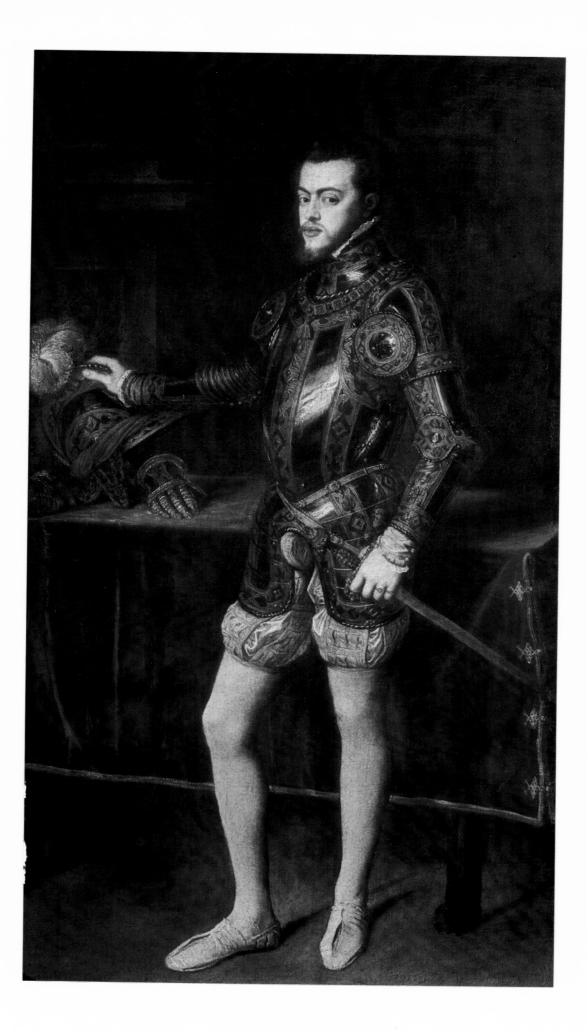

PORTRAIT OF
A KNIGHT OF MALTA
WITH A CLOCK

c. 1550–55

Oil on canvas, 48 × 39 3/4"

Museo del Prado, Madrid

Every element of this moving portrait contributes to its gently inviting profundity. The palette is deliberately muted, mixing warm and cool tonalities and playing them off against one another. The costume itself, rich yet quiet—a searching study in blacks and grays, relieved by the sharp accents of collar and cuffs and by the gray cross suffused with white—sets off the flesh tones of the face, which subtly blend cool touches of green shadow into their general warmth. A related chromatic structure defines the neutral backdrop: over a warm bolus ground Titian applied a thin layer of cool gray, through which the reddish ground appears, and the resulting tonal ambiguity yields a highly suggestive atmospheric fabric that serves as a foil to the varied surfaces of the costume.

The face of the sitter, rendered with the same quiet tonalism and a delicate touch, seems lost in reverie, his eyes averted from ours and unfocused in their gaze. An interpretive key to the mood of the man and the picture is offered by the mechanical clock on the table to the right;

the only object in the painting, it calls special attention to itself by its enameled gold brilliance. The loose and apparently casual grasp with which the protagonist holds the clock seems to match the wandering thoughts of his stare, and yet there is in this physical contact a direct relationship between man and object, in contrast to his distant gaze. The resulting tension resolves itself in the establishment of a further dimension to the psychological presence of the image, suggesting a theme for the sitter's interior meditation. More than a merely conspicuous ornament, an emblem of socio-economic status, the clock symbolizes, in the most immediate way, time; replacing the traditional death's head as a *memento mori*, it serves as a reminder of the transience of human life. In this unobtrusive way, traditional emblematic significance—functioning within the world of living substance and psychological reality created by Titian's brush—assumes an ever greater urgency and conviction.

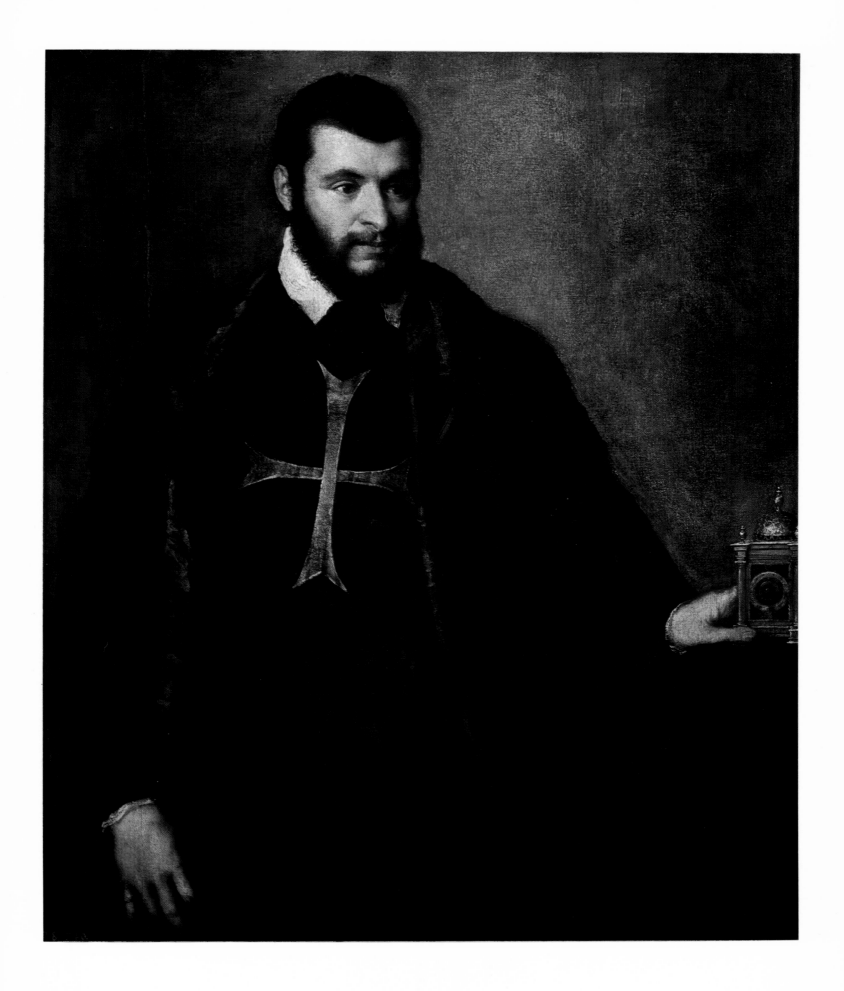

VENUS AND ADONIS

1553–54

Oil on canvas, 73 1/4 × 81 1/2"

Museo del Prado, Madrid

Venus and Adonis, the second of Titian's *poesie* for Philip II, was in progress in 1553, and in September of 1554 it was sent to the Spanish prince in London, the scene of his marriage to Mary Tudor; it arrived in a damaged state, about which Philip complained in a letter of December 6. Although areas of the picture have suffered a good deal of repainting—especially Venus' back—it nonetheless retains much of its original freshness and still makes a striking impression.

Ovid (*Metamorphoses*, x. 510–739) recounts the tale of Venus' love for Adonis, her warning to him against hunting the wild boar, her departure, his succumbing to the call of the chase, the hunt of the boar, Adonis' death, Venus' lament, and her transformation of the dead youth into the anemone. To an unusual degree, however, Titian has apparently ignored the classical text, willfully creating out of its materials an entirely new dramatic situation: the flight of Adonis. As narrated by Ovid, the legend is essentially without such direct conflict; the hunter's disregard of the goddess's advice occurs in her absence. The immediate juxtaposition of Venus and Adonis at his departure therefore offers dramatic possibilities unavailable in the Ovidian sequence. In so reinterpreting the story, giving it a new focus, Titian undoubtedly recalled similar subjects on Roman sarcophagi, which preserved an ancient pictorial tradition representing the departure of Adonis and his subsequent death.

In Titian's painting Adonis sets off resolutely, following the eager pull of his hounds, his motion drawing the pleading Venus off balance; he pauses for an instant, a moment of hesitation and doubt, and on their exchanged glances pivots the drama. Within the rich bower of Venus, scene of the past night's love, Cupid still sleeps: love off guard. The moment in the sequence is defined with further precision by the apparition in the heavens—Aurora herself, whose rays, interrupting the night and love, point the way to Adonis' future, his fated death. A single image thus contains the full cycle of narrative time—past, present, and future. Moreover, Titian has added a human element of

pathos that gives to the myth a new psychological poignancy and affective power.

If the painter has played rather freely with the Ovidian text in this case, he has, on the other hand, demonstrated a remarkable fidelity to a particular visual model, an often-copied antique relief of Psyche discovering the sleeping Cupid, known in the Renaissance as "*The Bed of Polyclitus*" (fig. 54). The most memorable feature of this design, which Titian had studied during his Roman visit of 1545–46, is the beautifully artificial contrapposto of the female figure, whose body, seen from the rear, makes a complete 180-degree turn, head and feet pointing in opposite directions; this motif—which had earlier inspired Raphael and Correggio—is the model for Titian's Venus, whose back becomes a field of the most delicately nuanced sensuousness. The powerful pronated arm of Adonis suggests that he in turn owes something to the heavy figure of the sleeping Cupid in the antique relief. This particular gesture, used often in Renaissance art in depictions of the dead Christ, is indeed to be read as a sign of death; it is therefore highly significant that the leashes of the dogs, leading Adonis to his tragic end, are so conspicuously tied to that arm.

Thus, more than merely borrowing individual figure motifs, Titian responded to the total configuration of the antique, absorbing and recasting it much as he transformed Ovid's narrative. The unusually planar structure of the composition, reinforced by the chromatic clarity of Titian's palette—a clarity not shared by the numerous studio replicas of the picture—reflects and, in turn, challenges its model. The entire design is based upon an insistent relief aesthetic. The figural group, to a degree rare in Titian's art, is easily imagined translated back into the medium of carved relief. The form of Venus, especially, maintains the planarity that intentionally betrays her sculptural origins, although stone has here been transformed into warm flesh. And the degree to which the traditional *paragone* between the arts of painting and sculpture informs the total pictorial idea suggests that Titian may have initially conceived it during his stay in Rome.

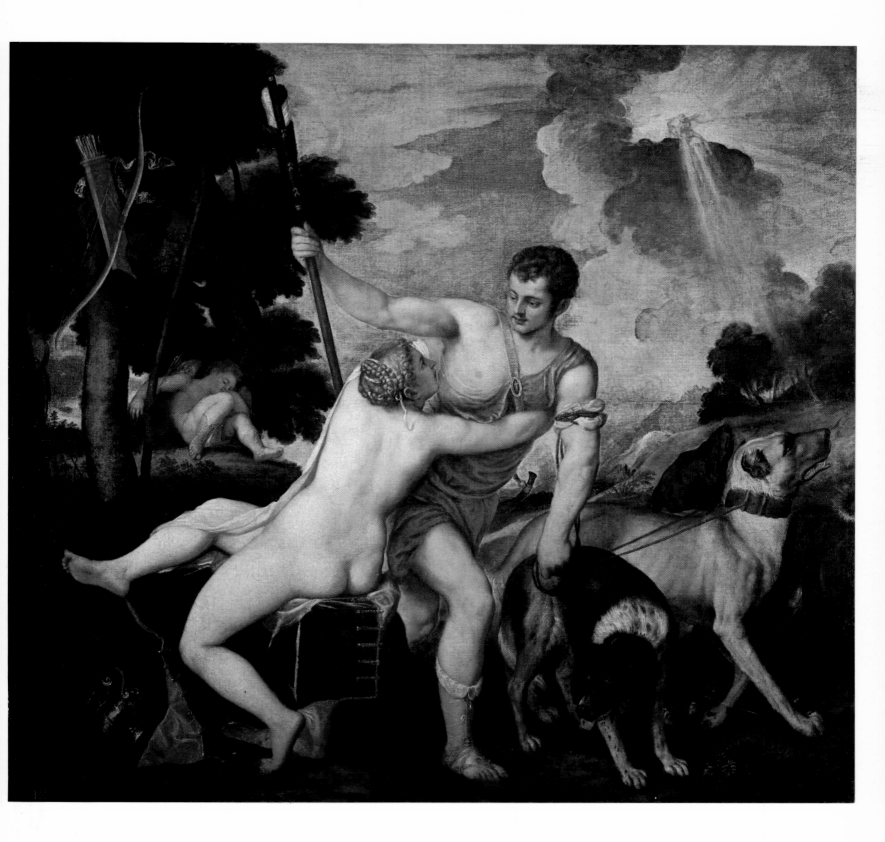

THE MARTYRDOM
OF SAINT LAWRENCE

c. 1548–59

Oil on canvas, 16′ 4 7/8″ × 9′ 2 1/4″

Signed (on the gridiron):

TITIANVS VECELLIVS AEQVES F.

Chiesa dei Gesuiti, Venice

Commissioned sometime before November 18, 1548, by Lorenzo Massolo for his chapel in Santa Maria Assunta (which later became the church of the Jesuits), this large altarpiece was still unfinished in 1557 and not finally in place until about 1559. Initiated only two years after Titian's return from Rome, the composition is replete with recollections of Central Italian art and archaeological references to Roman antiquity. The monumental background architecture, for example, is modeled after the Temple of Hadrian. According to Erwin Panofsky's interpretation, the statue of a veiled female figure holding a winged Victory probably represents Vesta, following a passage in Prudentius' *Passio sancti Laurentii*: "That death of the Holy Martyr was the real death of the [pagan] temples. Then Vesta saw her Palladium-guarding shrine deserted with impunity . . . and Claudia, the vestal, enters thy house, Oh Lawrence." The presence of Vesta thus bears witness to the conversion of pagan Rome.

Lawrence, an early deacon of the Church, was martyred in the year 258, during the reign of Emperor Vespasian, and Titian—despite his use of and allusions to figural inventions of Michelangelo, Raphael, and other artists—found his main inspiration in the historical, or legendary, accounts of that sacrifice. The motif of the executioner with the long fork, for example, occurs in the well-known engraving by Marcantonio Raimondi after Baccio Bandinelli's design, but Titian has adapted it, and the related actions, to a fuller realization of the saint's stoically ironic response to his torture: "I am already cooked on this side, turn me on the other." The structure of the lower part of the composition—the straining counterpoint of figures lunging forward and back into space, the sharp foreshortening of the victim with his leg thrust out at the viewer—and the

intensity of its chromatic temperature are calculated to heighten the affective impact of the scene. The aggressive violence of the Romans—the physicality informing these figures is epitomized in an energetic drawing, a study for the legs of the executioner (fig. 77)—serves as a foil to the accepting gesture of the saint, who turns to heaven for his ultimate salvation. And the heavens in turn open and shed divine illumination upon the Christian martyr. The diagonal activity of the bottom scene of torture yields to a series of vertical accents in the upper part of the painting, culminating in the major axis of the whole design, which links Lawrence's earthly torments and his heavenly vision.

Indeed, more than the physical actions of the figures, light functions as the primary organizing force in the nocturnal darkness of this painting. The pictorial motif of flames seen blazing through grillwork, echoed in the windswept torches and again, modified, in the internal light of the distant palace, the reflections on armor, and the glowing highlights defining contours—all are demonstrations of Titian's painterly skill. But beyond the professional delight in such challenges there is the dramatic and symbolic function of these motifs, which establish an earthly, material contrast to the single source of heavenly illumination. And here, too, Titian seems to have been inspired by a specific passage in a literary source, the account in *The Golden Legend*: "In that same night Lawrence was again brought before Decius. . . . Then every sort of torture was prepared for him, and Decius said to him: 'Sacrifice to the gods, or thou shalt pass the night in torments!' And Lawrence answered: 'My night hath no darkness: all things shine with light!'" The master's brush once again transforms poetic, or mystic, metaphor into pictorial reality.

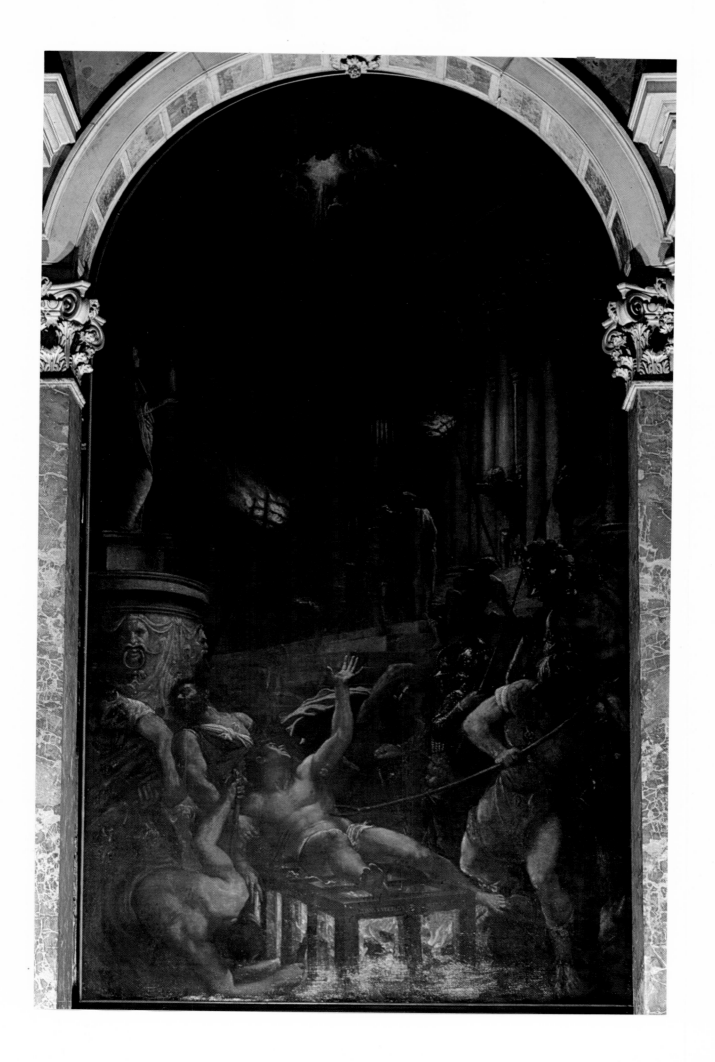

COLORPLATE 38

THE HOLY TRINITY ("LA GLORIA")

c. 1551–54

Oil on canvas, 11' 4 1/4" × 7' 10 1/2"

Signed (on Ezekiel's scroll, lower left): Titianus P

Museo del Prado, Madrid

It was probably during his Augsburg visit of 1550–51 that Titian received the commission from Charles V to paint the picture that, at least since the end of the sixteenth century, has been known as "*La Gloria.*" Titian himself referred to it as a representation of the Trinity and—in his request for the copyright of the engraving made for him by Cornelis Cort—as a Paradise. In his own last will and testament the emperor called it a Last Judgment. The complex iconography of the picture in fact supports and comprehends all these interpretive titles in a conception, based upon a variety of sources and traditions, of extraordinary richness. Below the persons of the Trinity, with no visible distinction between the Father and the Son, is assembled a heavenly court as in an all-saints picture, but these figures are primarily from the pre-Christian era: Old Testament prophets and, probably, the Erythraean Sibyl—the female figure seen from behind, reaching toward the deity, that recalls a figure in Michelangelo's *Last Judgment.* Mediating between this host and the Trinity is the Virgin Mary, and behind her, also bridging the eras before and of Grace, Saint John the Baptist. On the right of the composition Charles himself and his deceased empress, Isabella, dressed in white shrouds, are presented by angels to the source of salvation; further to the right are their son, Philip II, and Mary of Hungary, the emperor's sister. At the bottom of this portrait group are the imperial envoy to Venice, Francisco de Vargas—included, as Titian explained, at his own insistence—and next to him, in disappearing profile, the artist himself. The composition thus presents both a vast theological construct, an iconic statement, and, in its narrative, a drama of salvation, an active prayer at once before and within that icon.

Titian knit the diverse strands of the complicated iconography into a unified and convincing image through a compositional construction combining large-scale structural patterns and more subtly nuanced relationships. Chromatically, the dominant color notes are blue, gold, and white, and their distribution and modulation establish the hierarchical flow between earth and heaven, between the natural and the supernatural. And the mode of rendering, the application and substance of the paint, functions

as a correlative to the actuality of objects; the impasto solidity of the lower figures yields to the gossamer ethereality of the heavenly zone above where natural colors pale in the intensity of divine radiance. Moreover, chromatic distribution reinforces essential relationships in the figural design: browns, limited to the landscape and to Ezekiel's eagle and David's psaltery, define the lower realms of the picture, and the green of the sibyl's dress elevates the colors of the landscape; the color of the Virgin's robe echoes the intense blue of David's royal mantle, just as her downward glance seems to answer his fervent gaze to heaven, and these blues further extend the color of the distant mountains.

The ecstatic gestures of the figures, at once celebrating and appealing to the Trinity, set the dominant emotional tone of the composition. Inspired by a number of classical sources from the art of antiquity and that of Michelangelo, Titian's figures establish by their energy and palpability a basic contact with the natural realm. As in his earlier binary construction, the "*Assunta*" (colorplates 12, 13), Titian here, too, sought to create a heavenly vision that would be distant—literally, of another world—yet at the same time accessible through intermediary appeal to the senses. This accessibility—made all the more essential by the dramatic urgency of the theme, the presentation of the mortal Hapsburgs to their God—directly involves the spectator, who, from his position on earth, is invited to enter this holy congregation at the lower right. From that point of entry the clearly marked diagonal connects with the interceding Virgin, *Maria Mediatrix*; her figure, perhaps more than any other single motif, signals the profundity of Titian's experience of Michelangelo's *Last Judgment.* As in the Sistine Chapel fresco, Mary here is shrouded. Filled with compassion for humanity, she nonetheless seems to perform her role with hesitation: within the ambivalence of her closed person is an element of doubt that both balances and fuels the desperate prayer of the emperor.

In 1556 Charles, weary and in poor health, abdicated and retired to a Spanish monastery at Yuste, taking with him Titian's canvas. There, the dying supplicant gazed upon the image with fervent intensity, focusing his hopes for salvation upon this Last Judgment.

136

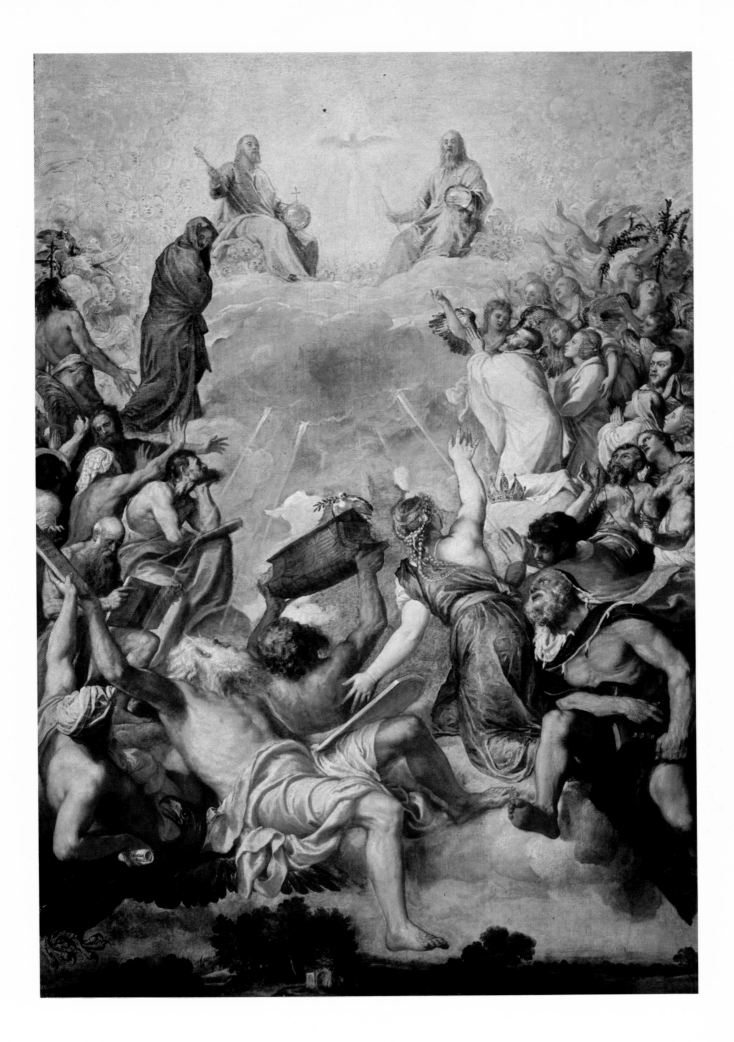

SAINT JEROME
IN PENITENCE

c. 1555

Oil on panel, 92 1/2 × 49 1/4"

Signed (on the rock below the saint's knee): TICIANVS F.

Pinacoteca di Brera, Milan

The subject of Saint Jerome penitent in the wilderness derives from the saint's own description of his ordeal "living in the desert, in that lonely waste, scorched by the burning sun, which affords to hermits a savage dwelling-place" (Letter xxii).

> I used to sit alone; for I was filled with bitterness . . . my only companions were scorpions and wild beasts. . . . I used to fling myself at Jesus' feet; I watered them with my tears, I wiped them with my hair; and if my flesh still rebelled I subdued it by weeks of fasting. . . . I remember that often I joined night to day with my wailings and ceased not from beating my breast till tranquility returned to me at the Lord's behest. . . . Filled with stiff anger against myself, I would make my way alone into the desert; and when I came upon some hollow valley or rough mountain or precipitous cliff, there would I set up my oratory, and make that spot a place of torture for my unhappy flesh.

Titian's altarpiece, originally in the Venetian church of Santa Maria Nuova, which had been rebuilt in 1555, varies a compositional theme he had elaborated more than twenty years earlier in a painting for Federico Gonzaga (fig. 33) as well as in the design for a woodcut (fig. 86). The earlier versions, conceived for private devotion or aesthetic appreciation rather than as public altarpieces, are horizontal in format and locate the saint in a more expansive landscape. In the more monumental conception for Santa Maria Nuova, the figure itself assumes a role of greater dominance, becoming the true protagonist, acting not within the landscape but rather against it; for, like the figure of the saint, the landscape, too, has increased in prominence and is articulated in more immediate and aggressive detail. A high degree of tension is maintained by the stiffened limbs of Jerome, his rigid left arm at once extending him toward the crucifix and yet insisting upon the distance between penitent and Savior. His pose and anatomy imply a certain force; he requires all that power to withstand and combat the diagonal counterforce of the plunging mountainside, ostensibly directed against himself. Within the dynamics of the composition the landscape thus functions as both the penitent's abode, his "oratory," and his adversary.

The saint's body, facing to the right and directly on the central axis, locates the dramatic focus to one side of the panel; balancing that stress, however, is the deep-eyed skull to the left. This prominently placed sign of the mortality of the flesh, and the hourglass, temporal symbol of transience, add specific resonance to the import of the image. The heavy volumes below these ominous objects allude to Jerome's work as translator and commentator of the Bible.

Titian's conception offers a complete image of the saint in the wilderness and, in the richness of its references, recalls the etymological explication of the saint's name in *The Golden Legend* of Jacobus de Varagine: "Jerome is from the Latin Hieronymus, which comes from *hierar*, which is *sanctus* in Latin, and means holy; and from *nemus*, grove, or *noma*, law: whence it is said in his legend that Jerome means a holy law. . . . He is called a grove after the grove wherein he made his abode for some time, and a law because of the rule and discipline which he taught to his monks, or because he set forth and explained the Holy Law."

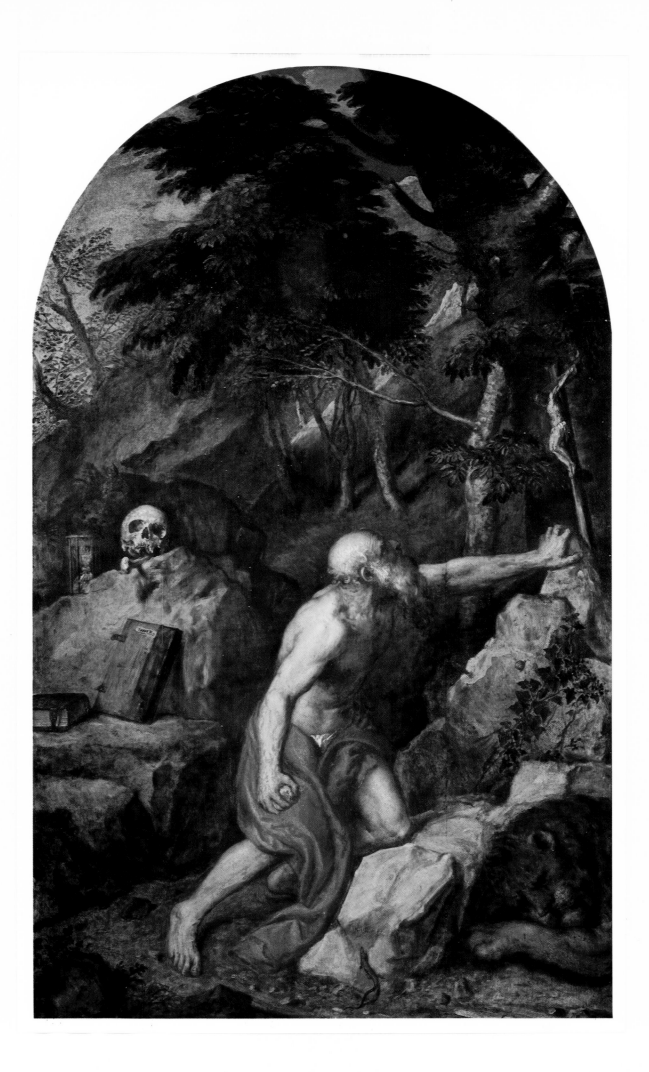

VENUS AND
THE LUTE PLAYER

c. 1560

Oil on canvas, 59 3/4 × 73 1/2"

Fitzwilliam Museum, Cambridge, England

Venus and the Lute Player, the culmination of Titian's long concern with the theme of the reclining nude goddess, exists in two versions: this one in Cambridge, which is the more finished, and the canvas in The Metropolitan Museum of Art in New York, which remained in the studio as a *ricordo*, a record of the composition fully blocked in but still incomplete. (After the death of the master it may have been among the pictures acquired by Tintoretto, and eventually it was given some finishing touches by another hand, possibly that of Tintoretto's son Domenico.) The Cambridge painting was in the collection of Emperor Rudolf II at Prague, where it is recorded in an inventory of 1621.

A celebration of love—whose object is beauty and whose means of expression are poetry and music—the composition offers a pictorial *summa* of Renaissance conventions of courtship; mixing the real and the ideal, nature and art, its highly cultivated aesthetic controls and sanctions its obvious erotic appeal. The musician-courtier, in fashionable sixteenth-century attire, serenades his beloved—or rather the sensual symbol of all beloveds, Venus herself. A narrative line extends from left to right, carried especially by his fervent glance in the direction of the head of Venus; crowned by Cupid, she gazes upward, toward a higher realm. Paying homage to Neoplatonic concepts, Titian creates a Triumph of Love that acknowledges the various levels of that power, from the earthly to the heavenly, from human passion to divine love. "There are three kinds of beauty," Marsilio Ficino had written in his commentary on Plato's *Symposium*, "that of the souls, that of the bodies, and that of sounds; that of the souls is perceived by the mind, that of the bodies we perceive through the eyes, that of sounds through the ears; love is always content with the mind, the eyes, and the ears."

Titian's picture is, above all, a full sensuous experience, a direct appeal to those senses approved by Ficino—as well as to the "lower" sense of touch, always a crucial mode of experience in this painter's art. But *Venus and the Lute Player* is hardly an illustration of abstract doctrine. It is a social image in the widest sense, in which a human action unfolds in time, articulated and measured—as so often in Titian's work—by music. The partbooks are open; the courtier sings a madrigal to the accompaniment of the lute, while the goddess herself still holds the recorder that she was playing a moment ago. Music, spanning past, present, and future, is the basic means of expression, articulating time; its harmonies serve as the fundamental unifying medium; its theme is, as it must be, love. As Titian's friend Aretino wrote, with regard to women, "the knowledge of playing musical instruments, of singing, and of writing poetry . . . is the very key which opens the gates of their modesty."

There is still a further dimension to Titian's picture, for beyond narrating the special rapport between musician and goddess, the painting also addresses the observer directly. Quite obviously, the lush nude is turned frontally, with studied artifice, for the viewer's delectation. Moreover, the viola da gamba propped as a *repoussoir* device in the lower right corner and extending beyond the space of the picture, awaiting its player, implicitly invites us to join the concert, to participate fully in the adoring perception of beauty.

The intricate social mechanics of Titian's painting, summarizing a range of Renaissance experiences and values, celebrating the ideality of divine love while recognizing the reality of human appetite, finds a parallel expression in the final ironic lines of the seventy-first sonnet of Sir Philip Sidney's sequence *Astrophel and Stella*:

> So while thy beauty draws the heart to love,
> As fast thy virtue bends that love to good.
> But, ah, desire still cries, "Give me some food."

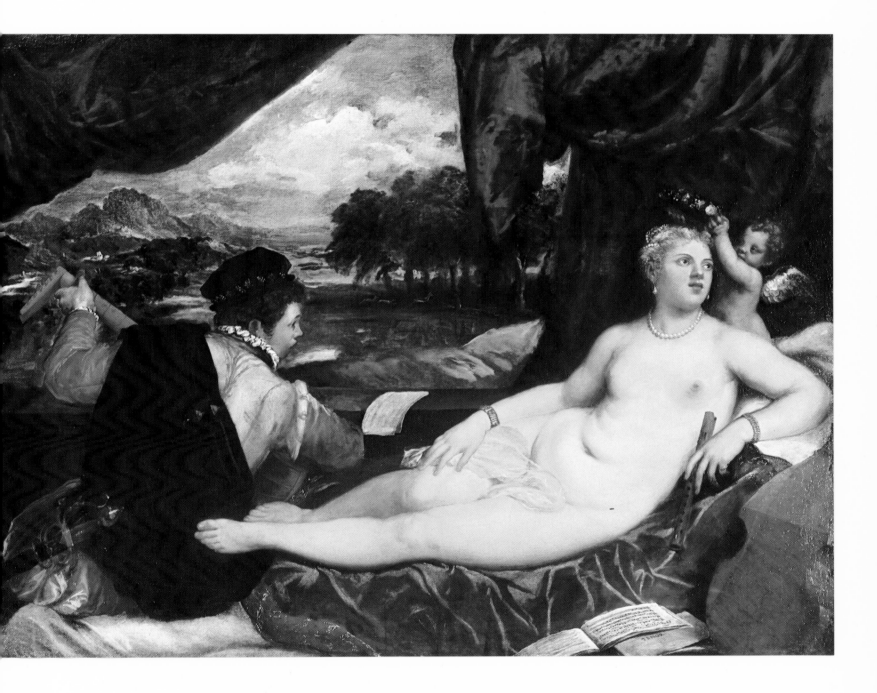

THE ENTOMBMENT

1559

Oil on canvas, 54 × 68 7/8″

Signed (on the plaque):

TITIANVS VECELLIVS AEQVES CAES.

Museo del Prado, Madrid

In July of 1558 Philip II ordered this painting to replace another of the same subject that had been lost in transit, and a letter from Titian dated September 27 of the following year announced shipment of the completed canvas. Serving as the basis for Titian's invention here was his own earlier composition of about 1525 (colorplate 21), but the controlled choreography of that version has yielded to a heightened urgency of expression. The figure-frame relationship now establishes a greater density of form, and this format tends to preclude a classical spatial structure. With a more dynamic counterpoint, the figures are compressed and the focus is concentrated on the body of Christ—now more fully illuminated but broken, as it were, by the very bending of the lower limbs.

And yet, despite the increased sense of agitation and the relative surrender of emotional composure, Titian has, if anything, designed a composition of even greater structural clarity and control. A pair of coordinates divides the field: the horizontal top of the sarcophagus is intersected by the vertical running along its near edge and continuing above in the separation between landscape backdrop and sky. Within the textural and chromatic unity of the whole, the resulting quarters of the composition are invested with their own special values. The left half of the painting carries, literally, the greatest weight: the concentration of mourners

around Christ and, above all, the terrible ponderation of his own figure. In contrast to these heavy verticals, the right half appears volatile, characterized by a horizontal linear direction: here it is the rushing figure of the Magdalen that establishes the essential thrust, along with the leaning body of Nicodemus. Realizing this pictorial structure, giving it unity and conviction, is, of course, Titian's brushwork. The organizational scheme is carried out in the smallest dimension as well, in the basic constitutive element of the brushstroke: on the left the paint has been applied directly and firmly, with substance; on the right the Magdalen's gossamer flight is achieved by longer, lighter strokes, and the graphic impasto functions against a very thinly painted ground.

On the illuminated face of the sarcophagus the sculpted relief is clearly legible: Abraham's sacrifice of Isaac, the Old Testament type of the sacrifice of Christ, which is paired with Cain slaying Abel. Leaning against the carving is a plaque bearing Titian's proud signature with its title of imperial knighthood; its placement alongside the obedient Isaac is hardly fortuitous, for this relationship reflects with some precision the dominant motif of the upper left quarter of the canvas, the careful juxtaposition of Christ and the supporting figure of Joseph of Arimathea—almost certainly a portrait of the painter himself.

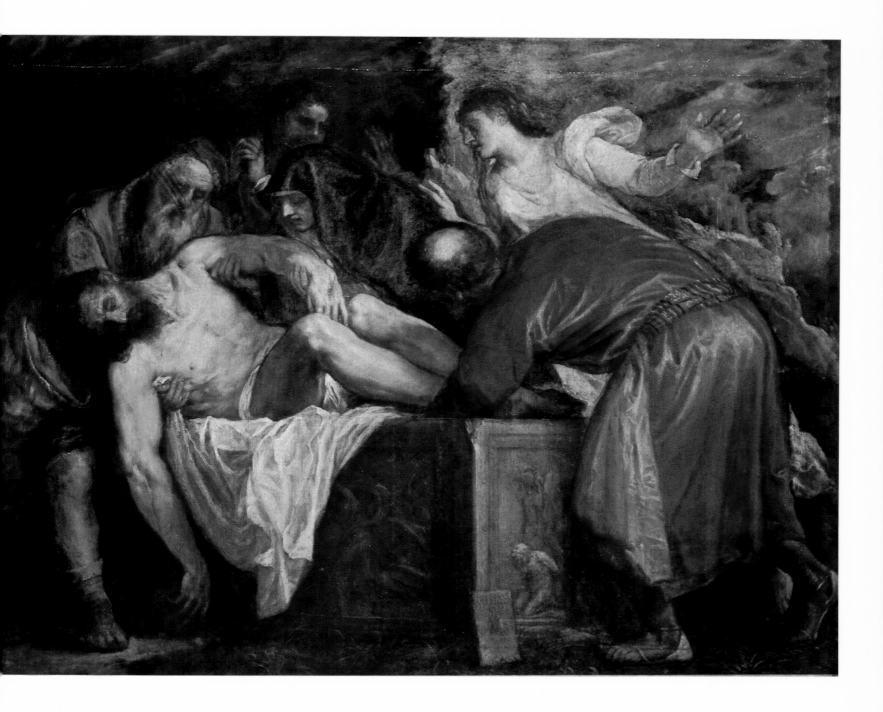

THE RAPE OF EUROPA

1559–62

Oil on canvas, 70 × 80 1/2"

Signed (lower left): TITIANVS. P.

Isabella Stewart Gardner Museum, Boston

Begun in 1559 and shipped to Spain in 1562, *The Rape of Europa* was the last of the *poesie* sent to Philip II.

Jupiter, disguised as a bull, charms the daughter of King Agenor of Sidon; once she and her companions have decked him with flowers and she has innocently settled herself on his back, he makes his way to the shore. "The god little by little edges away from the dry land, and sets his borrowed hoofs in shallow water; then he goes further out and soon is in full flight with his prize on the open ocean. She trembles with fear and looks back at the receding shore, holding fast a horn with one hand and resting the other on the creature's back. And her fluttering garments stream behind her in the wind" (Ovid, *Metamorphoses*, ii. 870–75). One of the most attentive readers of Ovid, Titian must have known such descriptions practically by heart, and was also familiar with the more detailed *ekphrasis* that opens the romance of *Leucippe and Clitophon* by Achilles Tatius (we quote the 1597 Elizabethan translation):

> her breast to her privy parts was attired with a vaile of lawne, the rest of her body was covered with a purple mantle, all the other parts were to be seene, save there where the garments covered, for she had a deepe navill, a plaine smooth belly, narrow flanke, round buttocks: her tender breasts seemed to swell, throgh the midle of which went down a fair narrow way most pleasant & delightfull to the beholders: with one hand did she holde his horne, with the other his taile, but yet so that the attire of her head covered with a scarf cast over her shoulders, was held on fast against the force of the wind, which did so beat on her bosom, that every where it seemed to swell. She thus sitting on the bull, was caried like a shippe, her scarfe serving in stead of a sayle. Round about the bull Dolphins floted about, and sported at their loves in such sort, as that you would thinke, you saw their verie motions drawn.

Responding to such enthusiastic descriptions of the distraught Europa, Titian outdid the ancient images. The most striking formal feature of his *Rape of Europa* is surely the heroine herself, whose heavy figure dominates the canvas and establishes the tone of its naturalism. Even within the world of Titian's late art there is scarcely another figure comparable to this unbalanced form of quivering flesh, which, in the words of Crowe and Cavalcaselle, "is not the less true to nature in its semblance because it displays no selection or ideal of contour, but is reality itself in rich substance of gorgeous tone." Titian does indeed have this figure "display its ample charms in a pose of ungainliness which only fear could sanction" (E. K. Waterhouse). But his Europa nonetheless maintains a classical *gravitas* and, despite the casual air of the naturalism, a certain composure as well. The gesture of her right hand, Titian's most blatant departure from the antique visual tradition of such representations, casts an ominous shadow across her face—a sign of tragic import that Titian developed to a refined poignancy.

The Rape of Europa is a magnificent example of the master's late manner, loose in its painterly fabric yet satisfyingly finished in appearance; the subtlety and audacity of its suggestive brushwork offer a perfect correlative to the grave sensuality of its narration. Foreground objects are rendered with a thick impasto, strokes varied according to their different mimetic functions, while background forms, painted quite thinly, partake of the very texture of the canvas weave, which helps create a veil of atmospheric distance. On one level the picture is a demonstration of Titian's full painterly power, and yet art somehow seems no longer to compete with art but rather to challenge nature herself, re-creating her models and informing them with a superabundance of her own organic stuff and energy.

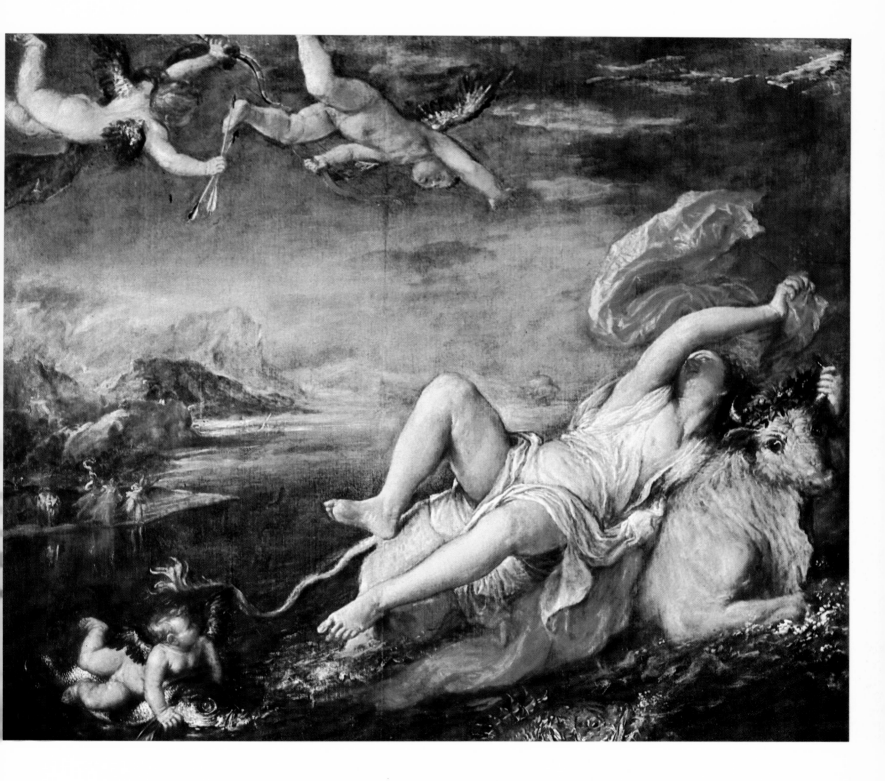

THE ANNUNCIATION

c. 1560–65

Oil on canvas, 13' 2 5/8" × 7' 8 1/2"

Signed (on the lower step):

TITIANVS FECIT FECIT

San Salvatore, Venice

According to the seventeenth-century biographer Carlo Ridolfi, the emphatic signature on this canvas was prompted by the friars' complaint that the painting had not been *"ridotta à perfettione"* (brought to perfection). Another legend explains that Titian repeated the *fecit* ("made it") to emphasize his full personal responsibility for the painting, a documentary demonstration that even at this advanced age—he would have been about seventy-five—his creative powers continued unabated. Such self-assertiveness was indeed typical of the old master, and the painting bears impressive witness to the exuberant freedom of his late painterly style, which undoubtedly perplexed many of his admirers, and to its firm control—a combination epitomized in the related large chalk study for the Archangel Gabriel (fig. 78). The energies unleashed in the composition—the thrusting entrance of the announcing angel and the realization of his message in the violent opening of the heavens and the luminous descent of the dove—are conveyed as much by the vigorous brushwork as by the design itself; they are, moreover, measured against the highly regular structure of the architectural coordinates that frame the scene: the verticals of the fluted colonnade to the left and the solid horizontals of the stepped pavement below.

The San Salvatore *Annunciation* culminates, both formally and iconographically, a series of such altarpieces by Titian: one painted in 1536 for Santa Maria degli Angeli at Murano (never delivered and subsequently lost, but known through an engraved copy), and another, probably completed by 1557, for San Domenico Maggiore in Naples. In both of these earlier compositions the Virgin responds with passive humility, her hands folded piously across her breast. In the latest version, however, her response is more active. She turns with a decorous serpentine movement to receive the Word, meeting the angel directly. Her studied, classically inspired bridal gesture, raising the veil, is particularly eloquent in its ambiguity:

on the one hand, an action of opening or unveiling; on the other, a sign of defensive self-protection. This emphasis on the ear is an elaboration of the traditional Augustinian interpretation of the Conception *per aurem*—Mary immaculately conceiving Christ merely by hearing the divine Word.

Totally integrated into the pictorial fabric of the San Salvatore canvas, the Virgin's slow movement mediates between the stability of the architectural units, which are of this world and which lend her physical support, and the more open, explosive forms of the intruding divinity. She is, moreover, the pivotal element in the picture's chromatic structure: the pure red and blue of her garments are distributed with muted intensity through the upper zone, modifying the essential golden luminosity of heaven.

Two specific iconographic motifs interpret rather explicitly the significance of this scene of the Incarnation. The glass vase filled with water and flowers, in front of the Virgin's *prie-dieu*, is a traditional symbol of her purity: as light passes through glass without breaking it, so does the holy spirit enter Mary's womb without affecting her virgin state. The inscription on the step below, IGNIS ARDENS NON COMBVRENS ("The fire that burns but does not consume"), further elaborates the same concept; the reference is to the burning bush by means of which God manifested himself to Moses (Exodus 3:2). And, in this case, the plant in the vase is literally that burning bush: Titian's charged brushstrokes render the petals actually bursting into flame.

These metaphorical allusions, with their luministic references, belong to an established theological tradition of Marian celebration, and Titian proves himself an exceptionally close and imaginative reader of the received texts, recognizing and realizing their full pictorial potential. Only by such reading, guided by the obedient energy of the master's brush, could the word, in turn, become paint.

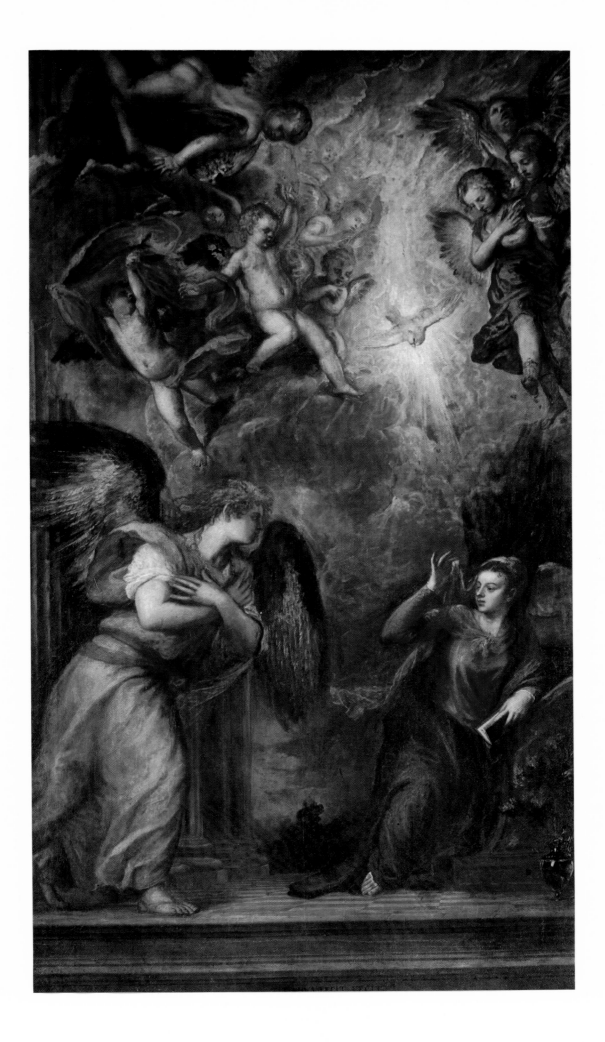

AN ALLEGORY OF PRUDENCE

c. 1565–70

Oil on canvas, 29 3/4 × 27"

National Gallery, London

The iconography of this emblematic triple portrait—probably representing Titian himself, his son Orazio (1525–1576), and his *nipote* Marco Vecellio (1545–1611)—has been the subject of several studies by Fritz Saxl and, particularly, Erwin Panofsky. The inscription, explicitly associated with the three heads, declares the meaning of the image: EX PRAETERITO/PRAESENS PRVDENTER AGIT/IN FVTVRA[M] ACTIONE[M] DETVRPET ("From the past, the present acts prudently, lest it spoil future action"). Thus articulating the temporal relationship of the three ages of man represented by the portraits, the motto further comments on the corresponding three animal heads—wolf, lion, and dog. This tricephalous creature, in association with an encircling serpent, originated as an attribute of the Egyptian god Serapis and became an accepted symbol of time: the lion's head, according to the fifth-century writer Macrobius, "denotes the present, the condition of which, between the past and the future, is strong and fervent by virtue of present action; the past is designated by the wolf's head because the memory of things that belong to the past is devoured and carried away; and the image of the dog, trying to please, signifies the outcome of the future, of which hope, though uncertain, always gives us a pleasing picture."

Beyond the images of the three ages of man and the zoomorphic triad, however, there is as well a temporal dimension to the artist's technique and handling of the medium itself. While the three portraits, rotating, as it were, toward the future, emerge from the darkness of the past to the bright hope of youth, a corresponding handling of paint gives increasing physical palpability to the heads. On the dark tonal ground, the profile of the aged master is only faintly suggested by the dry brush; the vigorous frontal image of the present, partially shadowed, is rendered with a more direct and assertive stroke; and the young face looking toward the future is most brightly illuminated and executed with the thickest impasto. The young profile, enjoying the heaviest texture of paint, rests upon a solid bust of its own, the white collar and specked maroon shirt adding further to its material substance. Our full experience of time thus gains a new dimension through the remarkable eloquence of Titian's brush. Once again, the master has naturalized an abstraction, endowing a symbol with life.

Enigmatic and unusual among Titian's portraits, this triple image may have served as an allegorizing cover for another picture or for a kind of wall safe. In any case, as Panofsky has insisted, the painting must be viewed as a document of the most personal nature, an expression of dynastic hope—a hope that would never be realized.

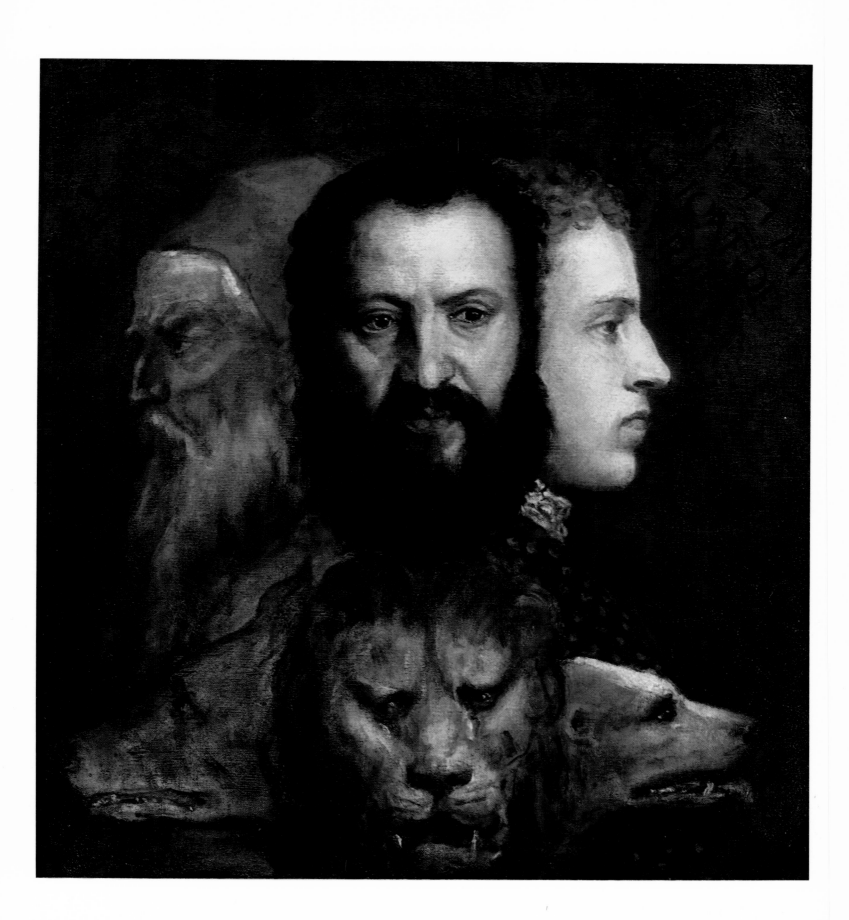

CHRIST CROWNED
WITH THORNS

c. 1570–76

Oil on canvas, 9' 2 1/4" × 5' 11 1/8"

Alte Pinakothek, Munich

This was probably one of the canvases left unfinished in Titian's studio at the time of his death, and subsequently acquired by Tintoretto. The composition of the painting revises that of the panel painted almost thirty years earlier (colorplate 29). While the individual revisions in the design may seem rather minimal, their overall effect is a nearly total reinterpretation of the theme. The basic figural grouping has been retained, with the elimination, however, of the helmeted soldier in the middle of the attacking cluster and the addition of the two youths holding extra canes at the lower right frame. The diagonal thrusts of the original conception have been muted, thereby reducing the violence of the physical aggression. The ominous darkness of the open doorway yields here to a more open vista of sky, itself of dark turbulence. And—perhaps the most significant iconographic transformation—the imperial portrait and its supporting lintel have been replaced by the blazing chandelier.

By reducing the spatial impulse of the foreground and opening up the area behind the figures, Titian has relieved the intense pressure that was so crucial a component of the earlier version. The drama is brought closer to the picture plane, and hence to us, yet it remains distant. Gestures no longer carry the immediate conviction of physical application, and the entire action assumes the quality of a ritualized performance, a strange pantomime that only vaguely recalls the harsh facts of actual torture. Christ, the patient sufferer, the still center of the surrounding movement, seems hardly to feel his earthly torment; his nearly expressionless head now contrasts with and relates to the flaming lamps above; sharing the reds and whites of his blood-stained cloak, these lights may well allude to the ultimate triumph of the Resurrection.

The quality of Titian's late personal style, with its characteristic loose and open brushwork, and his practice of keeping works in progress for long periods, often years, make it difficult to determine just how finished the painting is, precisely how much more Titian might have done before affixing his signature. But there can be no doubt that conception as well as execution is part of that late style, in which the vitality of the brushwork and its accompanying variety of color function as objective correlatives to the life of the mimetic subject itself. The very fabric of the canvas and the texture of the paint, applied with an energy recorded in the marks of color, create a pulsating tissue of substances that stand for, without ever quite imitating, the stuff of nature—flesh, cloth, stone. From out of the background shadow there emerge—rather than solid forms—areas of light; physical contact seems hardly possible in this realm of purely chromatic vision.

To the broken, active patterns of brushstrokes and canvas, of lights and darks, we bring our empirical knowledge of forms and willingly complete in our imagination the fictive world suggested by Titian's brush. Whereas in the earlier version of *Christ Crowned with Thorns* our participation was calculated and controlled with staged precision, here we are involved in the drama through the quality of the paint itself.

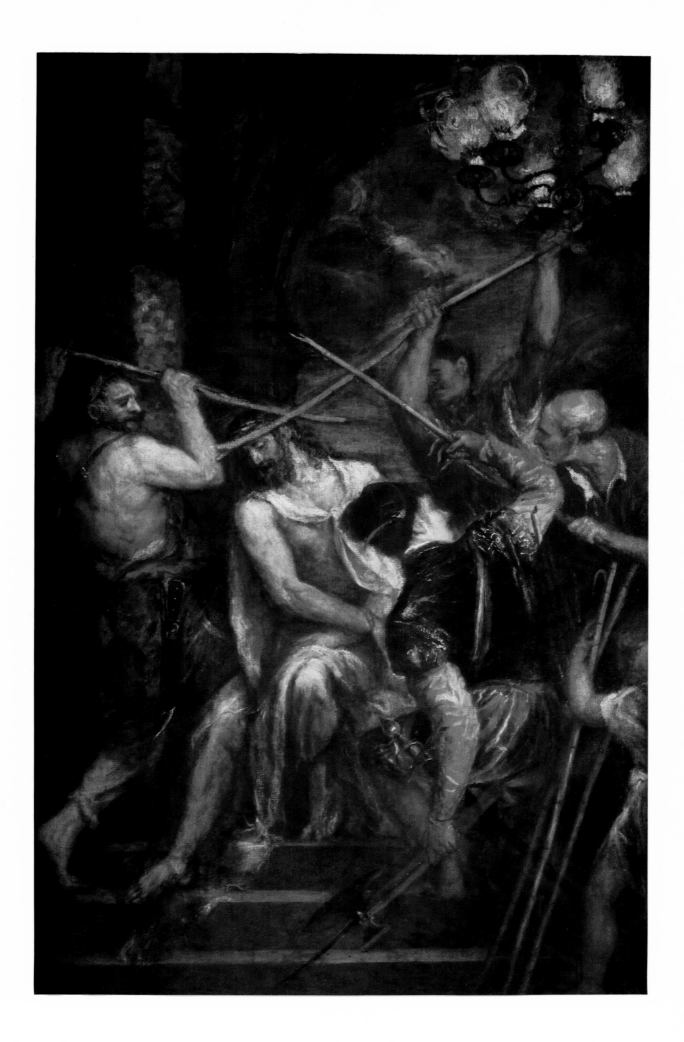

NYMPH AND SHEPHERD

c. 1570–76

Oil on canvas, 59 × 73 5/8"

Kunsthistorisches Museum, Vienna

Of the many interpretations of this melancholy pastoral, the most convincing is that suggested by Erwin Panofsky, who recognized in it the ill-fated lovers Paris and Oenone. Exiled from Troy and dwelling as a shepherd on Mount Ida, Paris loved the nymph, who, endowed with prophetic vision, foresaw that he would abandon her for Helen. When he was mortally wounded at the siege of Troy, she refused to heal him, and, at his death, she killed herself in remorse; the two were buried together. Titian's specific source of inspiration must have been the moving letter invented by Ovid in his *Heroides* in which Oenone addresses Paris, rehearsing and lamenting their tale: "You, now a son of Priam, were (to let respect give way to truth) a servant then; I deigned to wed a servant, I, a nymph! Amidst the flocks we often took our rest protected by a tree; and, intermixed with leaves, the grass became our bridal couch." These lines (*Heroides*, v. 11–14), as Panofsky writes, "anticipate not only the subject and the setting—the grassy ground, the goat nibbling at the foliage of the broken tree on the right, the big 'protecting' tree on the left—but the very mood of Titian's *ultima poesia*."

In this painting the old master again looks back to models of the early sixteenth century, specifically to an invention of Giorgione, preserved in an engraving by Giulio Cam-

pagnola: a female nude with her back turned, reclining in a landscape. The figure of Paris may recall that of Polyphemus in the fresco by Titian's old colleague Sebastiano del Piombo in the Villa Farnesina in Rome.

The canvas—left in the studio at Titian's death—records the moments in its process of becoming. Although the rough and varied brushwork provides the dominant impression of the painting, the composition is in fact highly structured. Indeed, it is precisely within and upon the architecture of clearly defined spatial strata, framing devices, and tectonic accents that the brushstrokes operate. Impasto and scumble articulate the natural objects in the foreground and lend substance to the distant atmosphere; the shared texture of paint becomes the essential unifying element, creating the brooding pictorial ambience that gives the picture its special gravity.

Cool tonalities—nearly pastel shades of blues, grays, mauves, and pinks—establish the somber mood. The most intense color note in the painting is the muted scarlet of Paris' Phrygian costume, repeated in the streaks illuminating the horizon to the right. As much as the figural design itself, which brings the joyless couple together in poignant proximity, Titian's palette, his *colorito*, carries the sad echoes of the flute's lingering sound.

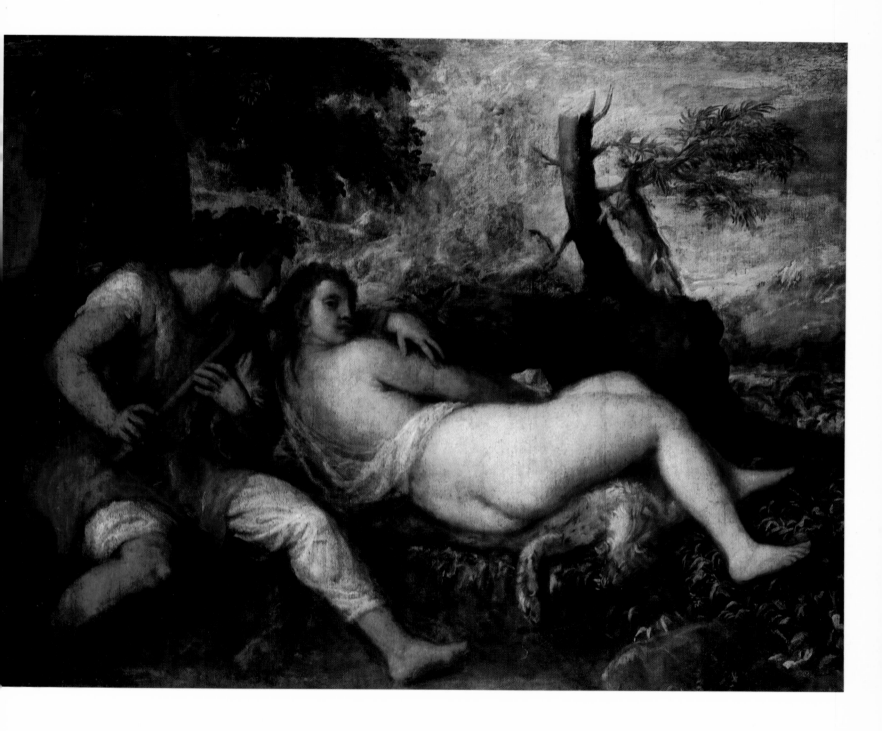

PIETÀ

c. 1570–76

Oil on canvas, 11' 6 3/8" × 12' 9 1/4"

Gallerie dell'Accademia, Venice

Titian originally conceived this canvas as an altarpiece for the Cappella del Crocefisso in Santa Maria Gloriosa dei Frari, where he had arranged for his own tomb, but the project was never realized, and the painting remained in his studio. After his death it was acquired by Jacopo Palma il Giovane, who added some finishing touches—most noticeably in the flying angel—and the inscription: QVOD TITIANVS INCHOATVM RELIQVIT/PALMA REVERENTER ABSOLVIT/DEOQ. DICAVIT OPVS ("What Titian left unfinished Palma reverently completed and dedicated to God"). Grand and sonorous, the painting is best considered in the light of its intended purpose, as the artist's own sepulchral monument, a personal religious expression, and of its intended setting, a side altar to the right along the nave of the Frari—although in its present, nearly square format it is difficult to imagine the painting as an altarpiece, which usually suggests a dominant vertical axis. When the *Pietà* is viewed in that particular physical context, it is evident that Titian was again dealing with issues that he had confronted half a century earlier in *The Madonna di Ca' Pesaro* (colorplate 14). The later composition also recognizes its dual function as altarpiece and wall painting. Iconic stability—centralizing the design above an altar—is established by the architecture, the great niche enframing Mary and the dead Christ. The auxiliary figures, Mary Magdalen and Saint Jerome, create a rising lateral movement from right to left, and that impulse is reinforced by the glances of the two statues of Moses and the Hellespontine Sibyl.

Traditionally static and, for all its tragic intensity, symbolic, the motif of the Pietà—the mourning mother holding in her lap the body of her son—represents a moment beyond historical time, an epitome of theological truth. By surrounding the image with two more actively lamenting figures, Titian has introduced a dramatic and narrative element without, however, undermining the eternity of the theme. And precisely this element of mimetic pathos invites the beholder to participate in the sorrow: the urgent eloquence of the Magdalen—appropriately transformed from a figure of Venus lamenting the dead Adonis on an antique sarcophagus—establishes a nearly hysterical pitch of response, while Jerome, more subdued, approaches the corpse of the Savior with humble piety. Together these two saints define a movement into and out of the space of the picture, following the viewing experience of the nave axis of the Frari.

On one level, the resonance of Titian's painting depends upon such inventive fusion of doctrine and drama, of iconography and emotion. From the silent focus of Mary's sorrow a network of symbolic imagery expands the dimensions of the picture's meaning. Moses and the Hellespontica, representatives of the era before Grace and removed from the reality of the holy present by their marmoreal nature, foretell the passion of Christ. In the glowing mosaic half-dome of the niche, its form and medium recalling the traditions of earlier Christian decoration, the pelican piercing her own body to feed her young alludes to the infinite charity of Christ's sacrifice for the salvation of mankind. And in the spandrels of the arch, trumpeting victory figures, inspired by those on Roman triumphal arches, proclaim the ultimate triumph over death.

The architecture itself, combining a variety of stylistic and functional references, is as richly allusive as the figural imagery; its ponderous forms, contributing to the solemn gravity of the composition, define the sacred site of this eternal encounter and articulate, as well, a hierarchy of spaces within it, reserving the interior niche exclusively for Mary and the dead Christ. This great monument rising over the fictive spot of lamentation was also intended to crown, on another, related level, the actual altar in the Frari, and, below it, presumably the tomb of the painter himself.

Ultimately, it is precisely this personal reference that adds the most moving dimension to the image, into which Titian seems to have put so much of himself. The aged

CONTINUED ON THE FOLLOWING PAGE

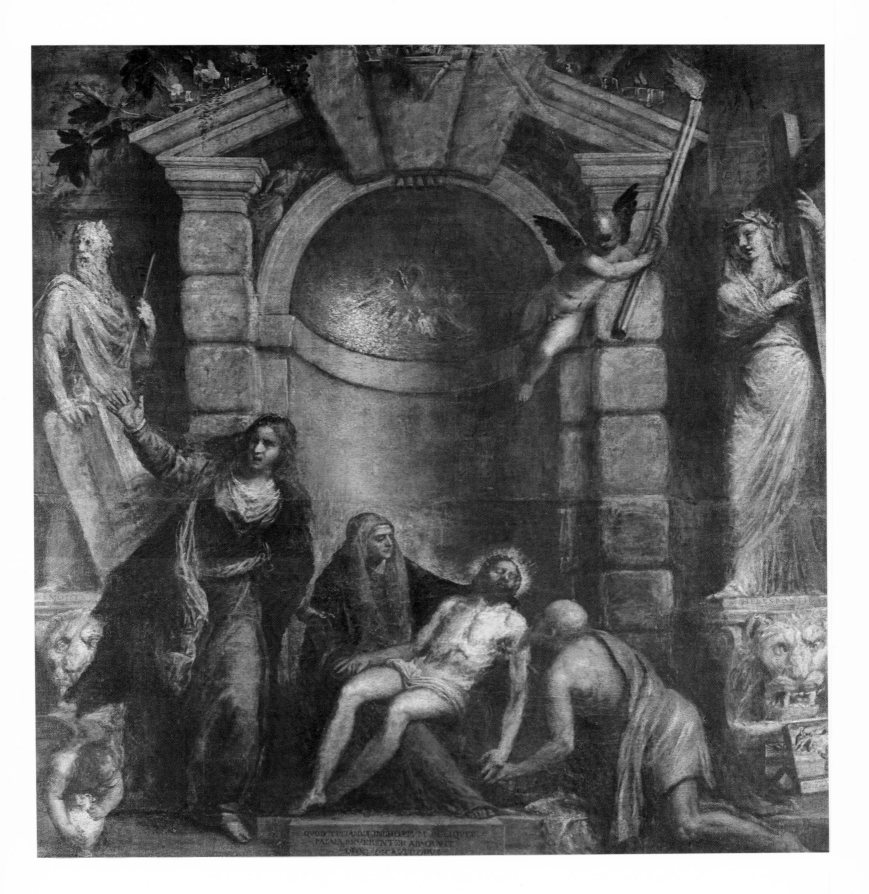

PIETÀ, detail

Saint Jerome, in fact, is a self-portrait, and his reverent touching of Christ's body becomes the painter's own prayer for salvation—just as Michelangelo, in the guise of Nicodemus, holds the body of Christ in the Florentine *Deposition* group he had intended for his own tomb. Leaning against the base of the statue of the Sibyl at the right are two devices that function as signatures: the Vecellio coat of arms and a small votive panel showing two figures, logically Titian and his son Orazio, in prayer before a vision of the Pietà. This little painting, with an unfortunately illegible inscription, is of a type popular throughout the Veneto—especially in such mountain communities as Titian's birthplace—and the crudity of its execution here may be read as a knowing comment on the simple piety of its model.

Such self-awareness, professional as well as personal, is a critical component of Titian's *Pietà*, which not only declares the piety of the painter but affirms his art as well. The canvas itself is composed of a number of separate pieces sewn together, documenting the practical efficiency of Venetian workshop production. The central section, containing the actual Pietà group, is encrusted with a heavier paint surface than the rest, and X-ray investigation has revealed that Titian painted over an abandoned composition of an Entombment. It seems somehow quite appropriate that for his own sepulchral image Titian should have left a palimpsest recording something of the activity of his studio.

On a more immediately visible level of professional interest the composition may be read as a monumental demonstration of the sort of *paragone* that figured so importantly in Titian's artistic self-consciousness: the painting includes within its world remarkable inventions of architecture and sculpture which are not merely decorative additions but totally integrated constituents of the expressive structure of the picture. Whatever their possible sources of inspiration in the art of Michelangelo or Sansovino, Titian's sculptures are conceived to invite just such comparison. The architecture, however, combines references to the formal vocabulary of the sixteenth century as well as to the experiences of earlier epochs. The mosaic niche, evoking the Byzantine world of Venice's most hallowed religious architecture, that of San Marco, seems also to pay tribute to another pictorial evocation of that world, the altarpieces of Giovanni Bellini (fig. 2). Whereas in the *Nymph and Shepherd* (colorplate 46) he had returned to his secular origins, Titian evidently envisioned this work, the concluding image of his long career, as a return to an earlier moment in the traditions of Venetian religious art. The *Pietà,* a unique conception in the context of later sixteenth-century painting, thus stands as an image extraordinarily rich in allusion; simple and sophisticated, humble and proud, eternal and temporal, it is Titian's final artistic testament and the epitome of his art.

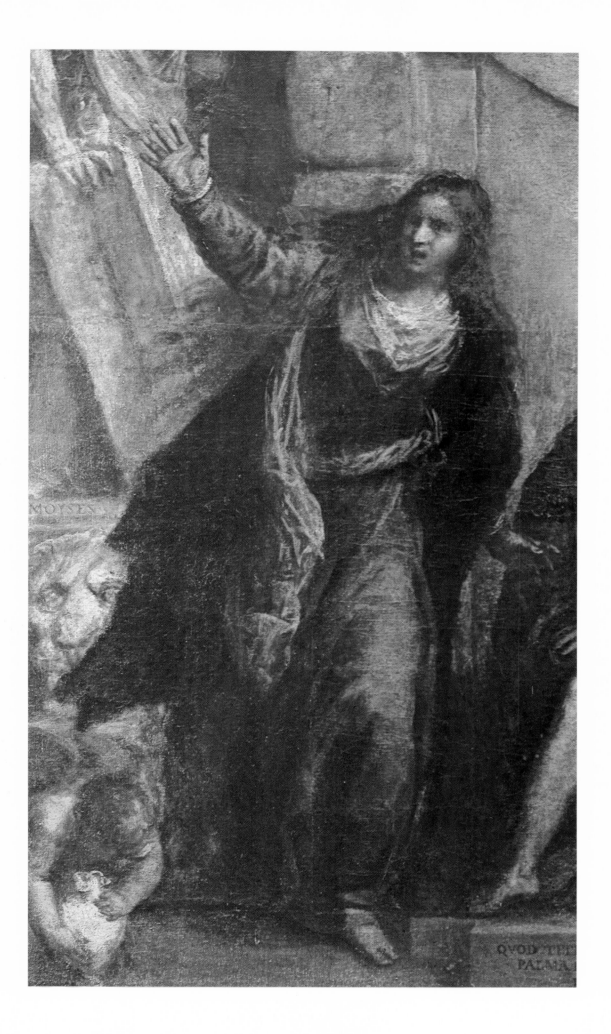

BIBLIOGRAPHICAL NOTE

For the fullest and most up-to-date list of publications on Titian, the reader is referred to the bibliographies in Harold E. Wethey's three-volume catalogue raisonné, *The Paintings of Titian* (London, 1969–75), and, for a more critical appraisal of the bibliographical situation, to the excursus in Erwin Panofsky's *Problems in Titian, Mostly Iconographic* (New York, 1969), pp. 172–76.

Sources Unfortunately, there is yet no complete edition of the collected documents relative to Titian—although a critical edition of the artist's correspondence is in preparation by Charles Hope. The two earliest literary sources of information concerning Titian's life and art are available in English translations: Lodovico Dolce's *Dialogo della pittura . . . intitolato l'Aretino* (Venice, 1557) is printed in both English and Italian in Mark W. Roskill, *Dolce's "Aretino" and Venetian Art Theory of the Cinquecento* (New York, 1968), and the second, enlarged edition of Giorgio Vasari's *Le vite de' più eccellenti pittori, scultori ed architettori* (Florence, 1568) may be found in several English versions. Two important seventeenth-century sources, however, have never been translated: Carlo Ridolfi, *Le maraviglie dell'arte ovvero le vite degl'illustri pittori veneti* (Venice, 1648; critical edition by Detlev von Hadeln, 2 vols., Berlin, 1914–24), and Marco Boschini's informative introduction to the second edition of his guidebook, *Le ricche minere della pittura veneziana* (Venice, 1674; text available in Anna Pallucchini's edition of Boschini, *La carta del navegar pitoresco*, Venice–Rome, 1966). Another rich source of information is provided by the letters of Pietro Aretino; those pertaining to art have been edited by Fidenzio Pertile and Ettore Camesasca as *Lettere sull'arte di Pietro Aretino* (3 vols., Milan, 1957–60).

Monographs Still the best and most readable modern biography, at once broad in scope and detailed in its wealth of documentation, is J. A. Crowe and G. B. Cavalcaselle, *Titian, His Life and Times* (second impression, 2 vols., London, 1881). Special mention must also be made of Panofsky's *Problems in Titian, Mostly Iconographic,* cited above; more than any other single book on the master, this series of lectures suggests the profundity and subtlety of imagination and the remarkable range of experience, intellectual and human, contained in the world of Titian's art. Wethey's three volumes, *The Paintings of Titian,* also cited above, now comprise the standard catalogue of Titian's work, fully illustrated.

Drawings Still of great use, especially for its illustrations, is the pioneering volume of Detlev von Hadeln, *Titian's Drawings* (second edition, London, 1929). The most thorough introduction to the problems surrounding the study of Titian's drawings and the most circumspect presentation of the material, with special attention to the context of Venetian workshop production, is the fundamental corpus by Hans Tietze and E. Tietze-Conrat, *The Drawings of the Venetian Painters in the 15th and 16th Centuries* (New York, 1944). The catalogues of two recent exhibitions summarize the fluid situation in the connoisseurship on the master's drawings: Konrad Oberhuber, *Disegni di Tiziano e della sua cerchia* (Venice, 1976), and W. R. Rearick, *Tiziano e il disegno veneziano del suo tempo* (Florence, 1976).

Woodcuts The catalogue by David Rosand and Michelangelo Muraro of the exhibition *Titian and the Venetian Woodcut* (Washington, D.C., 1976) offers a full survey and critical discussion of the graphic material.

INDEX

PHOTOGRAPH CREDITS

Note: Numbers refer to figures, and an asterisk (*) denotes a colorplate

The author and publisher wish to thank the libraries and museums for permitting the reproduction of works in their collections. Photographs have been supplied by the owners or custodians of the works of art except for the following, whose courtesy is gratefully acknowledged:

Alinari, Florence: 2, 19, 35, 38, 39, 40, 46; Jörg P. Anders, West Berlin: 8, 45, 64; Anderson/Alinari, Rome: 14, 25, 44, 50, 51, 71, 77, 78; Archives Photographiques, Paris: 32; Bildarchiv Preussischer Kulturbesitz, West Berlin: *1, *3; Joachim Blauel, Munich: *45; Osvaldo Böhm, Venice: 17; Brogi/Alinari, Florence: 24, 70, 72; Cameraphoto, Venice: 4, *43; Ludovico Canali, Rome: *10, *11, *23, *26; Cooper-Bridgeman Library, London: *32; Courtauld Institute of Art, London: 28, 57; Deutsches Archäologisches Institut, Rome: 54; Edizioni Artistichi Fiorentini, Venice: 6; Photo Étienne, Bayonne: 75; Guglielmo Giacomelli, Venice: *2, *4, *14, *24, *25, *37; Giraudon, Paris: 62, 74; Hirmer Verlag, Munich: 34; Lichtbildwerkstätte Alpenland, Vienna: 84; Foto MAS, Barcelona: *17, *20, 23, 30, *33, *34, *35, *36, *39, *41, 48, 49, 52, 53, 55, 60; Federico Arborio Mella, Milan: *30; Erwin Meyer, Vienna: *5, *28, *46; National Galleries of Scotland, Edinburgh: 29, 58; Rizzoli Editore, Milan: *39; David Rosand, New York: 13; SCALA, Florence: *6, *7, *12, *13, *16, *31, *47, *48; Service de Documentation Photographique de la Réunion des Musées Nationaux, Paris: 7, *15, *21, *29, 33, 43, 47, 68, 76; Soprintendenza alle Gallerie, Florence: 67; John Webb, London: *8, *9, *18, *19, *22, *44.